FIVE
One Hundred
STAR
American
FOLK
Masterpieces
ART

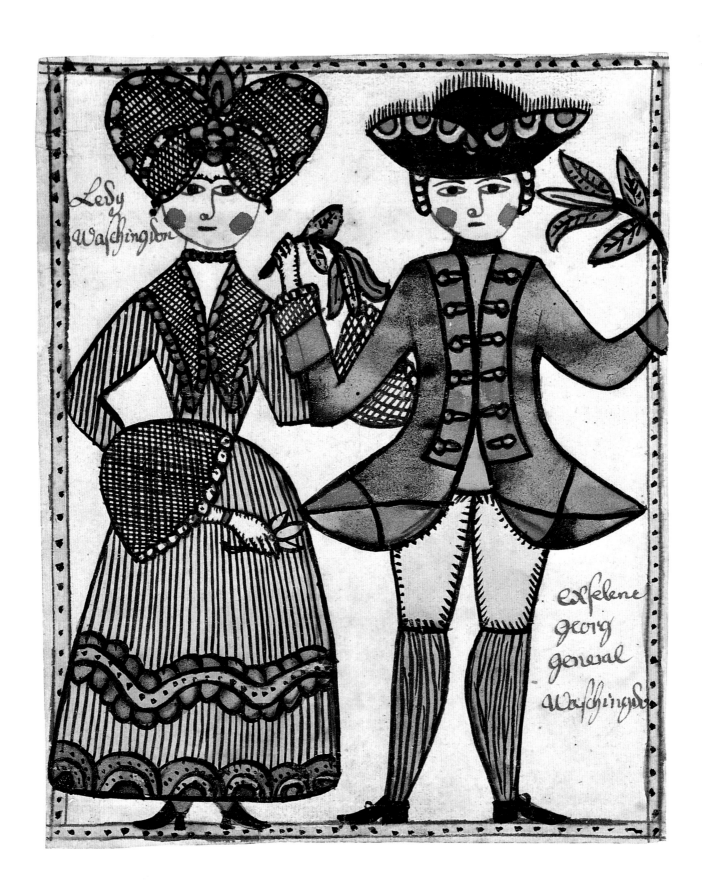

FIVE STAR FOLK ART

One Hundred American Masterpieces

★ ★ ★ ★ ★

JEAN LIPMAN
ROBERT BISHOP
ELIZABETH V. WARREN
SHARON L. EISENSTAT

★ ★ ★ ★ ★

Harry N. Abrams, Inc.
Publishers, New York
★
IN ASSOCIATION WITH
THE MUSEUM OF AMERICAN FOLK ART
NEW YORK

PROJECT DIRECTOR: DARLENE GEIS
EDITOR: ELLYN CHILDS ALLISON
DESIGNER: ELISSA ICHIYASU

Library of Congress Cataloging-in-Publication Data
Five-star folk art: one hundred American masterpieces / Jean Lipman.
p. cm.
Includes bibliographical references.
ISBN 0–8109–3302–0
1. Folk art—United States.
I. Lipman, Jean, 1909–
II. Museum of American Folk Art.
NK805.F56 1990 90–120
745'.0973—dc20 CIP

PHOTOGRAPH CREDITS

A number of professional photographers aided us in obtaining the best
possible images of our selections. We are especially grateful to Allan
Finkelman for figure 100; John Guider for figure 74; Schecter Lee for
figures 10, 62, 68, and 72; John Parnell for figures 23, 28, 46, 61, 71,
80, 81, 82, and 88; Mary Peck for figure 85; Richard Strauss for
figure 73; Sunami for the photograph of Holger Cahill on the dedication
page; Thomas B. Wedell for figure 66; and Dorothy Zeidman for
figure 50. In accordance with The Metropolitan Museum of Art's
request, the following information is included: figure 3,
"Copyright © 1981"; figure 29, "Copyright © 1990"; figure 39,
"Copyright © 1984"; figure 86, "Copyright © 1988";
and figure 90, "Copyright © 1988."

FRONTISPIECE
Exselenc Georg General Waschingdon
and Ledy Waschingdon
figure 45
★

HOLGER CAHILL IN THE EARLY 1930S

★

To the memory of Holger Cahill,
who laid firm foundations for
the study of American folk art

ACKNOWLEDGMENTS

★ ★ ★ ★ ★

Five-Star Folk Art would not have been possible without the enthusiastic support of the staff of the Museum of American Folk Art. We would especially like to thank Lee Kogan, Research Associate, who located significant background material, and Stacy C. Hollander, Assistant Curator, who also provided important research help and editorial assistance. As always, Gerard C. Wertkin, Assistant Director, provided insightful comments on the text. We would also like to acknowledge the contributions of Edith Wise, Director of Library Services; Janey Fire and Karla Friedlich, Photographic Services; Ann-Marie Reilly, Registrar; Didi Barrett, Director of Publications; and Cyril I. Nelson, Trustee.

We appreciate the help of both the private collectors and the many public institutions that allowed us to reproduce the one hundred objects shown here and provided us with the information we needed about them. In particular, we would like to thank Nancy E. V. Bryk, Curator, Division of Domestic Life, Henry Ford Museum and Greenfield Village; Richard Miller, Associate Curator, Abby Aldrich Rockefeller Folk Art Center; and Frank J. Miele, David A. Schorsch, Dorothy Miller, and Wendy Jeffers. Many other scholars and museum professionals aided us in our quest for photographs and information. We especially appreciate the help of Anita Duquette, Manager of Rights and Reproductions, Whitney Museum of American Art; John Bidwell, William Andrews Clark Library, University of California; Professor James F. O'Gorman; Brock W. Jobe, Chief Curator, Society for the Preservation of New England Antiquities; Nancy Druckman, Head of American Folk Art, Sotheby's, Inc.; Pastor Frederick Weiser of the Pennsylvania German Society; and Judge Judith P. Lentz of Killingworth, Connecticut. On behalf of The J. B. Speed Art Museum, Louisville, Kentucky, we make the following acknowledgment: the quilt illustrated in figure 92 was purchased for the Museum through the efforts of the Kentucky Quilt Project, Shelly Zegart, Eleanor Bingham Miller, and Jonathon Holstein, and through the generosity of the Bingham Enterprises Foundation of Kentucky, Incorporated, and several anonymous donors.

At Harry N. Abrams, Darlene Geis was unwaveringly enthusiastic and supportive of the *Five-Star Folk Art* project. We would also like to thank Ellyn Allison for her meticulous copy editing, and Elissa Ichiyasu for her thoughtful and sensitive design. Finally, for special editorial contributions, the authors would like to thank A.C.R.S., Plainfield, New Jersey, Irwin Warren, and Colonel Alexander W. Gentleman.

The Museum of American Folk Art gratefully acknowledges the generous support of Schlumberger Foundation for the presentation of "Five-Star Folk Art," the exhibition produced in coordination with this publication at its Eva and Morris Feld Gallery at Lincoln Square, New York City.

CONTENTS

FOREWORD: A CONCEPT OF QUALITY

★ ★ ★ ★ ★

Jean Lipman

Five-Star Folk Art has been planned as a serious book, not just a beautiful picture presentation but a guide to looking at and appreciating folk art. The key common denominator of the hundred selections is *quality,* a concept that our team of four people, representing the Museum of American Folk Art, has attempted to define and illustrate after two years of study and writing. The final selection for the book and companion exhibition are, we think, one hundred superlative examples from the multitude of outstanding works done during four centuries of life in America by the people—the folk, if you will—whom we call folk artists.

These artists are related by being somewhat less conventional, less formal, less worldly-wise than our early academically trained professionals or modern art-world sophisticates. But defining the field of folk art is difficult. The question remains, how does one draw a precise line between folk art and other art of its time? There really is no exact way to do it. Some folk art is relatively close to academic art—but the key word here is *relatively.* So we include only examples that are closer to mainstream folk art than to art with academic or avant-garde attitudes.

For folk art created in the twentieth century, one key question is more complex: are the artists who have self-consciously chosen folk-art subjects folk artists? I think not. They are painting—or carving or quilting—art *about* folk art. Folk-art history is their point of departure and folk art is their subject matter. This is not to denigrate their work. Art-about-art has been a respected style for a long time and is an important aspect of the contemporary art scene. Picasso, for example, did, among many other such appropriated paintings, a wonderful one about Velázquez's *Las Meninas,* but this did not make him an old master. Roy Lichtenstein's *Brushstroke* paintings, a series about Abstract Expressionism, did not make him an Abstract Expressionist. The "neo-folk" artists are commenting not about our time in any contemporary style but, with urbane know-how, about the way of life, ideas, and art of the earlier, ingenuous folk artists, whose work in recent decades has become so important to us all. Many of the "neo-folk" artists have done splendid things, but these remain art-about-folk-art rather than twentieth-century folk art—of which there is an important body of work by many artists with unique inner vision. Of this last group we have included a number of wonderful examples, relying upon the same criterion we applied to early folk art—five-star quality.

The characteristics and importance of quality, one might assume, are obvious today. Not so. In fact, the primary values of art seem to be in a strange new danger zone. The interest in and demand for art is booming as never before, and as a direct result of the over-inflated art market there has developed a widespread tendency among art dealers, magazines, museums, and collectors to avoid fixing a firm definition of quality for works of art and acting according to its implied dictates. Moreover, this negligence has recently been endorsed in a positive way by a group of "revisionist" art historians and "folklorists" who are promoting their opinion that the social history, not the aesthetic quality, of art objects is their only true significance. It is most important now for collectors to think both positively and negatively about the art they are offered and the critical writing they find in the press, in order to arrive at independent evaluations based on what they believe to be valid criteria.

In every field—folk art, old masters, new talent—it has become impossible to find enough five-star examples for the now vast art public.

Klaus Perls, a veteran gallery owner, says it is a market where "too much money and too many people are chasing too little art." So the art world has drifted into acceptance—prodded by sophisticated promotion—of acceptable rather than remarkable works of art. As for the future, encouraging and risking support for emerging artists has become feasible only for those few dealers who want and can afford to sponsor low-priced art despite their high overhead. The great majority of dealers require large-volume sales at big prices. And, not too surprisingly, prestige-oriented buyers now tend to be attracted by high prices. A young artist told me he could not get any one of six prominent Los Angeles dealers even to glance at the work he brought them, not so much as to look at the photographs, and when he asked one of them if his gallery might not miss some work of real quality, the director said that, frankly, he had to be primarily interested in an artist's established reputation, so the quality of new work would unfortunately be of no practical value to him.

A few dealers, functioning in much the same way as big-time advertising agencies or TV networks, do choose a few artists whom they feel they can promote to quick success—and top ratings among collectors and museums. Art-magazine advertising encourages parallel editorial coverage, and expensive, lavishly illustrated monographs (some of which are dealer-subsidized) also impress the art public. Museums are not reluctant to schedule show-biz extravaganzas that guarantee attendance and publicity as well as "retrospective" exhibitions for artists still in their thirties, newly arrived on the art scene and instant—though usually brief—sensations. As Andy Warhol remarked, "In the future everybody will be world-famous for fifteen minutes." In "A Critic's Musings" (*Christian Science Monitor,* 31 August 1987), Theodore F. Wolff wrote that "for a growing number of younger artists . . . the only worthwhile goal is art-world stardom, not the production of meaningful art." In fact, it is naive to expect young artists to bypass opportunities for quick fame; art magazines to discourage their advertisers with bad reviews; publishers to reject generous funding for monographs; museums to turn down opportunities for dramatic box-office income and press coverage; and, finally, collectors to pit their judgment against the collective art establishment. However, there are a few signs of hope for the 1990s, a chance that art will perhaps again be sought for personal enjoyment rather than profit or prestige. This future lies with a few farseeing critics, and they may turn the tide. I think they will.

The $40.9 million that Van Gogh's *Sunflowers* brought, then the $53.9 million for his *Irises,* followed by the $82.5 million for the *Portrait of Dr. Gachet* set astounding auction records. Various respected representatives of the press commented that these prices reflected high-level financial considerations, media promotion, rarity of examples of this kind of work by this artist—far more than the quality of these works of art. Kay Larson said recently in *New York* magazine that "art is irrelevant because no one can say quite what the word means anymore." In 1983, reviewing an exhibition of "Terminal Art," she chose as best of show a painting of blood-red lettering that stated: "I have nothing to paint and am painting it."

An artist friend, Dorothy Fratt, commented that investment-oriented collectors were now paying millions for big names almost without regard for the quality of the works—they were buying autographs rather than art. She suggested a possible title for an article: "What Ever

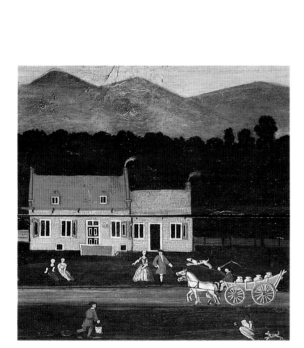

Van Bergen Overmantel
DETAIL
figure 30

★

Happened to Art?" The *Art News* promotion mailing that had triggered Fratt's suggestion provided some provocative answers to her query. In the "visually spectacular" pages of this guide to the "exciting, expanding, exploding art world," the mailing promised, one would find that "art has never been more fun," that it has become "a hot topic for the TV talk show," "a new leisure-time activity for millions of Americans." The mailing featured the magazine's up-to-date buying and investment guide and its reportage about "high jinks in the art world"—which include "misleading ads, dubious discoveries, inflated appraisals, even outright frauds." The boldface heading for the subscription offer ensured a "money-back guarantee if you ever feel let down!" (Subscribers, one must assume, would be embarrassed to be so out-of-step as to consider any of this depressing.)

Grace Glueck focused her gimlet eye ("Tastemakers," *New York Times Magazine*, 30 August 1987) on trends in this late-1980s art world, so enthusiastically touted by *Art News*—as well as by *Artforum*, *Art in America*, and the new *Flash Art*. Even a few random bits of Glueck's article add up to a significant overview of the current art scene, against which the world of the folk artists stands out in striking contrast. She talked about Smart Art, Neo-Geo, Post-Abstract Abstraction, funky painting, religious kitsch, and pseudo-art presentations—much of which could also be termed anti-art—all of which have been successfully promoted by the tastemakers: galleries, art magazines, and "megacollectors" (a Glueck coinage). The art audience is part of the promotion— "restless in its search for the new and newer." The promotion effort has been so successful, indeed, that demand for art often outpaced supply, causing eager-to-buy collectors to be put "on hold."

A few months earlier, Hilton Kramer wrote a remarkably frank article for the *New Criterion* (May 1987) titled "The Death of Andy Warhol." He wrote about both Warhol and the art world—about Warhol: "a figure who was famous for being famous"; and about the art scene: "Art, no matter how debased, still offered a kind of status that was denied to advertising, but otherwise there were now fewer and fewer differences separating the art world from the advertising world. The ethos was getting to be essentially the same. Success was the goal, the media would provide the means of achieving it. . . . The art public was now a different public, larger, to be sure, but less serious, less introspective, less willing or able to distinguish between achievement and its trashy simulacrum . . . for there was no longer any standard in the name of which a sellout could be rejected." Three years later Kramer was still exploring and explaining the problem in the *New Criterion* (February 1990): "To be free of the burden of aesthetic judgment makes the dealers' task and that of the artists they show infinitely easier than it would otherwise be."

The world of the folk artists is quite different from that of today's boom-time-hype scene. There is a purity of intention that is obvious, but there are other differences worth pointing out: folk artists are original without striving for originality; they were not and are not planning work that might make a splash on magazine covers; and they were not promoted by dealers, nor publicized by the media. The folk artists were and are not segregated in an "elite" art world; they were and are simply accepted as part of the everyday life of their communities. Their work is not designed for museums; modest in scale and intention, it is made for *people*—which, strangely enough, the most

Captain Samuel Chandler

DETAIL

figure 5

★

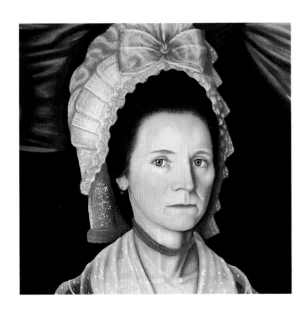

Mrs. Samuel Chandler
DETAIL
figure 5
★

"important," most publicized, most expensive art today is not. It seems that today gallery directors are encouraging their artists to compete for art-world ratings—much as TV programs are planned—and to produce art that will be especially suitable for museums, public places, corporate headquarters, and prestigious semipublic collections (open at least to the press). As with most TV presentations, *quality as art* is strictly secondary or totally ignored.

An active group of art historians is responsible for another trend endangering the appreciation of quality as the primary reason for interest in art—any art, including folk art. Grace Glueck has termed them "revisionists." Reporting on this phenomenon for the *New York Times* (20 December 1987), she quoted Hilton Kramer: "They are substituting social science for art history. . . . The quality of the work of art . . . is regarded as peripheral." In the folk-art field, a subgroup of "revisionists" known as "folklorists" also believes that the art object is important for what it reveals about its time and place—important because it is *there*—not for its quality as a timeless and universal work of art. Some years ago, in the exhibition catalogue *Beyond Necessity: Art in the Folk Tradition*, folklorist Kenneth L. Ames wrote that we must beware of "becoming bogged down in the usually irrelevant issue of artistic merit." He stated further, "The difference between objects considered folk art and those with no loftier designation than just 'things' has been exaggerated." I described his position in 1980 (*American Folk Painters of Three Centuries*) as "a giant step backward to the antiquated idea that folk art is in the category of archeology and history rather than art." We folk-art historians are interested in everything about the work under consideration, but the reason for considering it in the first place is its quality as a work of art. Right now, on many fronts, the concept of quality is in danger of being revised out of existence.

This book, primarily about quality in the field of American folk art, has broader applications: not only does it show how to judge folk art, it offers guidelines for looking at any art today and tomorrow. Our team of authors—Robert Bishop, Elizabeth Warren, Sharon Eisenstat, and I—believed that quality was the key to any desirable art, and we represented the Museum of American Folk Art as if we were forming a collection for the Museum of one hundred of the finest works of folk art that exist—with everything available to us, as it can be in a hypothetical situation. We found that the works that over the years would have been awarded five stars prevailed in that category for the most part—if not for the original reasons, for others. (This seems to apply in all periods in the history of art.) Many of the pieces shown in this book first looked fresh and wonderful fifty years ago, and still do, often for the same as well as other reasons. Five-star works seem to have a life of their own, variously stimulating and renewing our pleasure.

Some attitudes have certainly changed in the study and collecting of folk art. At the outset, folk art from the late-eighteenth century and early-nineteenth century was considered most desirable, but soon all agreed that American folk art actually reached the peak of its achievement well after the Declaration of Independence, when it too declared its independence in the flowering of a bold, new style. In the early years of folk-art study, it was believed that the more "primitive" the work the better it was. Now various degrees of innocence seem equally acceptable; though academic work is by definition excluded, extreme naiveté does not necessarily add to quality. Guidelines are more flexible; we are

Virginia Ivey Quilt
DETAIL
figure 92
★

more broad-minded, willing to push the boundaries outward. Good design is an essential ingredient of folk art, but subject matter may be equally significant: we are no longer basing the definition of folk art on the enthusiasms of the first wave of American abstract artists, who saw the "abstract" qualities of folk art as constituting the unique excitement of rediscovering these works. Aesthetic values remain of primary importance for any five-star work of art. But the artistic personality of the creator—the distinctive character that determines his or her unique style—is of crucial interest, as is the way the work provides insight into the attitudes and interests of its time and place. Art history, psychology, and social science all play a part in the study of any art object. Our approach to the critical examination of folk art is richer than ever before. Because the field is now seen to be more inclusive than the pioneering critics believed, the work of diverse cultural groups is being freshly appraised, exhibited, and published, with examples accepted in the five-star category.

We four authors agreed that no matter how important the artist or the owner; no matter how famous, much publicized, or prestigiously exhibited the work; and no matter how dramatically high its purchase price had been—the sole criterion for every choice would be five-star quality, as best we could define it. This accounts for the omission from our roster of a number of well-known artists whose body of work is extremely important but from which we were not able to select any single piece that could command five stars. We also decided that, having limited ourselves to one hundred examples from four centuries and many mediums, we should include only one work by a given artist, although there were quite a number who could well have been represented by several. I must emphasize that our hundred "stars" are merely examples of outstanding folk art and that we could have selected, with great pleasure, another hundred.

The crux of the project was, of course, deciding that most critical question of quality—discounting size, provenance, date, rarity, and every other peripheral consideration. Clearly, this did not require complex aesthetic investigation and analysis—rather, a primary sense of enjoyment, excitement, and wonder at the highest level, supported by our joint experience in the field of American folk art. The vocabulary needed to explain our decisions, we agreed, would not include the special language of art criticism. It seemed out of key to use words in the professional, elitist way; we thought it best to try for writing as plain and direct as the way the folk artists worked. Quoting Allan Bloom in *The Closing of the American Mind* in an editorial review of the book for *Reader's Digest* (October 1987), Ralph Kinney Bennett has pointed out that "in their retreat from making moral distinctions, Americans have amassed 'a whole arsenal of terms for talking about nothing.'" Substitute the word *aesthetic* for *moral* and you have a telling description of most of the current art criticism. We planned to talk about wonderful works—not "masterpieces" in the original sense of the word but as we define them today—pieces made with extraordinary vision and skill. We will be talking about folk art in wood, metal, and stone instead of "sculpture"; household furnishings instead of "decorative arts"; interest in line, color, and design instead of "abstraction" (something folk artists never heard of). We were all averse to the kind of esoteric critical writing Kay Larson described in *New York* magazine as "a soup of garbled artspeak." Quite simply, we decided on the following guidelines

(taken from an early and rather casual memo of mine), for distinguishing a five-star work of folk art—or any art, for that matter:

FIRST GLANCE: *Sense of pleasure, surprise, excitement, power.*
SECOND LOOK: *Everything adds up to a consistent whole—subject, line, color—all of a piece.*
FINAL IMPRESSION: *Strong—even if, for instance, lines, color, are delicate; sure-handed even if it appears casual. Nothing tentative, nothing expendable, no flaws. Everything exactly right for what the artist had attempted. Seems to have a life of its own that stimulates something new in mine. A perfectly wonderful object!!!!!*

Since the common denominators of quality are the same for folk art as for any other art, it occurred to me that it would be interesting to ask a few of the distinguished people in the art world with whom I had worked over the years (chiefly, as editor of *Art in America*) to join me in considering "the concept of quality"—what they would expect of a work of art that merited a five-star rating. Each of the contributors to the letter symposium that follows has—not at all casually—distilled his or her total art experience in the answer to my query. Representing the criteria of people who head museums, galleries, and auction rooms, and who are collectors, critics, and artists, the symposium is provocative and persuasive.

The same question about quality in art was posed to a number of people who were interested in art but had no connection with the professional art world. Art is for everyone, and appreciation of folk art, or any art, is not an elitist achievement. I found that their answers were basically similar to those of my group of experts. For example, here are the answers of a couple of my friends:

CAMILLE CURRIEL: *One thing I saw and hardly had time to look at; I wanted to go back and study it. I was drawn to it—mesmerized. It reached out and grabbed something that I didn't even know I had.*
NANCY DICKINSON: *The desire to acquire an outstanding work of art is because of a memory of the thing that won't go away—that haunts you and pursues you.*

I must add, in concluding, that world-famous artist Jasper Johns, whose painting *False Start* recently sold at auction for $17 million, William Rubin, Director Emeritus of Painting and Sculpture at the Museum of Modern Art, and Dominique de Menil, one of the most distinguished collectors of our time, declined my request to contribute to the letter symposium because they did not believe that quality can be fruitfully discussed, described, or measured.

JOHNS: *The question is simply outside my concerns at this time.*
MENIL: *"Quality" is intangible and I see no way of defining it.*
RUBIN: *"Quality" is the only thing besides "meaning" in a work of art that you can't really describe or measure.*

If it is not possible to measure the quality of various examples of art, how can one say that anything—a building, a costume, a play, a book, a dinner—is better than any other? We think that judging art, or anything else, can be done by anyone who is interested enough to try. That is what we did in this book. And defining quality has, it seems, been an enlightening exercise for the eighteen experts who contributed to the following letter symposium.

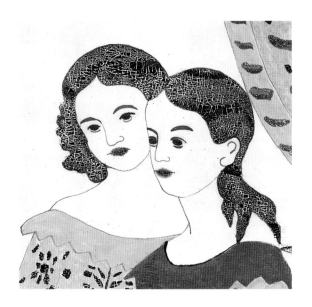

The Tow Sisters
DETAIL
figure 15
★

LETTER SYMPOSIUM:
A CONCEPT OF QUALITY
★ ★ ★ ★ ★

RUSSELL LYNES, AUTHOR OF *The Tastemakers*,
WRITES AS A COLUMNIST ABOUT THE ARTS

How very nice to hear from you! But what a hard question you ask. How do I define quality in a work of art? Heavens! I suppose one recognizes it without defining it when it makes the hair on the back of the neck stand up, or when one says "Wow!" without thinking or thinks Wow! without speaking. I suppose that anyone's scales for weighing quality are the sum total of his or her experience of looking, making comparisons, accumulating a vocabulary of images against which to measure other images, of refining one's perceptions (a tired, over-worked word), not necessarily consciously, somewhat by trial and error. Quality may be static, fixed permanently to an object. Judgment of it, like taste, is, however, changeable, don't you think?

So much for that . . . try this:

Quality says what it means (clarity) and means what it says (honesty).

Quality has something to say and can be said in only one way, its way.

Quality speaks for its time, its place, and its circumstances (culture); it is not an imitation of another time or place or culture.

Quality must be original, one artist's unique statement, which is another way of saying that it is personal. It is never original merely for the sake of originality.

The scale of a work of quality is appropriate to its particular medium. That is, it is superbly made and it could not be made equally well in any other medium. Painting, metalwork, drawing, textile, any medium whatever.

And, an object of quality tells me something I did not know about or perceive before and that nothing else could tell me.

★

ARNOLD B. GLIMCHER, DIRECTOR OF THE PACE GALLERY, NEW YORK

The question you ask regarding quality is both difficult and elusive. I believe the object of art represents a unique response by the artist to the world around him in both abstract and metaphorical as well as literal terms. I look for an expression that extends my perception and is unfamiliar, as nonreferential to anything I ever experienced before— like the extraordinary "ledger drawings" by the unidentified Kiowa Indian [fig. 48].

★

JOHN RUSSELL, ART CRITIC FOR THE *New York Times*

My idea of a five-star work of art is one that makes one think just a little differently about all other works of art. Obviously there are not many such works of art, but they do come along in the art of our own day and we catch up with them in the art of the past. It is also true of course that they may lie dormant within us until we are old enough, or free enough, or *something* enough, to get the point of them.

★

NANCY DRUCKMAN, VICE PRESIDENT AND HEAD OF
THE AMERICAN FOLK ART DEPARTMENT, SOTHEBY'S

Given what I do for a living, I grapple with the question of five-, four-, three-, two-, and one-star art on a daily basis. And since my professional objective is putting together successful and exciting auction sales

of American folk art, I am also faced with understanding and weighing factors involving market conditions, provenance, trends, fashions, availability, and competition which are subsidiary issues beyond the scope of considerations of quality in art.

So where does this leave me in terms of analyzing how I arrive at a five-star rating? Perhaps because my field of art encompasses a vastly disparate group of objects—some utilitarian, some decorative, some historical, some made by self-proclaimed artists, others by craftsmen and children—I tend to rely on relatively basic guidelines, which I pose to myself in the form of a series of questions, ranging from the objective to the subjective.

First I ask, is it authentic? Was it made when it purports to have been made, in a style or a form of construction and ornamentation that is consistent with its period? Second I ask, is it in good condition? Is it in a good state of preservation, with little or no damage, loss, restoration, or repair? If the candidate for stardom is a painted blanket chest consisting of six simple pine boards nailed together to form a box, but a box covered in the most dazzling and arresting skin of paint, then we had better be very sure that this paint is all original and totally the work of the artist's original intention and not a pastiche of recent, well-intentioned touch-ups. Having cleared these basic nuts-and-bolts questions, we then proceed to the good stuff—what was the artist trying to say? What was his perception about his subject or commission that led him to create a work of art that will become a prism to our eyes and sensibilities, focusing and funneling our attention so that we will inevitably experience a distillation of his experience? How did he go about it? Do the design, choice of materials, construction, accelerate and reinforce the statement he was making? And are all of these elements so fully integrated that there are no detours, nothing extraneous, nothing which contradicts? Last, does the experience of this work of art have the power to prevail? Does that experience take precedence over what I was feeling and thinking before I experienced it? Am I moved, soothed, excited, engaged, inspired, educated, charmed? Restored and refreshed with each encounter? And, finally, is it a unique creative work; does it have a spark of life? Is it totally of its own time and place, yet beckoning to something beyond, something universal?

If the answers to all these questions were yes, then my heart will already have begun to race and the five stars to blaze.

★

ROBERT HUGHES, ART CRITIC OF *Time* MAGAZINE

No critic has an inflexible yardstick that he/she sets beside the work, submitting it to the Procrustean bed of set experience. While it is not true that works of art "dictate their own standards" to the viewer, any more than writing does, it is certainly true that a fine work marginally changes you as you confront it; there is a degree of give-and-take, which with really great works may indeed lead (or force) the eye to revise its old assumptions.

There is no such thing as a great "accidental" work of art; and no painting which is merely egotistical, or trades on a pseudo-heroic myth of the artist's character, is worth serious eye-time. I despise bombast, posturing, and everything that is merely "expressive." That is why I find myself so often at odds with American taste, which is the product of a culture rotted by celebrity-worship and fantasies of the therapeutic.

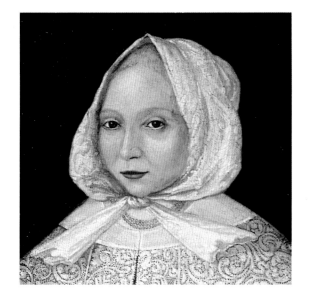

Mrs. Elizabeth Freake
DETAIL
figure 1

★

Fireboard
DETAIL
figure 33
★

Whether an artist has suffered or not in making his work is of the utmost irrelevance to me. Whose tears do you believe?—those of Ingres in struggling to get the bloom on Monsieur Bertin's sallow complexion right, or those of the Neo-Expressionist making his tenth canvas for July?

We know when an artist is straining or lying, inflating an experience or pretending to one he/she hasn't really had, just as we know (instinctively) when a politician is lying. Part of the ground of great art is that the experience should be seen to have been wholly absorbed and felt, on a level deeper than pictorial rhetoric.

Every great work of art, like every great poem or book, has its own natural tone of voice, in which a mysterious but seamless correspondence has been set up between diction, feeling, and subject. This unforced utterance gives the work its clarity.

All works of art that try to mimic the effects of mass media are doomed to irrelevance. Great art is only arrived at through meditation on its own processes, not on the processes of other media. The one thing a painting or sculpture can do for us, in the age of mass media, is to slow down the eye and make us concentrate on the unique, the specific, the reflective, the complex, the dense, as an antidote to the sense of weight-lessness and absurdly fast change of stimuli to which electronic culture condemns us.

To make sense of what is really good, we have to be frank in rejection. Nearly all the work produced in the West today, especially in the U.S., is bred by therapeutic illusions and headed for oblivion; the critic has no obligations to it. The basic task of the American art industry (for so it has become) is, it seems, not to develop serious taste, but to find as many ways as possible of selling bad art to eager pigeons.

Probably there are never more than a dozen major artists in the West at any given time; today, perhaps not even that. Allow for another couple of dozen who seem more or less "interesting." The art world in the late 1980s is such that taste is far worse off than it was in 1888. What a master Bouguereau seems, compared to Longo, Schnabel, or Scharf! The crust of received ideas through which Cézanne, Seurat, and Van Gogh had to break was actually quite fragile compared to the terms imposed on us by museums and dealers working in concert for the benefit of the market in America today. No one, I should think, can develop a sense of quality without seeing the American art world for what it is: a steaming Gran Chaco of superficiality, inflation, and venality, amid whose marsh-stinks a few genuine talents continue (rather against the odds) to survive and develop.

★

RALPH ESMERIAN, FIVE-STAR COLLECTOR;
PRESIDENT OF THE MUSEUM OF AMERICAN FOLK ART

Art is a language, a means of communicating an individual's inner fantasies as well as his vision of the outside world. Words and sounds, movement, pictures, and objects make up this language. Although initially spoken within the historic confines of a specific culture and society, a particular art may become a universal language, transcending events, geographic boundaries, and time itself.

Because art is derived from human experience, it is a language available to everyman.

Individual intensity and sensitivity, combined with discipline and technique, determine the quality of art. It varies enormously, but the ability to dovetail feelings and articulation is shared by all great artists.

The audience is eager to share the private world of the artist. But much more interest and emotion is generated when the creator draws upon common ground—human experiences and visions familiar to all and yet made different because of the special individual style of the artist. Yes, it is a picture of flowers; yes, it is a drama concerning death; yes, it is a sculpture depicting dancers—all universal subjects, but the artist's ability to convey the integrity, the honesty, and the intensity of his vision will determine the quality of his art.

Beauty in art emerges from that marvelous balance of emotion and technique, of nature and civilization. A work of art is born when an individual is able to see, to feel, and to convert specific emotions into language that will inspire and spark the daily lives of his fellow beings.

★

THOMAS HOVING, FORMER DIRECTOR OF THE METROPOLITAN
MUSEUM OF ART; EDITOR OF *Connoisseur* MAGAZINE

A five-star work of art is: tops in quality, the best example possible in its area, a work that is the summation of its epoch and artist; and above all something that seems to grow continually and has a timeless visual impact, a compelling sense of mystery or universal beauty.

★

J. CARTER BROWN, DIRECTOR OF
THE NATIONAL GALLERY OF ART, WASHINGTON, D.C.

Faced with your question, I quite naturally thought of the Edgar William and Bernice Chrysler Garbisch Collection here at the Gallery. Working from the Garbisch pictures, quality seems evident when a felicitous harmony of elements has been achieved—success is expressing the *essence* of a subject. It might be Edward Hicks's success in conveying, through extraordinary color and design, his clear sense of the satisfying order of the universe, as expressed in *The Cornell Farm*, or Winthrop Chandler's confident and evocative depictions of Captain and Mrs. Samuel Chandler [fig. 5]. So it seems that quality is a combination of factors having to do with superiority or originality of concept and the artist's ability to fulfill successfully that purpose.

★

LOUISE NEVELSON, KNOWN INTERNATIONALLY AS
ONE OF THE GREATEST ARTISTS OF THE TWENTIETH CENTURY.
THIS WAS THE LAST OF HER MANY STATEMENTS ABOUT ART

Art of any importance is a mirror of the times we're living in. So even if it looks brutal, we shouldn't dismiss it. These are tough times. Five-star quality? You will recognize it, feel it, when you see it—even if it needs taking on a whole new stance. You have to take it fresh for the moment; you can take a new point of view, but whether you want to or not you've absorbed much of the past, from the time that we've had a civilization. It goes through all our consciousness. It's not that you can make comparisons with the past, but it's all there.

Highest quality in art? It's innate. You can't move up into it. We're born with it, and it starts multiplying from then on.

Fireboard
DETAIL
figure 33

★

The best of art reaches out across time, space, and through culture to grab us by the throat, gut, heart, or whatever other part of the anatomy, to give us a distinct message about the human condition. The joy of folk art is that this message is presented without the clutter of self-consciousness or manifesto which often burdens the other products of our world. The art comes in a pure form and gives us a window to the aspirations, conditions, and insights of everyman. The best of folk art transcends the functional or utilitarian to present us with an often stunning and profound insight about the commonality of the family of man. What often makes this most astounding is that the art of the folk does this even though the artist may have been restrained by a number of factors such as the demands of a tradition-bound society, religious constraints, poverty of materials, lack of technique. These apparently have little relevance to the outcome. Quality comes not from the artist's ability to successfully maneuver through the constraints of his culture, but from his ability to transcend them. Folk art is no different from that of the "fine" artists; only a few are able to truly move us, but the best of folk art moves us even though this may never have been a goal of the artist.

★

NINA FLETCHER LITTLE, PIONEER FOLK-ART
COLLECTOR AND WRITER

GRACE GLUECK, ART NEWS EDITOR OF THE *New York Times*

Your book project sounds fascinating, but you shouldn't make me think so hard. What *are* my criteria for "five-star"? Well, all I ask is that a work have originality, power, and style. By that I mean that it should bowl me over with the freshness of its perception, the force with which that perception is conveyed, and the unmistakable sense of the artist's personality that informs it. I can think of many examples, but one will suffice: Matisse's *Red Room.*

★

NINA FLETCHER LITTLE, PIONEER FOLK-ART
COLLECTOR AND WRITER

It would seem to me that quality in folk art should perhaps be judged somewhat differently from that which applies to art in general. Therefore, not being a trained art critic, here are several attributes that contribute, at least to me personally, toward five-star folk art rating:

Most importantly in a picture I look for *impact,* which can result from one (or a combination) of elements that may include composition, color, or personality of subject. Being historically inclined, I value the inclusion of unusual accessories or symbols that illustrate significant or little-known usage in bygone domestic settings. Lastly, I expect originality of concept that mitigates the familiar or conventional in pose or presentation.

★

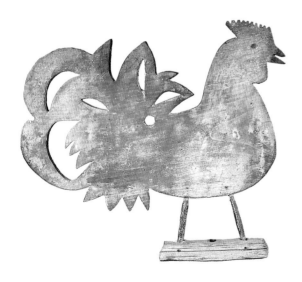

Rooster Weather Vane
figure 60

★

ROBERT L. PINCUS, ART CRITIC OF THE *San Diego Union*

All art that endures possesses a common quality: strength.

In work of the age of modernism—the late nineteenth century and the first half of the twentieth—it is the strengths of an artist's powers of innovation we most often admire. "Make it new," declared Ezra Pound

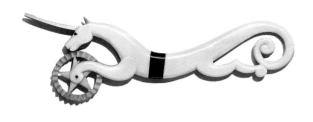

Sea Horse Jagging Wheel
figure 87

★

in the early years of this century, and many artists responded to this call in ways we have categorized as Fauvism, Cubism, Dada, Abstract Expressionism, and so forth.

Yet stylistic innovation is only one sort of strength, one way of locating quality in art. Another, less confined to any particular age, is strength of individual vision.

Nor is quality dependent upon technical expertise. There is an abundance of art by highly trained artists which has little vitality to it. And conversely, there is work by untrained painters, sculptors, and environmental artists—folk art, as we call it—which has a pictorial ingenuity and strength of vision which commands our attention. We see this vitality in the paintings by Edward Hicks and Joseph Pickett or the Watts Towers of Simon Rodia [figs. 26, 40, 77]. It is the powers of invention these artists possess which make their art great, which make it work of lasting quality.

★

SIDNEY JANIS, FOUNDER OF THE SIDNEY JANIS GALLERY,
NEW YORK, AND AUTHOR OF *They Taught Themselves*

Living for over twenty years with a great painting, *The Dream* by Douanier Rousseau, has given me a certain insight into the originality and delightful deviations found in the work of the self-taught or folk artist. André Breton, guru of the Surrealist movement and a true admirer of original expression, in commenting upon the work of the modern primitive artist, said, "The autodidact is saved from the strain of Art Education."

★

SELDEN RODMAN, POET AND ART CRITIC,
INITIATED MURAL PAINTING IN HAITI

Five-star folk art like five-star art of any sort must have quality; that indeed is axiomatic. But if *folk art* is intended to include what Alfred Barr called *popular art*—the art of the self-taught twentieth-century masters from Rousseau to Pippin and the great Haitians who followed—it must include much more. These artists are deeply rooted in a folk tradition. And they are concerned to say something meaningful and readily communicable about the world they live in. This is a concern that has been largely ignored by so-called modern art in this century, with its emphasis on form for its own sake and a purely personal expressionism. In consequence, such values in the great art of the past as love of nature, humanity, compassion, psychological penetration in portraiture, and religious beliefs deeply felt, have been given short shrift. In the art of many popular masters—American, Yugoslav, Brazilian, Haitian—these values have been reclaimed. And their art will therefore one day take its place with the complete masters of times past.

★

THEODORE F. WOLFF, ART CRITIC OF THE
Christian Science Monitor

"Quality" is harder to describe/define than "art"!!!!

I came up first with a 600-word piece, but that was too "heavy." Then a 200-worder—but *that* didn't work—so here's the best I can do. It's a bit pompous, but . . .

Quality is class. It is positive and generative. It can be as simple as formal or technical excellence, as subtle as an intuition of the wholeness of life, or as profound as truth itself. Perceiving it is essentially an act of recognition, of realizing that one is in the presence of something exceptional or superior, something that represents the best of what we believe in or desire, and that engages us at our most demanding and true.

In short, it can merely define the best of its type—or hint at perfection itself.

<div align="center">★</div>

ROY LICHTENSTEIN, THE MOST POPULAR POP ARTIST

A major work proceeds from a major insight, unified in the particular way that art is unified—all done in a period when the artist is most in touch with himself. It is when we go from this generalization to the particular of how to achieve it that we fail to bridge the gap between the verbal and the visual and produce no usable definition.

<div align="center">★</div>

HILTON KRAMER, EDITOR OF THE *New Criterion*, ART CRITIC OF THE *New York Observer*

Quality in art cannot be defined. It can only be experienced. And it is only through the accumulation of experience, in which the mind involuntarily makes comparisons with earlier and similar encounters with works of art, that one acquires a sense of what quality is. It may have nothing to do with newness or surprise or unfamiliarity, for it is, after all, in the acknowledged masterpieces that the experience of quality is most often found. It has much to do with a sense of something fully realized, of a conception brought to completion with every element of the execution contributing what is essential. On the other hand, not every conception is worthy of being brought to such a completion. The idea of quality is, like the idea of love, truly a conundrum, and equally one that we cannot live without.

<div align="center">★</div>

Here are a few key words, lifted from the letters sent by my panel of experts, that we believe collectively clarify today's "concept of quality" and perhaps represent a verbal time capsule for the meaning of art as we approach the twenty-first century: *impact, strength, power, honesty, order, clarity, authority, vitality, originality, memorable, riveting. Wow!* Any work of art may be graded in answer to the specific question, Which of these words are strong attributes of this example? And to what degree, rated on the basis of one to ten? We tried this somewhat complex test after making a few preliminary selections and found that it was the top-graded examples that had triggered that immediate "Wow!" reaction—a one-word definition by Russell Lynes of the immediate recognition of quality in a work of art.

This book proposes a renewed, dedicated respect for quality in art. A quotation from *Zen and the Art of Motorcycle Maintenance,* by Robert M. Persig, sums up our approach and purpose:

"What's new?" is an interesting and broadening eternal question, but one which if pursued exclusively, results only in an endless parade of trivia and fashion, the silt of tomorrow. I would like, instead, to be concerned with the question "What is best," a question which cuts deeply rather than broadly, a question whose answers tend to move the silt downstream. . . . Some channel deepening seems called for.

ONE HUNDRED EXAMPLES OF FIVE·STAR FOLK ART

★ ★ ★ ★ ★

Elizabeth V. Warren

PICTURES

As used here, *pictures* refers to essentially two-dimensional works of art that were created for a variety of decorative and utilitarian purposes, primarily in the home. While most of the examples, in the categories of portraits, genre and religious scenes, overmantels, fireboards, landscapes and seascapes, and schoolgirl watercolors and needlework, may have served other purposes in the society in which they were created—and usually did—they functioned primarily as parlor decoration. As such they are evidence of the taste of the men and women who created and commissioned them.[1] They provide insight into the aesthetics of the people who chose these objects to adorn their walls, to pass on to future generations, and to tell something about the world in which they were created. The works of art reproduced here are icons of American folk art, not only because they have undeniable impact today but because, for the most part, they gave pleasure to the people for whom they were made. The artists have combined color, form, mass, line, and all the other components of a picture (of which they may or may not have been aware) in ways that are so successful that they satisfied audiences who had little traditional art to look at and can still satisfy those who are daily inundated by a variety of communications media. What is it about these pictures that pleased people in the past; what still excites us today? To begin to understand this, one needs to look at the works of art themselves—observing how the artist combined all those important elements—and, where possible, to consider the roles those works played in the societies that created them.

Throughout the book, only representative works of art have been selected for discussion in detail. These examples—often objects that have been well researched and documented—provide insight into the ways in which folk artists work. They are examined in terms of historical content and aesthetic concerns. It should not be assumed, however, that if a work pictured here was not chosen for detailed examination it is any less worthy of attention. All of the objects in this book were selected because of their five-star quality.

★

PORTRAITS
★ ★ ★ ★ ★

The relatively few portraits that remain from the seventeenth century and early eighteenth century serve as points of departure for tracing the development of folk portraiture in America. *Mrs. Elizabeth Freake and Baby Mary* (fig. 1) represents both the continuation of a European style of painting in America and the birth of an American tradition. Its antecedents are obvious, for the portrait would not look dramatically out of place hanging among the Elizabethan paintings in the National Portrait Gallery in London. It is clear that the late seventeenth-century artist was familiar with the style of painting that had predominated in England since the late sixteenth century, a style of portraiture that was heavily influenced by European Mannerism. Mannerist painting emphasized ornamentation and exaggerated the proportions of the human figure rather than created exact representations.[2] The painting of the Freake mother and child could not be called a realistic portrait—it has been idealized, with the artist focusing upon what he and his client considered most important: material wealth as exemplified by clothing and accessories. The background is simplified and stylized, and the painting has a flat, two-dimensional appearance.

Recent scientific evidence about this painting provides much insight into both the purpose of the portrait and the aesthetic concerns of the

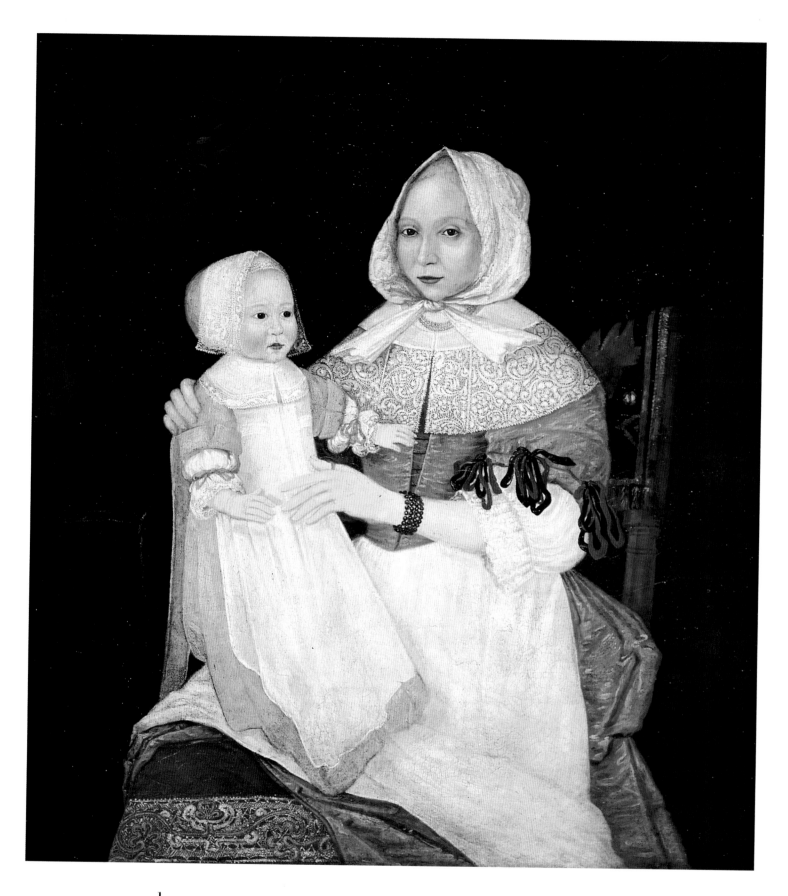

1

Mrs. Elizabeth Freake and Baby Mary

ARTIST UNIDENTIFIED

Boston; 1671–74

Oil on canvas; 42¹/₂ × 36³/₄ inches

Worcester Art Museum, Worcester, Massachusetts

Gift of Mr. and Mrs. Albert W. Rice

★

painter and subject. Radiographs taken in 1981 revealed that the painting (as well as a companion portrait of Mr. Freake) was significantly updated as few as three years after it was first painted, probably in 1671. Baby Mary was shown to be an addition and not part of the original design: Mrs. Freake once sat alone in her chair, probably holding a fan. Her clothes were enhanced and updated, and jewelry, including a beaded bracelet, pearl necklace, and gold thumb ring was added.[3] Clearly, the Freakes wanted to record not only additions to their family but increases in their wealth and social position. The portrait served as a record of achievement in the material world.

If possessions were important enough to warrant revision in just three years, it is not surprising that the artist lavished a great deal of care in painting them. The figures of Mrs. Freake and her child appear illuminated against the plain background, which has been enhanced only by the suggestion of a subdued red drape in the top left corner and a table below it. Bold hues combine with sparkling white to focus our attention on the subjects and their luxurious attire. We are meant to appreciate the material comforts of the sitters, and we do. We also, however, are delighted by the bright, dark eyes of mother and daughter, shining from pale faces, the way the child's arms reach out for her mother, and the way the entire composition has been balanced, with the chair on one side of Mrs. Freake offset by the baby on the other.

The painting of Pau de Wandelaer (fig. 2), attributed to Pieter Vanderlyn, represents a second style of portraiture, introduced to America in the beginning of the eighteenth century by new waves of immigrant painters. These artists were influenced by the High Renaissance style that had been brought to England by the Italian and Dutch artists who traveled and fulfilled commissions there in the late seventeenth century and early eighteenth century. Artists working in this mode attempted to accurately re-create realistic spatial relationships within their compositions, and so their works have a more three-dimensional quality than the earliest American portraits. In these paintings, more effort is made to create a realistic likeness of the sitter and to capture something of the subject's personality.

There is much in this portrait that foreshadows future developments in American folk portraiture. While early eighteenth-century portraits of upper Hudson River inhabitants frequently rely for their background settings, poses, and accessories on engravings made from portraits painted in England by such artists as Sir Peter Lely and Sir Godfrey Kneller, the scene behind this subject is realistic and probably related to de Wandelaer's life. The young man stands, with an American goldfinch perched on his finger, beside a stretch of the Hudson River near Albany, New York. A Dutch sloop, actually used to transport cargo and passengers between Albany and New York City, can be seen in the river. Such personal references would become common in American portraiture: the painting (fig. 5) of Captain Samuel Chandler, a Revolutionary War soldier, for example, includes a detail of a battle between the British and Americans.

Much of the strength of the portrait of Pau de Wandelaer lies in its simplicity, especially evident when it is compared with the earlier Hudson River portraits. The face, shown in three-quarters view, is the most important element, and the composition has been arranged to draw the viewer's attention to that face. Background and clothing colors are muted and do not compete with the handsome visage. The face is

2
Pau de Wandelaer
ATTRIBUTED TO PIETER VANDERLYN (*1687–1778*)
Albany, New York; c. 1730
Oil on canvas; 44³/₄ × 35¹/₄ inches
Albany Institute of History and Art, Albany, New York
Gift of Catherine Gansevoort Lansing
★

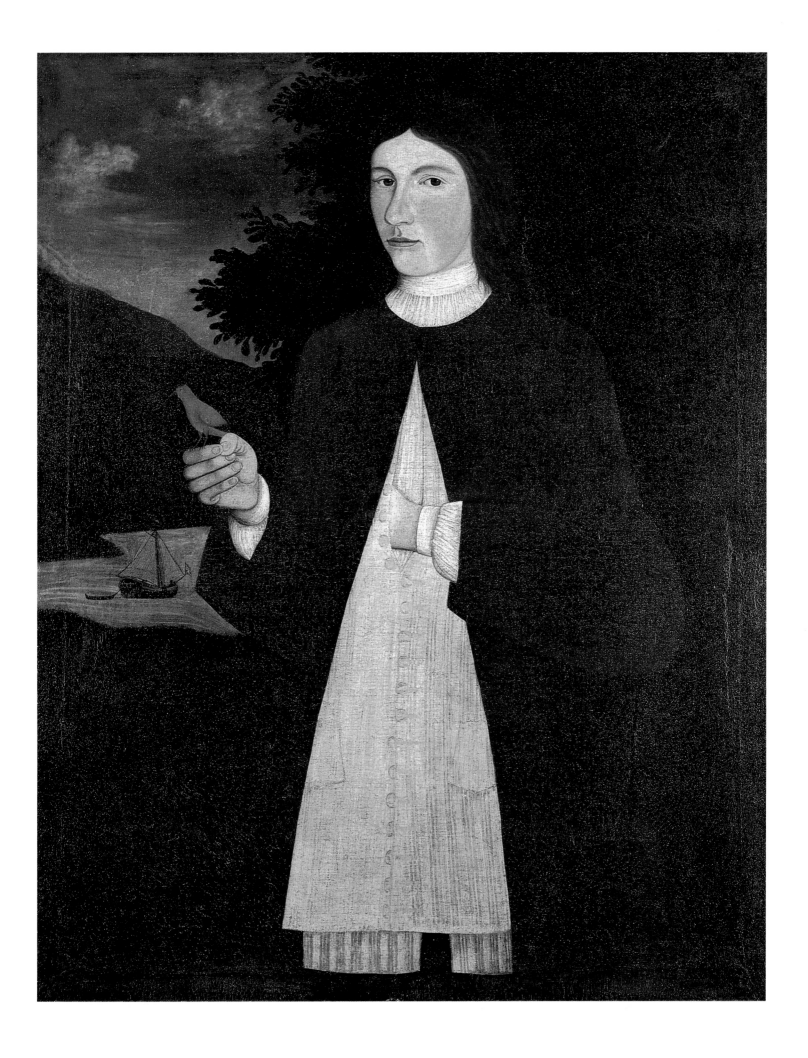

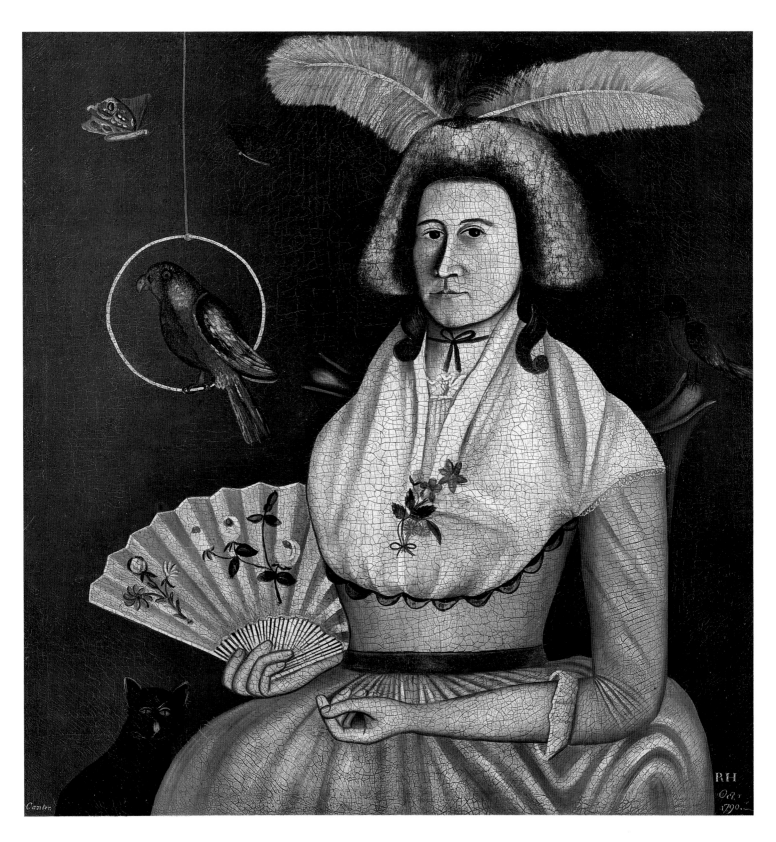

3

Lady with Her Pets

RUFUS HATHAWAY *(c. 1770–1822)*

Massachusetts; 1790

Oil on canvas; 34 1/4 × 32 inches

The Metropolitan Museum of Art, New York

Gift of Edgar William and Bernice

Chrysler Garbisch. 1963 (63.201.1)

★

framed by dark hair that flows into a coat of the same color and by a white collar around the neck. The coat falls open from the top button to reveal an arrow of white shirt and waistcoat that direct the eye back to the face. The figure stands in front of the landscape, yet seems part of it. The setting is natural, not contrived. In its powerful simplicity, *Pau de Wandelaer* foreshadows works by such painters as John Brewster, Jr., and Ammi Phillips (figs. 6,7). The subjects of the other eighteenth-century Hudson River portraitists were the patricians of the period, members of the wealthiest families. Pau de Wandelaer was, like Vanderlyn's other sitters, and the majority of the subjects of folk portraits to come, one of the middle-class working people, proud of their accomplishments and as desirous of having them recorded for posterity as Mrs. Freake was of having her new jewelry added to her likeness.

By the late eighteenth century, when Rufus Hathaway began painting in Massachusetts and Winthrop Chandler began painting in Connecticut, the styles represented so distinctively by *Mrs. Elizabeth Freake and Baby Mary* and *Pau de Wandelaer* had begun to blend. They became part of a heritage that new generations of painters drew upon and added to as they became aware of new styles and conventions or found their own solutions to the problems of painting.

The subject of Rufus Hathaway's *Lady with Her Pets* (fig. 3) is shown seated with a fan in her right hand, much as Mrs. Freake may have originally been depicted more than one hundred years earlier. Like Mrs. Freake this lady, who has been identified as Molly Wales Fobes Leonard, is dressed in her best, complete with ostrich feathers and the latest hairstyle from Paris. While "Canter," the cat, is named and may be the lady's own pet, it is possible that all the creatures that accompany Mrs. Leonard in the picture—the cat, two birds, and two moths—are symbolic, a characteristic common to Flemish paintings, of which Hathaway may have been aware through prints.[4]

The decorative aspects of this painting—the attention to the details of clothing, the enigmatic pets, the flowers on the fan and dress—also recall the Mannerist overtones of the Freake painting. Yet Mrs. Leonard's face has none of the idealized beauty of Mrs. Freake's—this is clearly an attempt to render, to the best of the artist's abilities, a true likeness. What makes the picture successful, however, is the combination of the more fanciful aspects, such as the pets and the feathers, with the rather serious face of Mrs. Leonard. Hathaway was also adept at capturing the viewer's attention by the use of decorative patterning. In this picture, the pattern created by the pleats of the fan is almost exactly repeated in the folds of the sitter's dress as they fall away from her waist.

Besides expressing material success by means of luxurious clothing or other belongings, the portrait artist was able to establish his sitter's place in society by indicating profession or other accomplishments. The painting of Philemon Tracy (fig. 4), for example, depicts a doctor at work: with his right hand Tracy takes the pulse of a patient discreetly located behind a curtain; a vial of medicine is in the doctor's left hand. Captain Samuel Chandler's status as an army officer is made clear by his uniform and the battle scene painted in the background (fig. 5). Like the unidentified subject of *Woman with Two Canaries* (fig. 9), who holds a book in her hand, Mrs. Chandler was evidently literate. The books shown behind her were actual family possessions valued in an inventory at two pounds.[5] And to be sure that the books are noticed, the artist has placed one on its side to catch the eye of the viewer. In these portraits of

4
Dr. Philemon Tracy
ARTIST UNIDENTIFIED
Connecticut; c. 1790
Oil on paper mounted on board,
mounted on canvas; 31 1/8 × 28 7/8 inches
National Gallery of Art, Washington, D.C.
Gift of Edgar William and Bernice Chrysler Garbisch
★

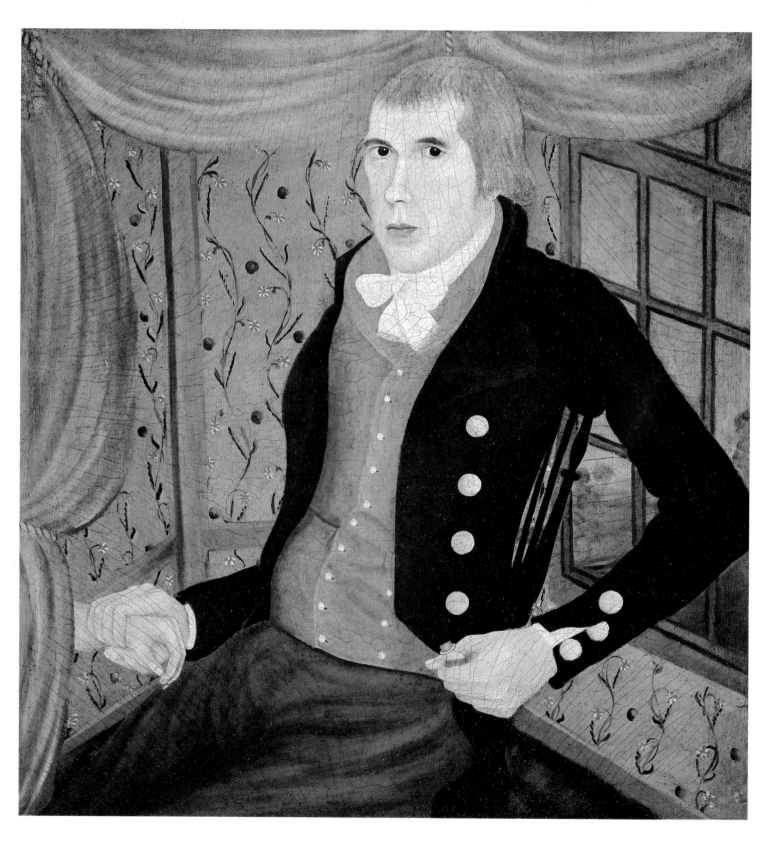

his older brother and sister-in-law, Winthrop Chandler displays an awareness of the work of contemporary New England artists. Although he was born and spent much of his career in Woodstock, Connecticut, research has shown that he probably received some training as a housepainter and sign painter in Boston.[6] His realistic portrayal of the subjects' faces recalls the works of John Singleton Copley, yet Chandler's style is more straightforward, unadorned by the nuances of light and shadow that the academic painter could manipulate so movingly. Considering that he was probably self-taught in the techniques of portraiture, Chandler's faces are remarkable both for their likenesses—the viewer truly feels that these are *real* people—and for the sensitive way in which they have been painted. Their three-dimensional quality surpasses anything in the portraits previously discussed and marks the beginning of a trend in paintings to come.

In his emphasis on creating a true likeness Chandler has not ignored the wishes of his sitters who, like earlier portrait subjects, wanted to be recorded in their finery with their most prized possessions at hand. Both Captain and Mrs. Chandler are dressed in their best for the occasion and, like the portrait of Mrs. Freake, the portrait of Mrs. Chandler was revised by the artist at some point, with changes made in her chair, dress, and the surrounding drapery. Even the tripod table next to Mrs. Chandler must have had significance in her life, for it, too, was inventoried and valued at twelve shillings.[7] The voluminous drapery, however, was apparently the artist's addition to the scene.

Sarah Prince's status as an accomplished, well-to-do young lady of Newburyport, Massachusetts, is indicated by her pose at the pianoforte (fig. 6). John Brewster, Jr., the painter of this wonderfully serene portrait, received some training from the Reverend Joseph Steward, a successful self-taught portrait painter, and was probably at least aware of the work of another Connecticut-born artist, Winthrop Chandler.

It has been remarked that Brewster's disabilities—he was born deaf and mute—"rendered him uniquely sensitive to the distinctive personality of each sitter."[8] Whether this was true or not, Brewster's portrait of Sarah Prince shows that he had the ability to eliminate the superfluous in a painting and concentrate on creating a realistic likeness. As seems appropriate for the portrait of a fresh-faced sixteen-year-old girl, *Sarah Prince* is not overburdened by flowing drapery or fanciful accessories. Instead, the subject is set against an almost abstract background. We see neither the sides of the pianoforte nor any legs: the instrument appears to float in space. Similarly, Sarah's voluminous dress hides the chair. The verticality of her body is in direct contrast with the horizontality of the pianoforte, a juxtaposition that provides the basic tension of the composition. Two solid planes of color—a warm brown-black for the wall and yellow for the floor—are used to suggest the outlines of a room, and even Sarah's dress is a solid area of white, embellished only by touches of lace at her collar and on her sleeves.

In this painting, attention *must* be given to the subject. There is little else to distract the viewer. Sarah's deep brown eyes and her softly rounded face, faintly blushed with red, command interest. While the body has been less skillfully handled than the face (the left arm and the arrangement of the dress at the back are particularly awkward), this does not detract from the success of the composition. The notes on the sheet music Sarah holds in her hand and the bellflower design on the piano provide the only counterpoint to the features of the face.

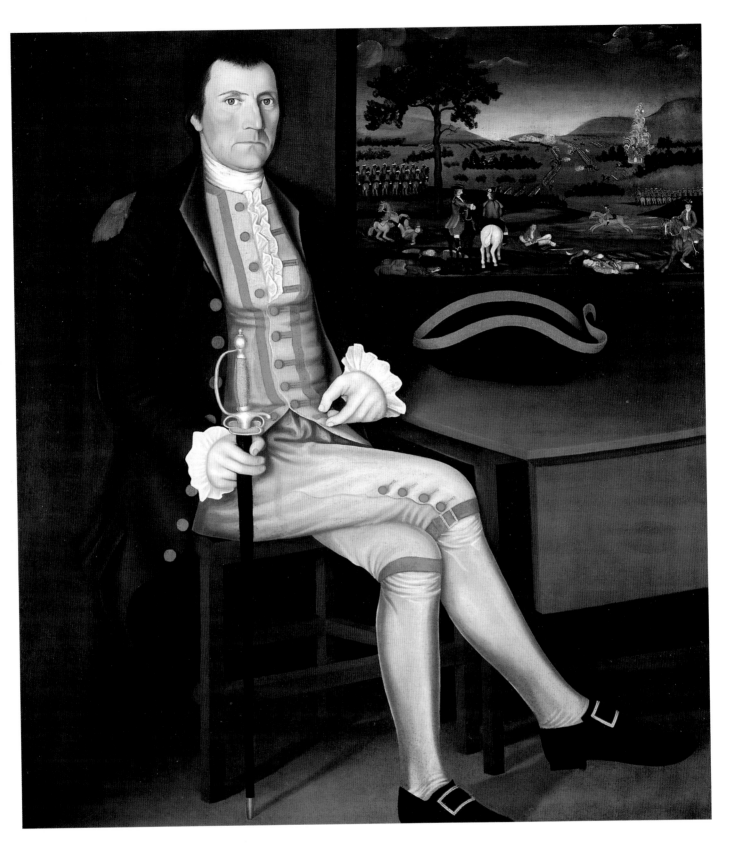

5
Captain and Mrs. Samuel Chandler
WINTHROP CHANDLER (*1747–1790*)
Connecticut; c. 1780
Oil on canvas; Captain Chandler 54⁷/₈ × 47⁷/₈ inches,
Mrs. Chandler 54³/₄ × 47⁷/₈ inches
National Gallery of Art, Washington, D.C.
Gift of Edgar William and Bernice Chrysler Garbisch

★

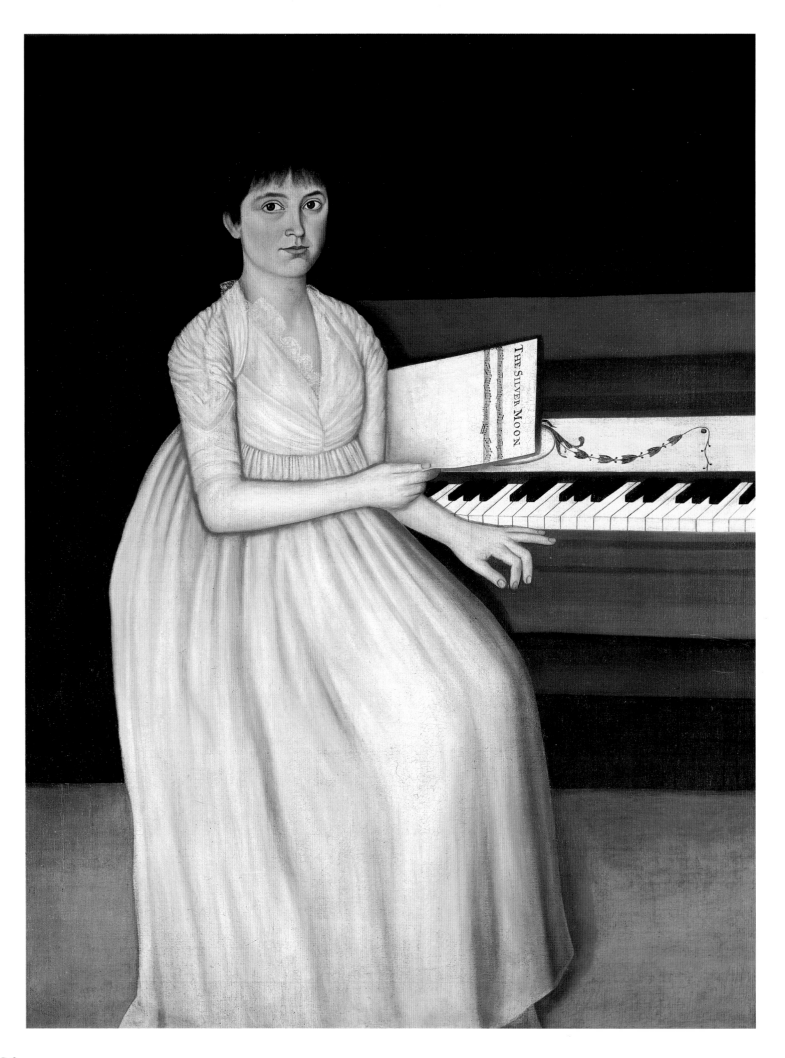

The simplified background of *Sarah Prince* may indicate an attempt to increase the speed at which the artist worked so he could travel on to the next sitter (Brewster was an itinerant artist, dependent on portrait commissions for his living), but the comparatively elaborate settings he used for contemporary portraits of Sarah's father and brothers would seem to contradict this assumption. More likely, Brewster felt he could present the girl to best advantage in a simple setting. Ammi Phillips, the painter of *Girl in Red Dress with Cat and Dog* (fig. 7), habitually placed his subjects in plain settings and often repeated poses, gestures, costumes, and accessories.

Phillips, who painted in three completely distinct styles during his long career, was an extremely prolific artist known for more than five hundred portraits made in the border areas of Connecticut, Massachusetts, and New York during the first half of the nineteenth century. His many surviving portraits dating between 1828 and 1838 show especially that, like many other painters of the time, Phillips developed a formula—a repertoire of themes and motifs upon which he could call as needed. A professional portraitist, he, too, was obliged to finish paintings as quickly as possible, for the more pictures he completed the more he earned, and as timesaving devices he frequently used stock methods of solving such problems as costumes, backgrounds, poses, and anatomy. This was also, however, a reasonably sure way of pleasing clients, essentially conservative in nature, who could be shown recently completed commissions and feel confident of what their finished portrait would look like. Because most folk paintings are unsigned, such stylistic devices also provide clues for folk-art historians in attributing works.

Girl in Red Dress with Cat and Dog is the most successful of a number of very similar portraits of children and pets that Phillips completed during the years known as his Kent period, when he painted many residents of Kent, Connecticut.[9] The same dog appears in almost all the portraits, and all the children are in nearly identical poses, seated on stools, or on their mothers' laps, with their arms in the same position. Small details vary: the number of strands of beads around the child's neck, the color of the shoes, the pattern of the carpet. The painting illustrated here, however, is the only one that includes a cat in the child's arms. The difference in impact is striking—the white of the cat against the red of the child's dress is arresting, while the universality of the pose has immediate meaning for the viewer. Who hasn't watched a child wrestling to keep an impatient pet in its lap—or been that child? The face of the unidentified girl is also prettier than the faces of Phillips's other children of the period. Her cheeks are pinker and rounder, her smile sweeter, her countenance softer. Since many surviving portraits of rather homely subjects prove that Phillips did not as a rule flatter his clientele, we may assume that in this case he was blessed with a naturally beautiful model.

Also typical of Phillips in his Kent period is the plain, dark background. The strong contrast between the background and the figure permits the silhouette of the child to be clearly traced: the line of her slender neck leads to the billowing sleeves just below her shoulders. This combination of convex and concave curves is repeated as her slim waist meets the fullness of the skirt over her knees. The composition is beautifully balanced by this alternation of narrow and broad areas, although attention is purposely directed at the face and neck, so alluringly highlighted by the off-the-shoulder dress.

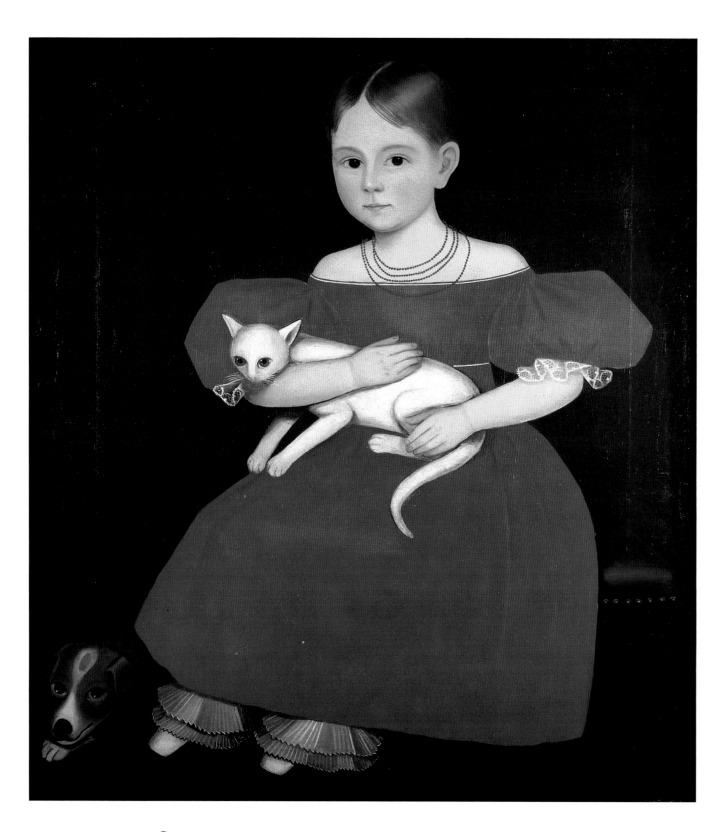

7

Girl in Red Dress with Cat and Dog
AMMI PHILLIPS *(1788–1865)*
Vicinity of Amenia, New York; 1834–36
Oil on canvas; 30 × 25 inches
Museum of American Folk Art, New York
Promised anonymous gift

★

8
Mrs. Keyser
ARTIST UNIDENTIFIED
Possibly Baltimore, Maryland; 1834
Watercolor and ink on paper; 23×18 inches
Private collection
★

9
Woman with Two Canaries
SAMUEL A. SHUTE *(1803–1836)*
New England; 1830–32
Watercolor, gouache, pencil, gilt decoupage,
bronze paint, and collage on paper; 25×20 inches
Private collection
★

Phillips is not the only artist included in this book who employed personal formulas to create successful works of art. Watercolor portraitists often developed techniques that enabled them to work both swiftly and effectively. As yet, no other portraits have been attributed to the masterful hand that was responsible for the ethereally beautiful *Mrs. Keyser* (fig. 8). *Woman with Two Canaries* (fig. 9) is one of a large number of portraits in watercolor, oil, and pastel painted by Dr. Samuel A. Shute, many of them in collaboration with his wife, Ruth Whittier Shute. This painting has characteristics that distinguish the couple's most impressive compositions, including the use of collage for the jewelry and canaries, and a strong wash background. It exhibits, however, the lighter drawing technique typical of those portraits painted by Dr. Shute alone.

Jacob Maentel used a number of different, readily identified styles for the watercolor portraits of friends and neighbors he made in Pennsylvania and Indiana during a long and prolific career. One of his most popular compositions for twin portraits of husbands and wives is represented here by *John and Caterina Bickel of Jonestown, Pennsylvania* (fig. 10). This depiction of a somber, black-clad couple set in a gaily patterned interior beside a table that has been split down the middle is one that Maentel repeated many times. In this double portrait, the artist painted a separate mirror for each subject, providing husband and wife with extra glitter and excitement. Also exceptional is the interplay of painted patterns on floor, wainscoting, and wall.

Watercolors by Deborah Goldsmith and Joseph H. Davis are also easily recognized. Goldsmith's best-known group portrait, *The Talcott Family* (fig. 11), is perhaps more celebrated today for its detailed depiction of the costumes and interior decor popular in early nineteenth-century New York State than for its representations of three generations of Talcotts. In Joseph H. Davis's New England portraits, exemplified here by *Thomas and Betsey Thompson* (fig. 12), couples placed in a simple setting usually face each other across a painted table on a floor with a lively design. Although the faces are in profile (making them faster and easier to paint), the bodies are turned to display details of clothing, such as Mrs. Thompson's beautifully patterned shawl. Davis usually took pains to include accessories or other clues (sometimes the local newspaper) that would help personalize his otherwise very similar portraits. In this case, a picture made in memory of a departed family member, W.J.H. Thompson, hangs above the painted table. And so that there would be no confusion in future generations, the names and ages of the sitters are also generally written on the portrait in Davis's decorative script.

The introduction of photography in 1839 changed the way Americans regarded portraiture and the way the folk portraitist worked. Daguerreotypes, introduced in this country by the painter Samuel F. B. Morse, better known today as the inventor of the telegraph, were cheaper and faster to produce than painted portraits, and they were also more realistic. Many portrait artists found they could not compete and had to find other ways to earn a living; often they learned the new camera technology themselves and took to the road as itinerant photographers. Others stayed in business as portrait painters for a while by offering what the photographs could not—color, large format, and the option of including family members who were absent or deceased. And some artists found a way to combine painting and photography in their

10

*John and Caterina Bickel of
Jonestown, Pennsylvania*
JACOB MAENTEL *(born 1778)*
Jonestown, Pennsylvania; 1820–25
Gouache and watercolor on paper;
John Bickel 17 1/4 × 11 inches,
Caterina Bickel 17 × 10 7/16 inches
Private collection

★

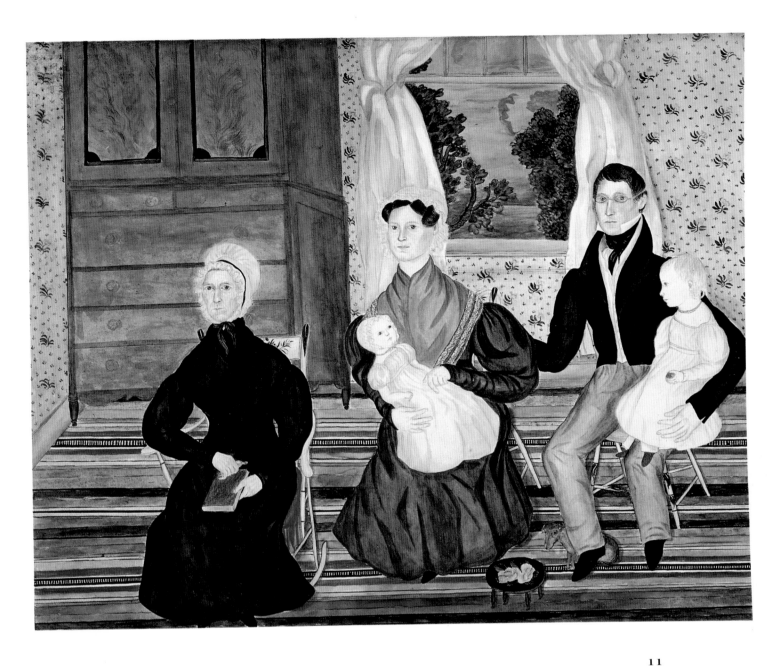

1 1

The Talcott Family

DEBORAH GOLDSMITH *(1808–1836)*

Probably Hamilton, New York; 1832

Watercolor, pencil, and gilt on wove paper;

14 1/4 × 17 3/4 inches

Abby Aldrich Rockefeller Folk Art Center,

Williamsburg, Virginia

★

Thomas and Betsey Thompson
JOSEPH H. DAVIS *(active 1832–1837)*
Durham, New Hampshire; 1837
Watercolor on paper; 10 1/2 × 15 inches
Private collection

★

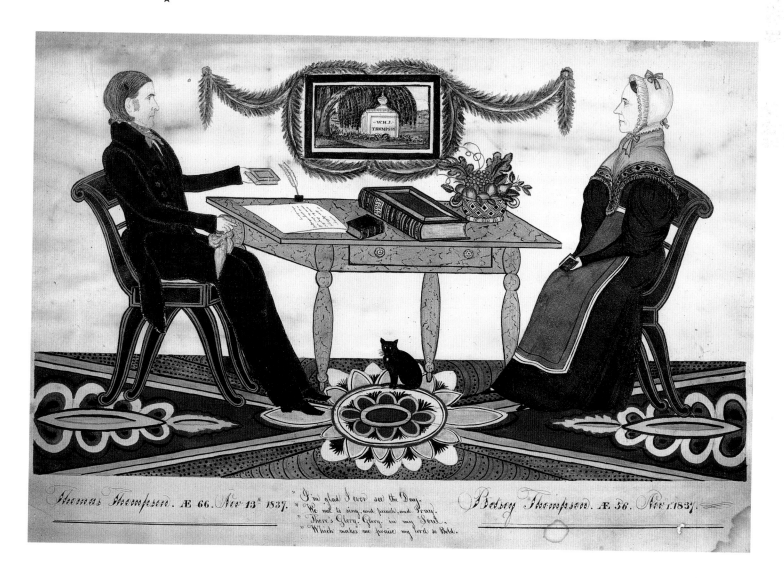

portraits, either by painting over photographs or transferring photographic images by hand to larger canvases in color. In general, however, folk portraits declined in technical quality and artistic merit after the mid-nineteenth century and the artists were forced to find new avenues of artistic expression and ways of making a living.

At first, the prevailing styles of portraiture influenced the photographers, who adopted poses, accessories, and backgrounds from popular painting styles. Eventually, the need to compete with the photographers forced the folk portraitists to adapt their methods to please the new taste for the realism of photographic likeness.

Sheldon Peck was one of those painters who adapted their style to compete with photography. Like Ammi Phillips, Peck changed his technique over time; three different styles correspond to the periods when he lived in Vermont, New York, and, finally, Illinois. The double portrait, *David Crane and Catharine Stolp Crane* (fig. 13), completed about 1845, is a fine example of Peck's Illinois portraits. The brighter palette and larger size of these later paintings indicate a conscious attempt to offer features that his patrons could not obtain in a daguerreotype. Peck's painting of the Cranes, like others of the period, also boasts a trompe l'oeil grained frame painted on the canvas. By saving his clients the cost of framing, Peck was making it easier for them to afford his services. In the case of the Cranes, we know that the artist was successful in his efforts, for the couple also engaged Peck to paint a very similar portrait of Mr. Crane's mother and their daughter Jennette. The value of a portrait must have been considerable, for the family Bible recorded that this second painting was exchanged for one cow.[10]

The painting of the Cranes compared to Peck's earlier work also reveals another way in which photography influenced folk portraiture. While most of Peck's previous portraits were waist-length with little or no background, the Crane portrait and others from his Illinois period show full-length subjects, usually seated in a simple setting beside a covered table topped with a vase of flowers and a book or the family Bible. The standardized poses and diminished scale of the figures, with the emphasis on as realistic a likeness as the artist was capable of producing, combine to create pictures that frankly tried to resemble photographs of the time.[11] Clearly, however, to the eyes of those who commissioned the portraits and those who view them today, Peck's paintings are far more exciting and visually interesting than the mechanical daguerreotypes of the period. This double portrait, especially, demonstrates the artist's sensibility in his rendering of faces and his flair for arranging a balanced, yet lively, composition. In one respect Peck's work did not change over the years. The artist did not often sign his name to his portraits, yet he did leave his "signature" on his work: his hallmark, found in some form on almost all of his paintings, is a rabbit's-foot motif, seen here as the design edging the lace collar of Mrs. Crane's dress.

In contrast to nineteenth-century examples, twentieth-century folk portraiture is characterized by idiosyncratic styles that owe little to the accurate depictions of the camera. Portraits are rarely undertaken as commissions, nor are they necessarily meant to please their subjects. Instead, they are usually the work of artists who have chosen portraiture as a medium for self-expression. Unlike the eighteenth- and nineteenth-century portraitists, rarely do these artists depend on commissions to make their living.

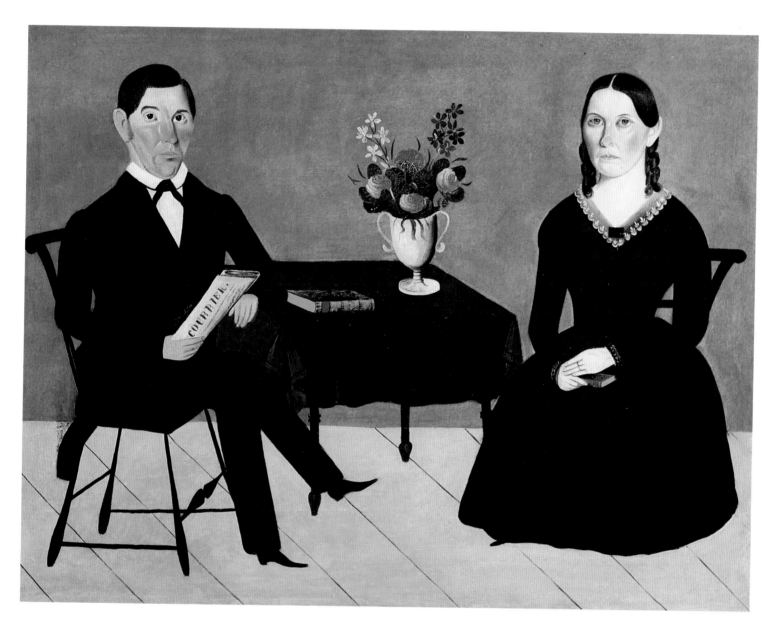

13
David Crane and Catharine Stolp Crane
SHELDON PECK *(1797–1868)*
Aurora, Illinois; c. 1845
Oil on canvas; 35 3/4 × 43 3/4 inches
Private collection

★

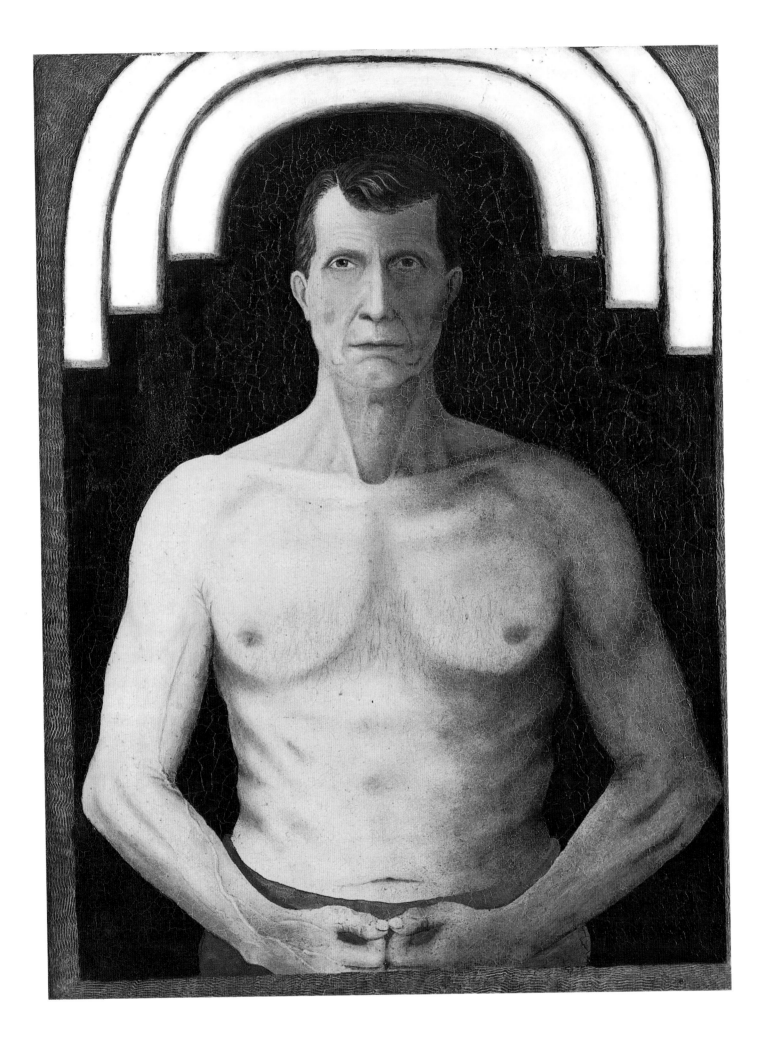

14

Self-Portrait

JOHN KANE *(1860–1934)*

Pittsburgh, Pennsylvania; 1929

Oil on canvas over composition board;

36 1/8 × 27 1/8 inches

Collection, The Museum of Modern Art, New York

Abby Aldrich Rockefeller Fund

★

GENRE SCENES

★ ★ ★ ★ ★

John Kane was a twentieth-century self-taught artist who occasionally chose to paint portraits. The forceful self-portrait painted in 1929, when he was sixty-nine years old, is Kane's best-known painting and his most successful (fig. 14). Contemporary photographs show us that *Self-Portrait* is a good likeness, but recording a likeness for posterity is, in this century, no longer the role of a portraitist. The strength of this painting lies in its powerful composition and its ability to communicate to us something about the subject that we could not comprehend by looking at a photograph. Kane has painted himself standing, partly in shadow, in front of a mirror.[12] Stripped to the waist, muscles tensed, he shows the strength that still remains in the body of a man who has spent most of his life at hard physical labor. Against a dark background, he stands unsmiling and staring straight ahead, an iconlike pose that is reinforced by the triple arch that surrounds his head. This is the portrait of a man who has coped with great poverty and terrible tragedy (including the loss of a leg in a railroad accident and the death of a son) yet wants to be remembered for the virility and dignity that he shows in this self-portrait.

★

In portraying the world around them, folk artists often based their compositions on printed images. Both *The Tow Sisters* by MaryAn Smith (fig. 15) and *The Quilting Party* (fig. 16) by an unidentified artist were derived from print sources: the former from a Nathaniel Currier lithograph published in 1845 titled *The Two Sisters;* the latter from a black-and-white illustration that appeared in *Gleason's Pictorial* in 1854. In each case, the folk artist copied the composition in watercolor almost exactly, enlivening a static picture not only with color but with patterns, textures, and a new sense of excitement.

The Tow Sisters (evidently a misspelling of the correct title) looks as if the artist took an outline of the original composition, then filled in the spaces with her own choice of pattern and design. Bold, "country" prints are used for draperies and the sisters' dresses, replacing what appears to have been expensive solid-colored silks and satins in the lithograph. The vase of flowers, the chair, and the windowsill have all been enhanced by an exuberant use of patterning and blocks of color in bright shades of red, pink, and yellow. In converting a lithograph to a watercolor painting, MaryAn Smith liberated the original composition and gave it a brilliant new life as a work of folk art.

No doubt MaryAn Smith was taught how to copy in school or learned from one of the many books on painting and drawing that were available in America beginning in the eighteenth century. The number of schoolgirl artists and other amateurs increased in the nineteenth century, when materials became easier to use and afford. Watercolor gained in popularity early in the century, largely because of the development of a wide range of colors in solid form, an improvement over the earlier, hand-ground pigments, which had to be dissolved in water. Nonprofessional painters found the small boxes of colors inexpensive, easy to carry, and simple to use. It was a medium that lent itself to rapid, informal work and it was considered especially suitable for young girls and ladies. In 1840, Mrs. A.H.L. Phelps noted, "Painting in water colors is the kind of painting most convenient for ladies; it can be performed with neatness, and without the disagreeable smell which attends oil painting."[13]

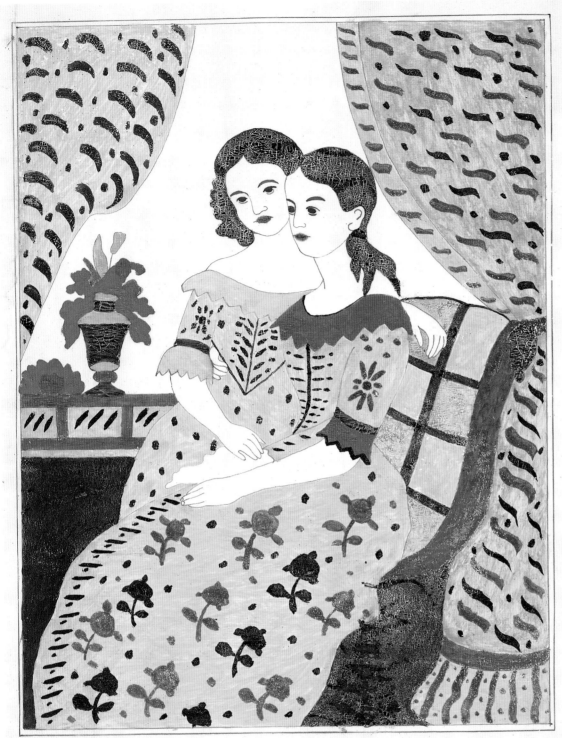

The Tow Sisters. 1854.

MaryAnn Smith.

15
The Tow Sisters
MARYAN SMITH
United States; 1854
Watercolor and ink on paper; 14 3/4 × 12 inches
Private collection

★

16
The Quilting Party
ARTIST UNIDENTIFIED
United States; 1854–75
Oil and pencil on paper mounted on plywood;
19 1/4 × 26 1/8 inches
Abby Aldrich Rockefeller Folk Art Center,
Williamsburg, Virginia
★

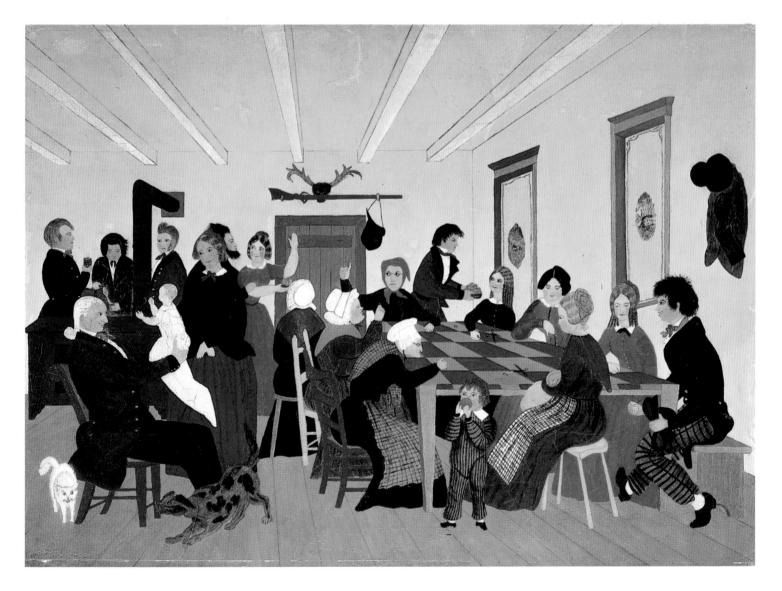

Eunice Pinney was one such amateur, a talented housewife who took up painting in her middle years. Her *Two Women* (fig. 17) is a masterpiece of design in which the artist has cleverly adapted the furnishings (including the draperies) to suit the oval design. Another female watercolorist, Mary Ann Willson, was known to have sold her pictures to neighboring farmers in Greene County, New York, in the early part of the nineteenth century. *George Washington on a Horse* (fig. 18) demonstrates that she, like MaryAn Smith and Eunice Pinney, delighted in pattern and design.

Literary and historical sources, family legends, and folktales could be as inspirational to folk artists as printed compositions. Horace Pippin's painting *John Brown Going to His Hanging* (fig. 19) conforms in almost every detail to eyewitness accounts of the execution. Pippin's source for the events of the memorable day in December 1859 may have been his grandmother who, he said, witnessed the hanging of the white abolitionist. He may have immortalized her as well as John Brown in this painting.

As John Brown is driven away in an open wagon, arms tied to his sides and seated on his own coffin, almost all eyes in the crowd are focused on him. The most notable exception is the woman in the lower right corner of the painting who stands out from the rest of the onlookers: she is the only woman, the only one not dressed in a dark overcoat, the only figure squarely facing front, and the only black person. Not only is she not looking at the passing scene but she is pointedly looking in the opposite direction.

Whether this woman is Pippin's grandmother or not, she clearly commands attention, and we see the scene as it must have affected her —and the artist—all those years later. Viewers today can only speculate about Pippin's thoughts, but an event so important in African-American history must have had deep meaning to a black man who grew up the son of a domestic in the early days of this century. John Brown's hanging was a tragedy in a war that had not yet officially started in 1859, and was still, in many ways, continuing in 1942, when the picture was painted.

In the nineteenth century and, especially, the twentieth century, many folk artists have drawn inspiration from their early lives, looking backward in "memory pictures." Research has often shown that the memories they recall in their paintings are sweeter than their lives actually were—they preferred to paint life as they wished it had been rather than as it was.

Olof Krans, a Swedish immigrant who spent part of his childhood in the Janssonist colony of Bishop Hill, Illinois, recalled the communal spirit of life there in a number of paintings, including this brilliantly conceived *Corn Planting* (fig. 20). The straight line of nondescript women—all dressed exactly the same, all leaning at exactly the same angle, all holding their planting sticks exactly the same way—recedes into a featureless landscape. The purposeful rigidity of the scene informs us that this was a regimented community that stressed group efficiency at the expense of individual expression. It is inspiring in its single-minded pursuit of a communal goal, one that evidently impressed Krans. Yet the picture pays homage to a utopian society that did not succeed and had actually been dissolved approximately thirty-five years before Krans painted his tribute.

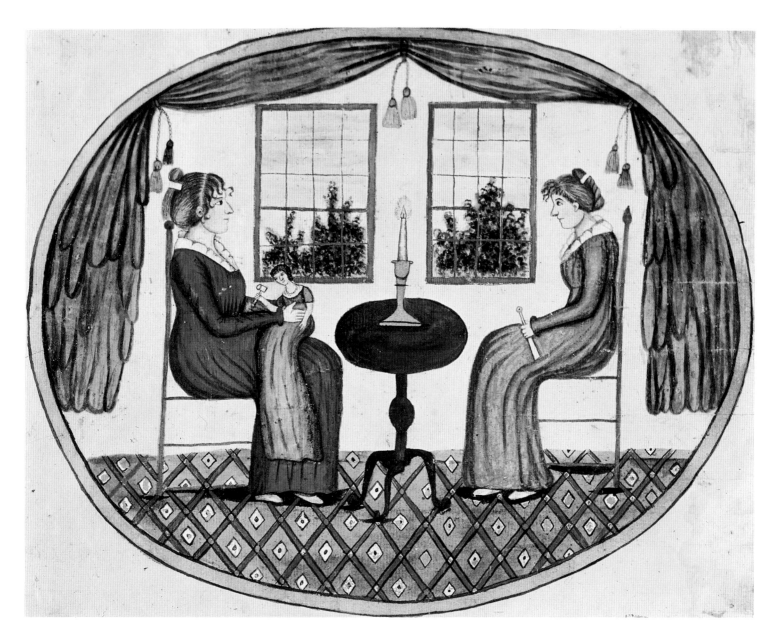

17

Two Women

EUNICE PINNEY (*1770–1849*)

Connecticut; c. 1815

Watercolor and ink on paper;

11 × 14 3/8 inches

New York State Historical Association,

Cooperstown, New York

★

18

George Washington on a Horse

MARY ANN WILLSON *(active 1800–1825)*

Greene County, New York; 1800–1825

Watercolor and ink on paper; 12 1/4 × 15 3/8 inches

Museum of Art, Rhode Island School of Design,

Providence, Rhode Island

Jesse H. Metcalf Fund

★

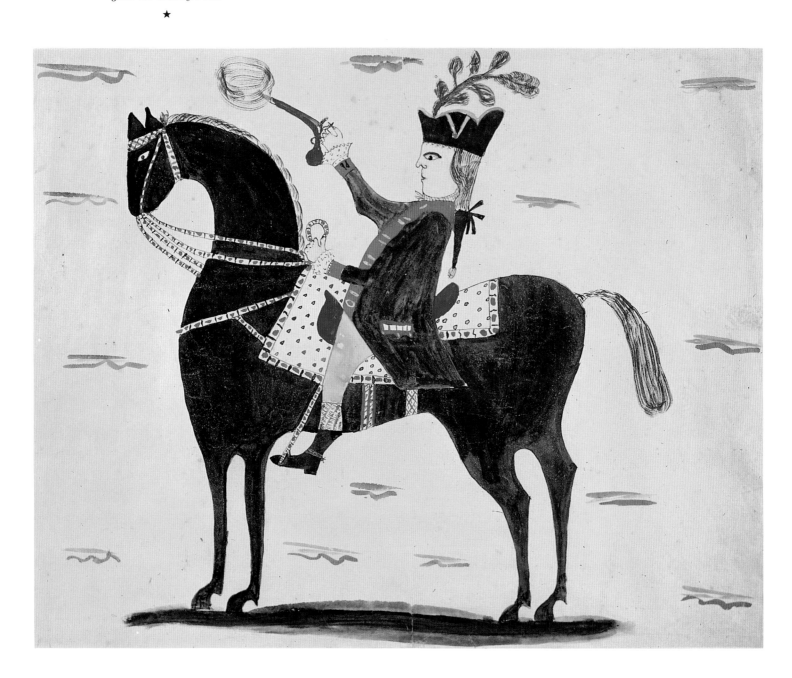

19

John Brown Going to His Hanging

HORACE PIPPIN (*1888–1946*)

West Chester, Pennsylvania; c. 1942

Oil on canvas; 24 1/8 × 30 1/4 inches

Courtesy of the Pennsylvania Academy

of the Fine Arts, Philadelphia

John Lambert Fund

★

Frequently, the artist's inspiration is his own imagination. Perhaps there is a legend or family story that prompted the watercolor called *Man Feeding a Bear an Ear of Corn* (fig. 21), or it may be totally the product of the artist's whimsical mind. The style of painting is reminiscent of Pennsylvania-German fraktur drawing, yet the scene has no function, religious or otherwise, that can be determined. It is purely anecdotal. Its effectiveness, however, is undeniable. The style is spare, as befits the painting's very small size (only 5⅝ by 7½ inches), yet its impact belies its dimensions. A patch of dark blue sky with the man-in-the-moon and five flowerlike stars stands for an entire night backdrop. The truncated tree, to which the bear is tethered, with its one large branch and one giant flower, represents a more luxuriant (but more space-consuming) plant. The tree limb, patch of sky, and roof of the house combine to form a canopy over the action—the man in a top hat and blue coat feeding an ear of corn to a large and hungry animal—while the tree and the house complete the frame on either side. A cautious cat, watching the scene from the relative safety of the roof, is an additional example of the artist's sense of humor.

Like *Man Feeding a Bear an Ear of Corn*, or Morris Hirshfield's dazzlingly decorative *Girl with Her Dog* (fig. 22), Bill Traylor's *Man and Large Dog* (fig. 23) appears to be a lighthearted composition. However, facts about the artist's life and knowledge of the possible influences on his work lead to deeper appreciation of the drawing. Traylor was born a slave in 1854 on a plantation near Benton, Alabama. He did not begin painting until he was eighty-five years old and had left the farm for Montgomery, Alabama, where he spent his nights sleeping in the back room of a funeral parlor and his days drawing on any pieces of paper or cardboard that he could obtain.

References have been made to possible African and African-Caribbean themes in Traylor's work. In this drawing, for example, the man in the top hat has been likened to Haitian images of Baron Samedi, lord of cemeteries. Clothing with geometric designs, such as the man's spotted shirt, may relate to Cuban and Haitian religious costumes.[14] Such influences may have been unconscious, or may not apply at all in this example of Traylor's painting. Similarly, the seemingly menacing dominance of large beast over man may or may not be meaningful. In any case, Traylor's interpretation of a common theme—a man and his dog—is original and striking. His sparing use of color, such as a thin line of bright red for the dog's tongue, provides an element of surprise in an almost monochromatic painting. Using the poorest of materials under the poorest of conditions, Traylor created simple yet powerful compositions whose meanings, perhaps complex in many cases, remain to be explored.

While much research has been devoted to interpreting the scene depicted in *The Old Plantation* (fig. 24), the exact nature of the event remains speculative. Several scholars have construed it as a slave marriage ceremony since jumping over a stick, as the figure in the center of the watercolor appears about to do, is believed to have been part of that ritual. Other researchers feel that the action is secular in nature, since dancing barefoot with sticks and scarves is common among the Yoruba of Nigeria. The headdresses worn by some of the participants are believed to be of West African origin, and the instruments played by the men on the right have also been shown to have African precursors.[15]

Corn Planting
DETAIL

★

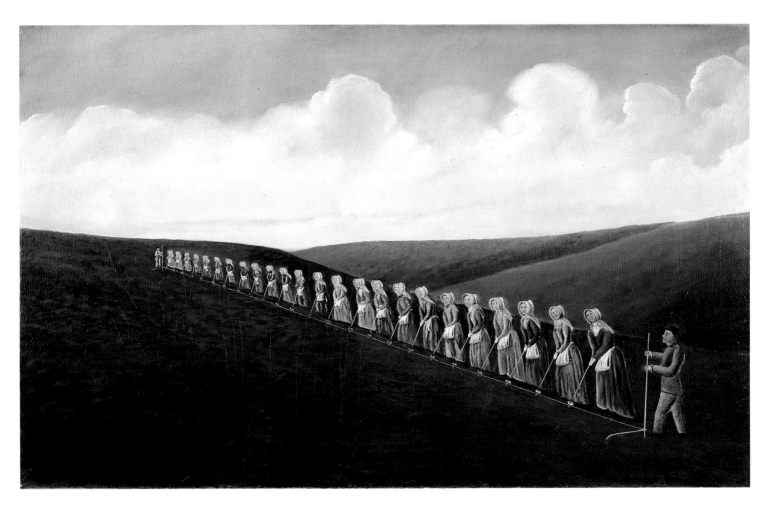

20

Corn Planting

OLOF KRANS *(1838–1916)*

Bishop Hill, Illinois; 1896

Oil on canvas; 25 × 40 1/8 inches

Bishop Hill State Historic Site

Illinois Historic Preservation Agency

★

21

Man Feeding a Bear an Ear of Corn

ARTIST UNIDENTIFIED

Probably Pennsylvania; c. 1840

Watercolor and ink on paper; 5⅝×7½ inches

Private collection

★

Girl with Her Dog
MORRIS HIRSHFIELD *(1872–1946)*
Brooklyn, New York; 1943
Oil on canvas; 45 1/2 × 35 1/2 inches
Bragaline Collection

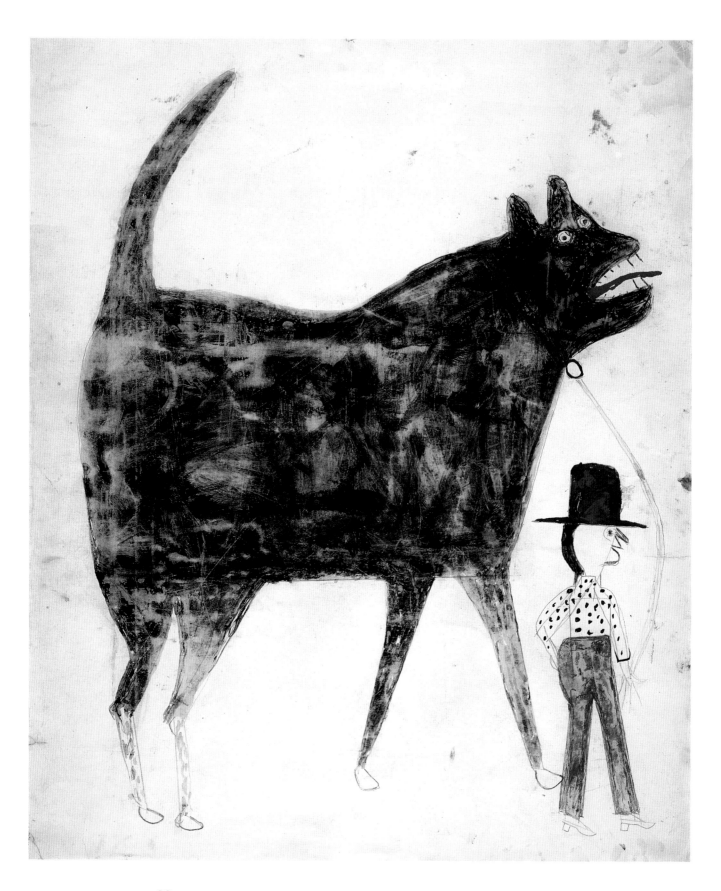

23

Man and Large Dog

BILL TRAYLOR *(1854–1947)*

Montgomery, Alabama; 1939–42

Showcard color and pencil on paper;

28 5/8 × 22 1/2 inches

Courtesy Luise Ross Gallery, New York

★

24

The Old Plantation

ARTIST UNIDENTIFIED

Probably South Carolina; 1790–1800
Watercolor on laid paper; 11 11/16 × 17 7/8 inches
Abby Aldrich Rockefeller Folk Art Center,
Williamsburg, Virginia

★

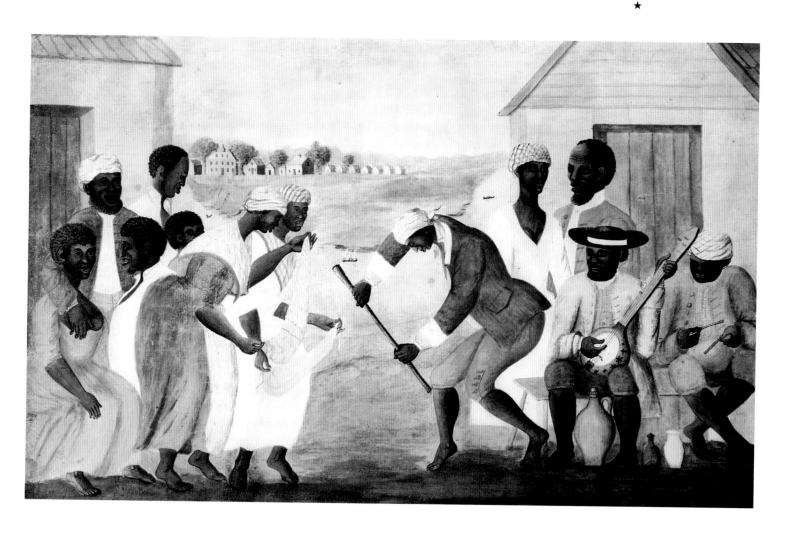

This painting is believed to have been executed on a plantation between Charleston and Orangeburg, South Carolina, and one can see the big house and all its dependencies across the river in the background. In the foreground, two other outbuildings flank the central action and provide backdrops against which the brightly colored clothing and dark faces of the celebrants stand out. The feeling of action is palpable—the three figures in the center lean forward as if captured in mid-step, their feet obviously in motion. Even the musicians look as if they have been caught in mid-note. While the composition has been arranged to draw attention to the center, there is other action taking place here: the figures on the far left are obviously enjoying the celebration in their own way.

<p style="text-align:center">★</p>

RELIGIOUS PAINTINGS
★ ★ ★ ★ ★

Religion—whether formally organized or interpreted as a general concern for the spiritual and moral life—has always been a major source of inspiration for the folk artist. In some cases, the artist believes that he or she is merely the means by which a higher being is transmitting a message. The visions that appeared to the Shaker Sister Hannah Cohoon, for example, appeared in the form of drawings brought by an angel. The inscription on her drawing *The Tree of Life* (fig. 25), describes the experience of receiving inspiration:

City of Peace Monday July, 3rd 1854. I received a draft of a beautiful Tree pencil'd on a large sheet of white paper bearing ripe fruit. I saw it plainly; it looked very singular and curious to me. I have since learned that this tree grows in the Spirit Land. Afterwards the spirit shew'd me plainly the branches, leaves and fruit, painted or drawn upon paper. The leaves were check'd or cross'd and the same colors you see here. I entreated Mother Ann [Mother Ann Lee, founder of the Shakers] to tell me the name of this tree: which she did Oct. 1st 4th hour P.M. by moving the hand of a medium to write twice over, Your Tree is the Tree of Life. *Seen and painted by, Hannah Cohoon.*

The subject of *The Tree of Life* would have been immediately recognized and understood by Cohoon's fellow Shakers. The Tree had first appeared to James Whittaker, one of the original disciples of the United Society of Believers in Christ's Second Appearing (the Shaker's official name), while they were still a small, persecuted group in England. The Tree was part of a vision calling them to America, and it became a symbol of the unity of the Shaker church.

Such a vision of a burgeoning tree would have had special meaning for the Shakers in the mid-nineteenth century. After a period when the original, celibate members had died and new converts were slow to join, the communities were in the midst of a revival. By reducing the tree to its essential elements of fruit and leaves and dramatically enlarging those elements, Cohoon made its life-affirming nature immediately apparent. While the composition as a whole gives the impression of being balanced, the arrangement is not completely symmetrical—leaves are turned in different directions; a piece of fruit on one side of the tree is not correlated with one on the other side—and this imparts a fresh, lively feeling to the picture. The crosshatched leaves and dotted fruit recall contemporary fabrics, and may indicate Hannah Cohoon's familiarity with "worldly" textiles.[16]

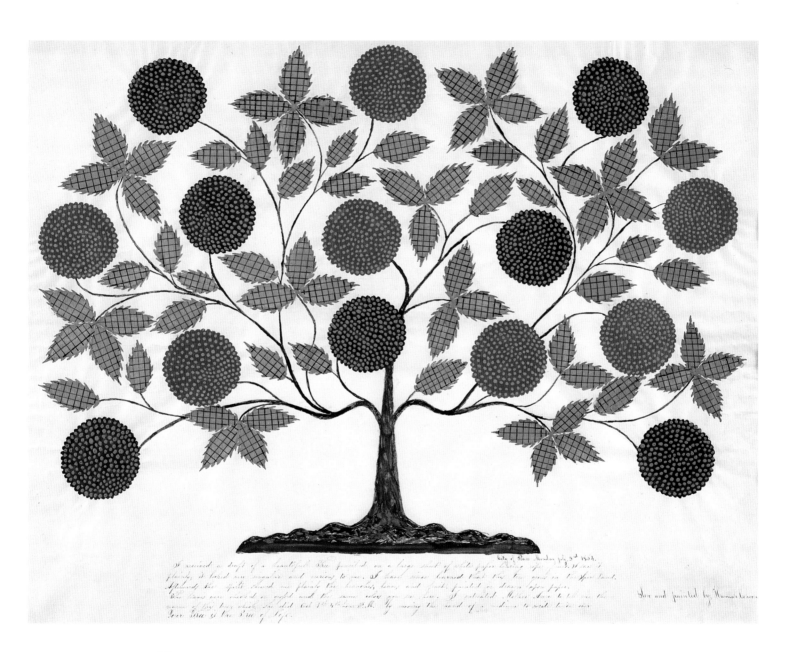

25

The Tree of Life

HANNAH COHOON (1788–1864)

Hancock, Massachusetts; 1854

Ink and tempera on paper; 18 1/8 × 23 1/4 inches

Hancock Shaker Village, Pittsfield, Massachusetts

★

26
The Peaceable Kingdom
EDWARD HICKS (*1780–1849*)
Bucks County, Pennsylvania; 1844
Oil on canvas; 24 × 31 ¹/₄ inches
Abby Aldrich Rockefeller Folk Art Center,
Williamsburg, Virginia
★

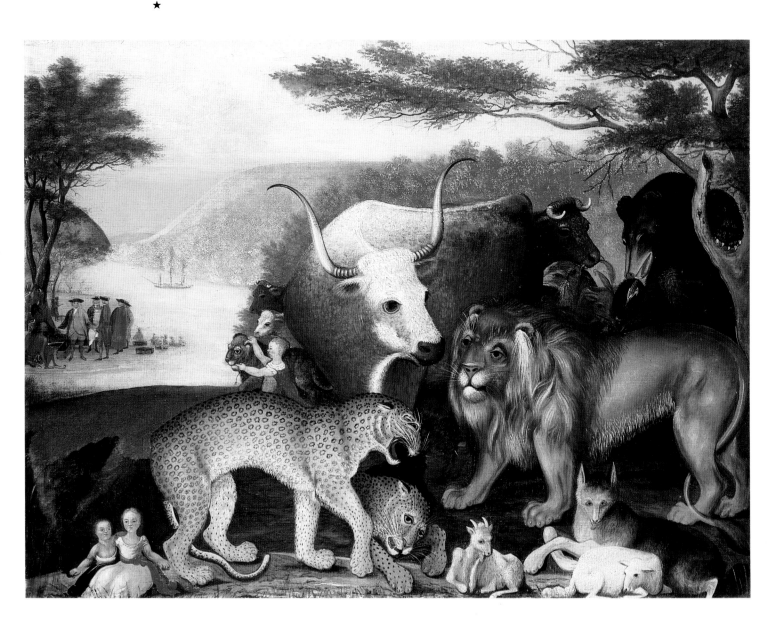

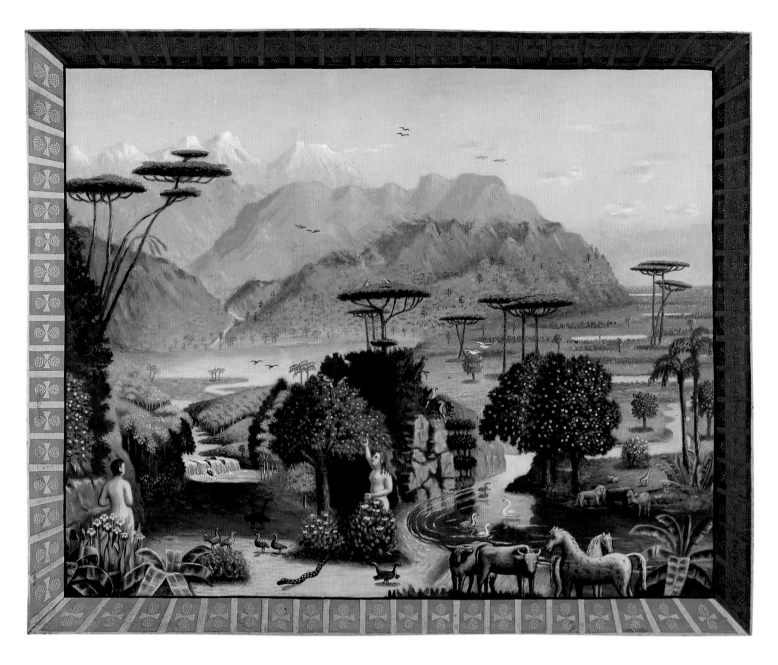

27

The Garden of Eden

ERASTUS SALISBURY FIELD (*1805–1900*)

Massachusetts; c. 1865

Oil on canvas; 35 × 41 ¼ inches

Shelburne Museum, Shelburne, Vermont

★

Other folk artists who have been inspired by religion are essentially preachers who use their talent as a means of spreading the Gospel or teaching a moral lesson. Edward Hicks was, in fact, a Quaker preacher, as well as a coachmaker and painter of carriages and signs. He is best remembered, however, for his many painted versions of *The Peaceable Kingdom*, including the one seen in figure 26.

In creating his compositions for the approximately sixty known *Peaceable Kingdom* paintings, Hicks combined a number of sources. The foreground scene of animals and small children was originally adapted from an engraved illustration of an English painting, *The Peaceable Kingdom of the Branch,* by Richard Westall. The picture illustrated Isaiah's prophecy of a world at peace under the reign of the Messiah: "The wolf also shall dwell with the lamb, and the leopard shall lie down with the kid; and the calf and the young lion and the fatling together; and a little child shall lead them" (Isaiah 11:6). The scene in the middle ground, adapted from an engraving after Benjamin West, depicts William Penn and his companions signing a treaty with the Indians, an event that Hicks saw as a realization of the peaceable kingdom on earth.

Meaning and symbolism are rife in all of Hicks's paintings, and especially in his *Peaceable Kingdom*s. Changes in the artist's personal feelings about his faith and dissension in his church can both be traced through the evolution of this composition. The version shown here was painted late in the artist's life, when he was still refining the combination of animals and the placement of the figures. This painting is principally distinguished from most other versions by the appearance of two leopards, including a snarling one with arched back, instead of a single animal lying calmly on the ground. The prominence of this snarling leopard in the foreground, and its role as part of the central triangle formed by leopard, ox, and lion, underline the importance of its meaning to Hicks. In fact, Hicks had preached on the "nature of man and his relationship to the divine in terms of the Kingdom animals." The angry leopard is here balanced by other, gentler creatures, including the second leopard. These are animals that have apparently disavowed self-will and allowed themselves to be guided by divine will.[17] Hicks, whose religion rejected the bright color and visual symbolism he nevertheless employed in his paintings, and who preached peace even though he was known as a contentious man, clearly understood such conflicts of the human soul.

When compared to earlier versions of *The Peaceable Kingdom*, this version of 1844 shows that Hicks's talents grew stronger as he aged. The arrangement of the animals is more three-dimensional, and their appearances are more naturalistic and less stereotyped. Not only do the leopards, the lion, and the ox stand out by virtue of their central placement, but their brighter colors contrast with the darker and paler animals and the land. The scene of Penn's Treaty, given less prominence here than in many other versions, is, however, framed by the pale river so that it is clearly visible. The tree on the left and the branch on the right that provides a canopy over the animals keep the light sky and background from pulling the eye away from the important subjects and letting the painting fade away at the top and side. Hicks was not mistaken when he sent this painting to Joseph Watson in 1844 with a letter calling it "one of the best paintings I ever done."[18]

Folk artists today have as much need to share their religious and moral beliefs through their art as did Hannah Cohoon, Edward Hicks,

The Blessing and the Curse
DETAIL
★

28

The Blessing and the Curse

HARRY LIEBERMAN *(1876–1983)*

Great Neck, New York; c. 1970

Acrylic on canvas; 40 × 30 1/8 inches

Helen Popkin and Rose Blake Collection

★

or Erastus Salisbury Field, who, although best known for his portraits, turned toward the end of his life to religious themes, such as *The Garden of Eden* (fig. 27). Harry Lieberman, who was born Naftulo Hertzke Liebhaber in Gniewoszow, Poland, in 1876, began rabbinical studies as a child but was never ordained. After emigrating to America in 1906, he operated a candy business on New York's Lower East Side and did not begin painting until he was 80 years old. Lieberman proved to be a prolific artist, painting until he died, at age 107. His many works, including *The Blessing and the Curse* (fig. 28), illustrate tales from the Old Testament and the Talmud as well as from Jewish folklore and literature. Usually, they raise moral and ethical questions and, to be sure that people understood the meaning of his paintings, Lieberman wrote out each story in Yiddish and placed it in an envelope on the back of the canvas, along with his own commentary on the subject.

The story of *The Blessing and the Curse*, subtitled *The Twelve Stones*, relates to the biblical injunction against the worshiping of idols. Lieberman's words, in literal translation, read:

Moses commanded to the elders of Israel when they crossed the Jordan they should put up twelve stones on Mount Ebal and write the laws on them so everybody could read. Then Simeon, Levi, Issacher, Judah, Joseph, and Benjamin should stay on Mount Gerizim to bless the people who worshipped and acted according to the laws. Reuben, Gad, Asher, Zebulon, Dan, and Naphtali should stay on Mount Ebal to curse those who worshipped idols and sinned against the laws. I think the symbol is, you get from Heaven the privilege to understand what is right and what is wrong. You do good, you will be blessed. You do wrong, you really are cursing yourself. The religious person believes no wrong comes from up there because all is heavenly in Paradise. Any suffering happens down here is your fault and your punishment is down here.

With their bright colors and lively rhythms, Lieberman's paintings recall the joyous aspects of Hasidic life in Poland, including a love of singing, dancing, and storytelling. He reveled in the use of color and shape: the cone-shaped trees, for example, owe nothing to nature for their bright hues or geometric forms. As is common in folk art, scale and perspective are purposely ignored in favor of content and design: those figures that are more important—Simeon, Levi, and others—are larger than those less important, regardless of where they stand in the landscape. Lieberman's stylized painting also adds to the mystical mood of the scene, making it clear that this is not a real landscape but one that the artist has created out of the mists of legend and religious history. Lieberman has added a striking touch of realism, however. The twelve tablets have been created with a collage technique employing actual printed Hebrew prayers pasted onto the painted stones.

★

OVERMANTELS AND FIREBOARDS

★ ★ ★ ★ ★

A decorative device that came from England, an overmantel, such as *The Hunting Party* (fig. 29), the *Van Bergen Overmantel* (fig. 30), and *Situation of America, 1848* (fig. 31), was the painted section of wall above a parlor fireplace. These scenes were usually painted directly on the plaster or on a paneled wall that covered the chimney, although occasionally a painted canvas was set into the woodwork. Overmantels represent one of the earliest forms of landscape painting in America,

29

The Hunting Party

ARTIST UNIDENTIFIED

Overmantel, Van Horne family house,
Communipaw (Jersey City), New Jersey;
late seventeenth century–early eighteenth century
Oil on canvas; 25 3/4 × 47 1/8 inches
The Metropolitan Museum of Art, New York
Gift of Mr. and Mrs. Samuel Schwartz.
1979 (1979.299)

★

30

Van Bergen Overmantel

ATTRIBUTED TO JOHN HEATEN *(active 1730–1745)*

Leeds, Greene County, New York; 1732–33

Oil on wood; 15¹/₄ × 87¹/₂ inches

New York State Historical Association, Cooperstown, New York

★

31

Situation of America, 1848

ARTIST UNIDENTIFIED

New York, New York; 1848

Oil on wood overmantel; 34×57 inches

Private collection

★

SITUATION OF AMERICA, 1848.

32

Bear and Pears Fireboard

ARTIST UNIDENTIFIED

New England, probably New Hampshire; c. 1830
Oil on wood; 39×54 ¹/₄ inches
New York State Historical Association,
Cooperstown, New York

★

33
Fireboard
ATTRIBUTED TO L. JOHNSTON
New England; c. 1835
Oil on panel; 44×54 inches
Private collection
★

and as they frequently depicted local scenes, they are excellent sources for studying the everyday life of the past.

The *Van Bergen Overmantel*, in particular, has been said to convey "more information about Dutch life in America than any other surviving object of the period."[19] This painting has provided resource material for the study of architecture, costume, transportation methods, agriculture, and other activities of daily life on a Dutch farm in New York State in the first half of the eighteenth century. It is also a remarkable record of relationships among different cultural groups of the period, as included in the painting are Native Americans and African-American slaves.

The artist has clearly adapted his composition to fit the function of the painting: it was probably originally created to hang above a wide fireplace or to fill a wide wall. A series of horizontals defines the landscape—the road, the fence, the trees, and the mountains. The alternating bands of green and tan provide discrete sections within which the figures are situated and the action occurs. The place of prominence in the center, however, is properly reserved for the red-roofed farmhouse, where the overmantel originally hung, and the sumptuously dressed Mr. and Mrs. Marten Van Bergen.

Fireboards, also called chimney boards, are another type of functional painting. Used to cover a fireplace opening during the summer months when heat was not needed, fireboards were prevalent during the eighteenth century and the first half of the nineteenth century. Executed by general "fancy" or ornamental painters, frequently the same artisans who were called upon to paint walls, floors, woodwork, and overmantels, they were considered part of the decoration of the room. *Bear and Pears Fireboard* (fig. 32) represents a style of painting that has been found on murals and other interior decorations as well as fireboards in a number of buildings in New England and New York. While the spindly trees with feathery leaves are typical of this group, the combination of an undersized bear with oversized pears makes this example especially appealing.

A most unusual fireboard is one signed "L. Johnston" (fig. 33). Like the scene on the *Van Bergen Overmantel*, this one probably depicts the farm and the house in which the fireboard was once used. At least part of the view is imaginary, as we see among the domesticated animals browsing at the lower left of the painting two improbable wild ones, a lion and a leopard. Also unusual is the boldly painted name (whether of the artist or the owner of the farm is not known) floating in the sky on the wings of an eagle. The style of lettering suggests that a sign painter, or other artisan accustomed to writing or stenciling in paint, was responsible for this unique fireboard. Also unusual, if not unique, is the large, three-dimensional fireboard (fig. 34) from Somerset County, Pennsylvania. The style of carving, particularly of the tassels, is reminiscent of that used on hearses in the nineteenth century, and the spires in the center resemble church towers. The original location of this sculptural piece remains unknown.

34

Fireboard

ARTIST UNIDENTIFIED

Somerset County, Pennsylvania; 1830–40

Carved and painted pine; 43¹/₄ × 47¹/₈ × 7 inches

Museum of American Folk Art, New York

★

LANDSCAPES, CITYSCAPES, AND SEASCAPES

★ ★ ★ ★ ★

Burroughs
DETAIL
★

Landscapes and seascapes that were not used for architectural decorations became popular in the nineteenth century, when prosperous homeowners and shipowners would commission artists to paint their houses or ships, much as they would hire a portrait painter to paint likenesses of themselves and their family. Such "portraits" of homes, farms, ships, and businesses had much in common with portraits of people: they, too, functioned as status symbols, showing their owners' pride of possession; they were often "formula" paintings, as the artists relied on frequently used motifs to speed their work; and their compositions were sometimes based on printed sources.

A number of the paintings included in this category are believed to have been commissioned works: *Burroughs* (fig. 35), by Jurgan Frederick Huge; *Residence of Mr. E. R. Jones* (fig. 36), by Paul A. Seifert; and *Thomas Hunt & America* (fig. 37), the double ships' portrait by James Bard. And while it is not known whether *View of the Buildings & Surroundings of the Berks County Almshouse* (fig. 38), by Charles C. Hofmann, was specifically commissioned, like the numerous versions of this painting that Hofmann completed, it was no doubt executed for sale to an employee or trustee of the almshouse.

Although he is best known as a marine painter, Jurgan Frederick Huge, a German immigrant, painted a number of townscapes that show the homes and daily life of his adopted city of Bridgeport, Connecticut. The Burroughs Building, an important commercial establishment in the center of town, was just four years old when Huge painted it in stunningly meticulous detail in 1876. The sharp watercolor-and-ink rendering portrays with intense scrutiny the elaborate facade of the building, the pavement, the shop windows, and even the shoppers inside, the horse-drawn streetcar and carriages, the horsemen, and the people on the street.

However, like many landscapes by Huge and other folk artists, *Burroughs* is not realistic in an academic, visual sense. These paintings are composite scenes made up of more elements than would meet the eye at any given moment, with details shown more sharply than they could possibly be seen from any single viewpoint. Huge planned his compositions to present as many as possible of the elements that interested him—and his clients. The building appears as imposing and important as its owner could have desired; indeed, everything else seems oddly small in comparison. Rather than detracting from the picture, the faulty scale and perspective draw the viewer into the picture and practically lead him in the front door of the Burroughs Building.

In comparison with *Burroughs*, the *Residence of Mr. E. R. Jones* appears airy and spacious. The artist, Paul A. Seifert, was also a German immigrant, who reached Richland City, Wisconsin, on a lumber raft in 1867. At first Seifert earned his living selling the flowers, fruits, and vegetables that he grew on his farm; later in life he became a taxidermist. His greatest enjoyment, however, was painting, and he often took off on foot with a stack of colored papers and boxes of paint. He would travel from farm to farm, sketching on order for the proud residents their neat homesteads, the livestock, the daily activities, all set against the wide skies and vast plains of Wisconsin.

Though it is similar in composition to much of Seifert's other work, *Residence of Mr. E. R. Jones* clearly shows the artist at the peak of his powers. In this picture, painted in 1881, we see his orderly sense of

35
Burroughs
JURGAN FREDERICK HUGE *(1809–1878)*
Bridgeport, Connecticut; 1876
Watercolor, ink, and gilt on paper;
29 1/4 × 39 1/2 inches
Bridgeport Public Library, Historical Collections,
Bridgeport, Connecticut

★

37

Thomas Hunt & America

JAMES BARD (1815–1897)

New York, New York; 1852

Oil on canvas; 35×65 inches

Courtesy Henry B. Holt

★

View of the Buildings & Surroundings of the Berks County Almshouse
DETAIL

★

design, his love of anecdotal detail, and his crisp, clear palette. It is interesting to note that Seifert typically used colored paper or cardboard for his scenes, and this basic background color—tan, or gray, or blue—determined the dominant tone of the painting. The Jones farm, depicted after a snowfall, is given a wintry feeling by the gray paper, here seen at the top and bottom and in the unpainted wood of the outbuildings. The gray base also provides a cold cast to the sky and snow. The bright red barn, green fir trees, and orange oaks stand out in vivid contrast to this subdued background. As was probably true of life on this farm, it is the barn rather than the house that is the center of attention; the matching red color of the inscription emphasizes its importance.

Accuracy was of great importance to the captains or shipowners who would hire a port painter, such as James Bard of New York, to make a permanent visual record of their vessels. This specialized type of folk painting came into fashion with representations of sailing ships in the late eighteenth century and remained popular through the age of steam and into the beginning of the twentieth century. The ships' portrait painter was usually an artist familiar with the ways of the sea and the construction of ships, and James Bard is known not only to have studied the plans of construction but to have personally measured the ships he was employed to paint.

Bard, who first painted with his twin brother, John, specialized in portraits of the steamboats that traveled up the Hudson River from their home port of New York. The formula the brothers developed when they painted together changed little when James began to work on his own. Ships painted by the Bards are almost always shown from the port side—traveling from the right to the left of the canvas—and none is shown at anchor or next to a dock. A spray of foam at the bowsprit of sailing vessels and by the paddlewheel of steamships is also characteristic of the Bards' formula.

Thomas Hunt & America is a rare, perhaps unique, double portrait by James Bard, showing two vessels that he also painted singly. The largest known example of Bard's work, the painting celebrates *America*'s 1852 triumph in the 100 Guineas Cup. The *Thomas Hunt*, newly launched, leads the proud yacht up the Narrows on her return from victory.[20]

The combination of two such sleek vessels—one wind-powered, one steam-driven—in a single portrait is enough to make this painting memorable. But Bard's technique here is so crisp, his use of color so effective, and his sense of movement through the wind-tossed water so real that the feeling of being at sea comes across here far more clearly than in his many standardized portraits. The blue-green waves topped by whitecaps are echoed by the ominous dark nimbuses that are punctuated by puffy white cloudlets. The ships are clearly heading straight into the wind—the flags are stiffly unfurled and the golden smoke of the *Thomas Hunt* is blowing straight back. Far from being simply a record of two handsome ships, this painting is an important seascape that stands on its own as a work of art.

Landscapes and seascapes that were not commissioned works, such as *The Plantation* (fig. 39), by an unidentified artist, *Manchester Valley* (fig. 40), by Joseph Pickett, and *Marblehead Harbor* (fig. 41), one of dozens of J. O. J. Frost's scenes of Marblehead often draw more heavily on the artist's imagination and ability to interpret a scene—the way it is viewed in the mind's eye—than on an actual event or topography.

The Plantation is especially informative about folk artists' approach to landscape. The entire hill, the main house, and all its outbuildings are visible in this painting because unlike the artist who paints from nature—paints what he *sees*—the folk artist is more likely to paint what he *knows*. It did not matter to the creator of this picture that no single perspective would have enabled him to see everything in it at one time; it only mattered that he knew that all the elements existed. Included in the landscape, therefore, are all the important components of life on this plantation: the water-driven mill; the waterfront warehouse; the ship that carries the produce to market and brings back news, goods, and people; even the grapes that grow on the land. Perspective and nature have been distorted by the artist in the interest of design—note how the hill narrows to provide a pocket of sky that silhouettes the grapevine—and in order to present his composite scene in orderly detail.

In *Manchester Valley,* Joseph Pickett provided his own vision of a local landmark. Although painted to commemorate the coming of the railroad in 1891 to New Hope, Pennsylvania, the picture was often called *The School House* because its most prominent feature is the imposing New Hope High School that stood on a hill just outside town, in the area known locally as Manchester Valley. As in *The Plantation*, we see in this painting how the folk artist arranged perspective to suit his needs, with objects of greater importance given greater scale, regardless of distance. Here, the school dwarfs the mills in the foreground, even though the latter were actually taller buildings. There is also a dramatic feeling of tension in this painting, created by the train, the creek, and the contours of the land all flowing to the left, while the prevailing winds, indicated by the trees and the position of the flag, blow to the right.

Pickett worked on each of his handful of known paintings for years, adding color until he achieved the raised textures that give parts of his pictures the appearance of relief. In *Manchester Valley,* the tiny figures on the train (the engineer and the fireman) are modeled in half-round relief, and the bark of the trees is built up to high relief. Pickett also added interest here by mixing in such materials as shells and sand, giving the trestle foundation the actual feel of cement.

Insight into Pickett's technique, as well as the thought processes of many folk artists, is provided by Pickett's friend Mrs. Martha R. Janney. In this excerpt from an article, she describes Pickett at work on *Manchester Valley.*

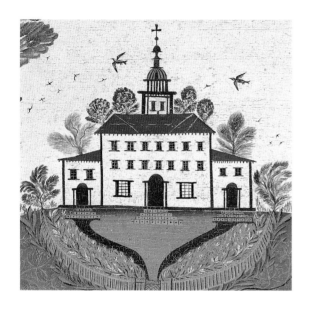

The Plantation
DETAIL

★

"*What do you think of the flag?" Joe would ask. "Doesn't it need another coat of paint?"*

As the paint was already about a quarter of an inch thick, the answer would be "no." And the flag would get another coat of paint anyway.

"Now look at that train," Joe would say. "See—you can read 'Reading Rail Road' right on it."

And you could!

"Joe," I would say, "if you would paint what you see and not what you know, you would get somewhere."

"What do you mean?" asked Joe.

"There is no fence around the schoolhouse."

"Yes, there is," says Joe.

"Let's look."

There was no fence. It had been gone for years.[21]

39

The Plantation

ARTIST UNIDENTIFIED

United States; c. 1825

Oil on wood; 19¹/₈×29¹/₂ inches

The Metropolitan Museum of Art, New York

Gift of Edgar William and Bernice

Chrysler Garbisch. 1963 (63.201.3)

★

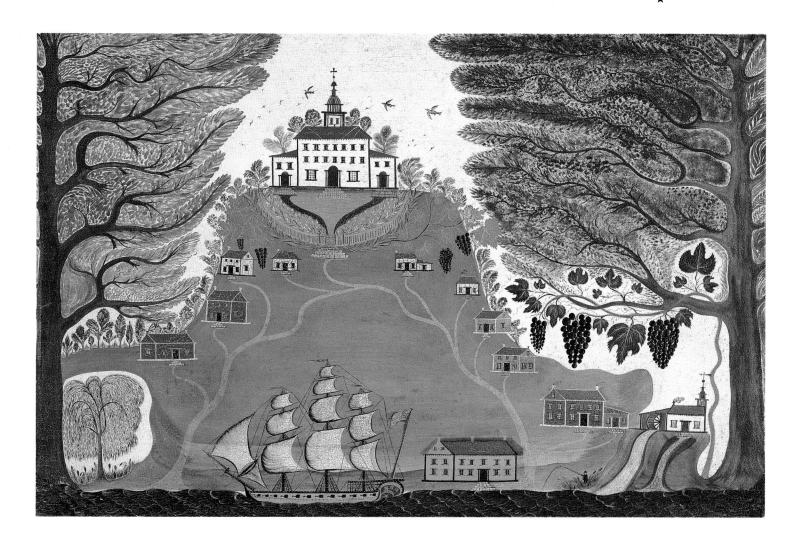

40

Manchester Valley

JOSEPH PICKETT *(1848–1918)*

New Hope, Pennsylvania; 1914–18

Oil with sand on canvas; 45 1/2 × 60 5/8 inches

Collection, The Museum of Modern Art, New York

Gift of Abby Aldrich Rockefeller

★

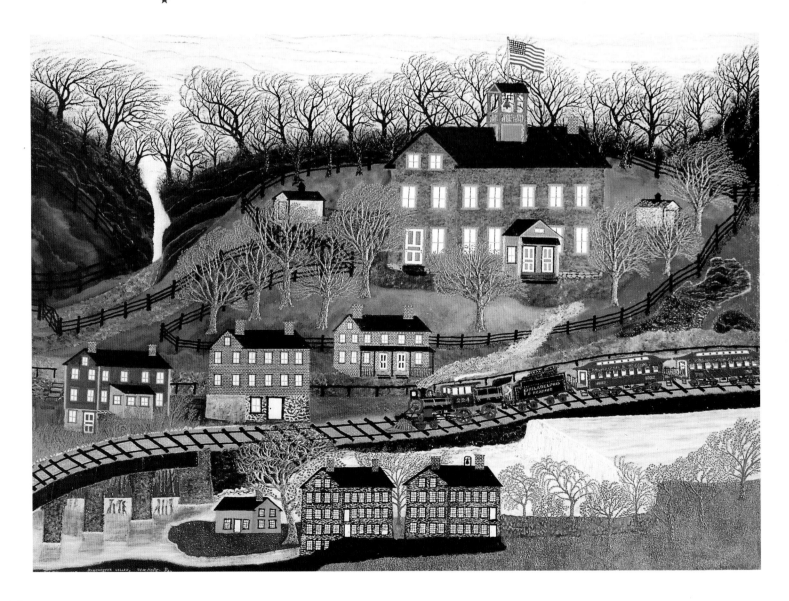

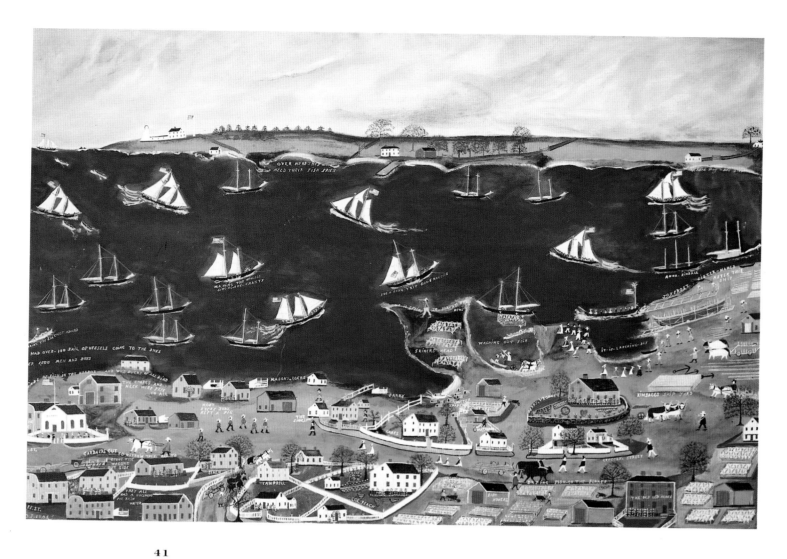

41

Marblehead Harbor

J. O. J. FROST *(1852–1928)*
Marblehead, Massachusetts; c. 1925
Oil on wallboard; 48×74 inches
The Marblehead Historical Society,
Marblehead, Massachusetts

★

INN AND TAVERN SIGNS

★ ★ ★ ★ ★

Artists who painted overmantels, fireboards, coaches, interiors, and even portraits were often called upon to paint signs for the many taverns and inns that served travelers and local customers. As early as 1645, the town of Salem, Massachusetts, required that taverns display signs for the convenience of travelers. Rhode Island had an equally early court order that commanded all tavern keepers to "cause to be sett out a convenient Sign at ye most conspicuous place of ye said house, thereby to give notice to strangers it is a house of public entertainment." These signs, such as *E. Fitts, Jrs. Store and Coffeehouse* (fig. 42), advertising the store on one side, the coffeehouse on the other, in the vicinity of Shelburne, Massachusetts, and *Strangers, Resort* (fig. 43), which directed people to J. Carter's Inn in Clinton, Connecticut, often sported eye-catching designs, intended to entice customers inside.

Signs usually carried pictures or lettering on both sides and were hung so as to be visible from either direction. Literacy was not as common in past centuries as it is today, so most signs bore pictures that explained the name of the establishment or the services to be found within. *Strangers, Resort,* for example, portrays a soldier and a gentleman traveler exchanging toasts across a tavern table set on a boldly patterned floor. Their hats, seemingly suspended in midair, are actually hanging on hooks. Compact though the scene may be, the artist has carefully conceived the composition: the arms and legs of one man are in graceful counterpoint to those of the other.

★

FRAKTUR AND DECORATIVE DRAWINGS AND PAINTINGS

★ ★ ★ ★ ★

The distinctive Pennsylvania-German style of drawing known as fraktur, broadly defined as illuminated manuscript, is an art form that can be traced back to medieval Europe. *Fraktur-schriften* (fraktur writing) was one of the arts the German-speaking immigrants brought from the Old World. Almost every eighteenth-century group of German-speaking Protestants included a minister or schoolmaster who was skilled in fraktur writing. They and their successors prepared the certificates of birth, baptism, marriage, and death required by law in Europe and made by tradition-loving Germans in their new home. They also made decorative drawings such as *Military Wedding* (fig. 44) and *Exselenc Georg General Waschingdon and Ledy Waschingdon* (fig. 45).

Johann Adam Eyer, the artist who painted *Military Wedding*, was a Pennsylvania schoolmaster who supplemented his income by creating a wide variety of fraktur, including awards of merit, writing examples, bookplates, illustrated hymnals, house blessings, and *Taufscheine* (baptismal certificates). *Military Wedding* shows tulip, bird, and heart designs, the trumpeting angel, and the stylized tree that are found in other examples of Eyer's work. He also used the same simple method of drawing faces. As is typical in fraktur drawing, the ladies and soldiers are representative and not meant as exact depictions. We know that Eyer had two brothers who fought in the Revolutionary War, and this drawing may have been a wedding gift to one of them,[22] or it may represent the double wedding of both brothers. The heart-shaped bodices of the ladies' dresses may offer visual evidence of the romantic purpose of the painting, or they may simply be a decorative device.

In this drawing, the repetition of patterns and colors gives a lively rhythm to the composition. Six soldiers, identically dressed from their black tricorn hats to their black shoes, stand guard at the top. Slightly

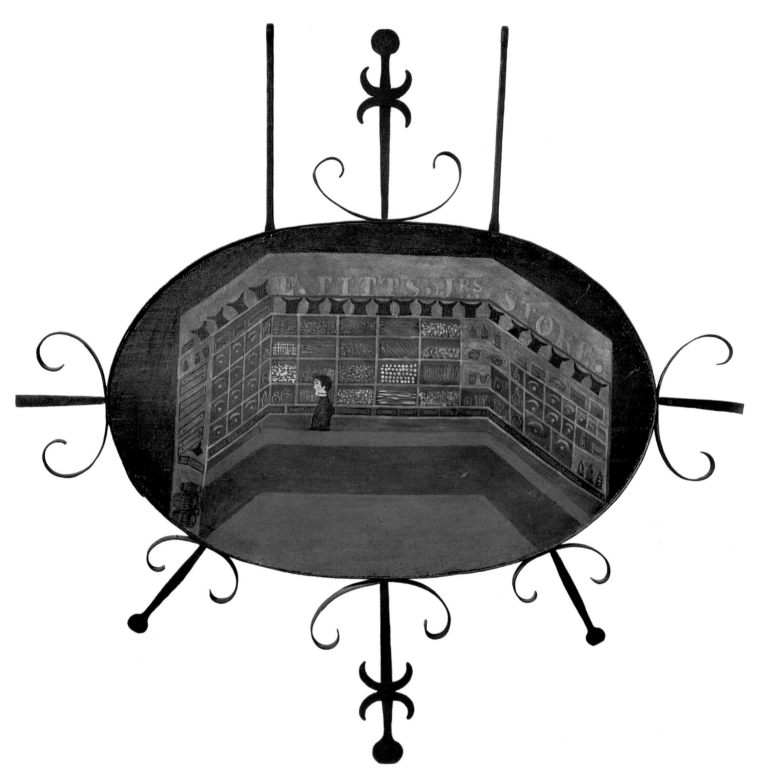

42

Trade Sign: E. Fitts, Jrs. Store and Coffeehouse

ARTIST UNIDENTIFIED

Vicinity of Shelburne, Massachusetts; 1832

Painted wood, wrought iron;

image oval 22³/₈ × 34¹/₂ inches

Museum of American Folk Art, New York

Gift of Margery and Harry Kahn

★

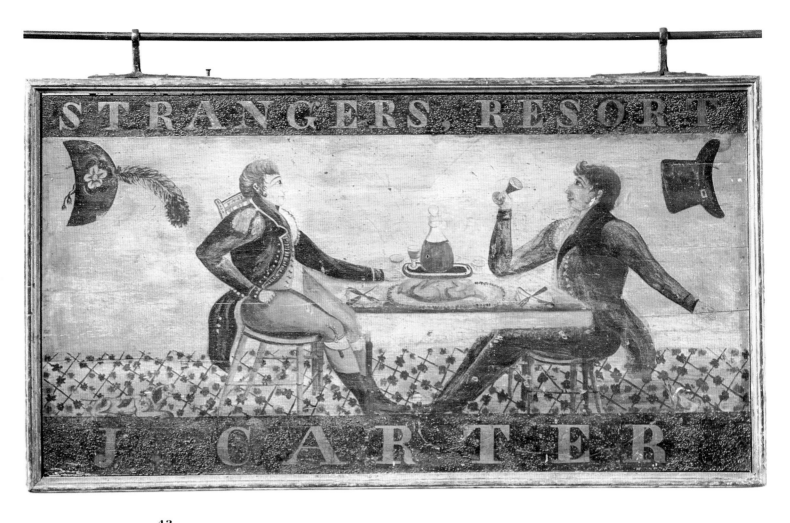

43

Strangers, Resort

ARTIST UNIDENTIFIED

J. Carter's Inn, Clinton, Connecticut; 1815
Painted wood; 22 1/2 × 42 inches
The Connecticut Historical Society, Hartford, Connecticut

★

44

Military Wedding

JOHANN ADAM EYER *(1755–1837)*
Probably Bucks County, Pennsylvania; c. 1780
Watercolor and ink on laid paper; 12 3/8 × 15 1/2 inches
Courtesy, The Henry Francis du Pont Winterthur Museum,
Winterthur, Delaware

★

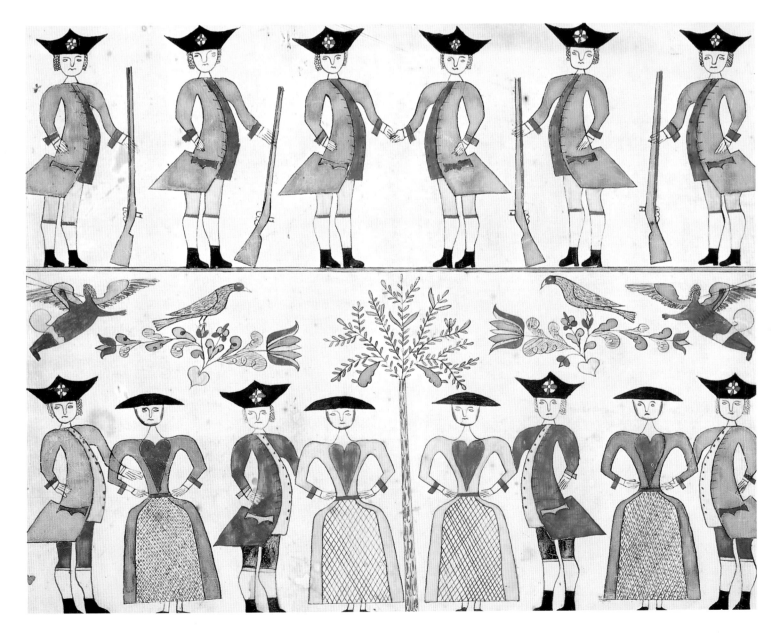

45

Exselenc Georg General Waschingdon
and Ledy Waschingdon

ATTRIBUTED TO THE SUSSEL-WASHINGTON ARTIST *(active 1775–1800)*
Probably Lebanon County or Lancaster County, Pennsylvania; c. 1780
Watercolor and ink on laid paper; 8×6 1/2 inches
Abby Aldrich Rockefeller Folk Art Center,
Williamsburg, Virginia

★

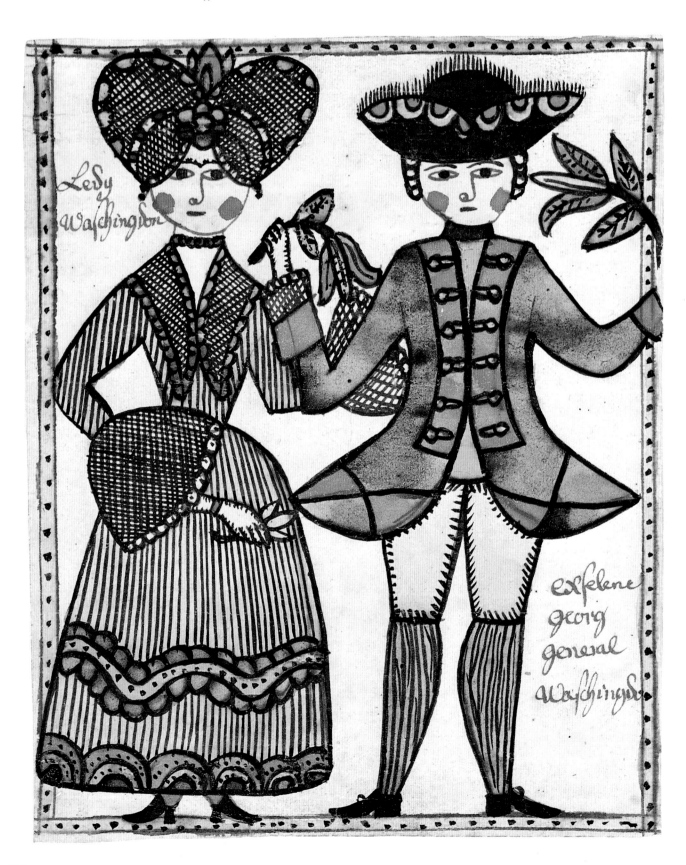

46

Heart and Hand Valentine

ARTIST UNIDENTIFIED

Possibly Connecticut; 1840–60

Cut paper, varnish, ink; 14×12 inches

Museum of American Folk Art, New York

★

47

Still Life

ARTIST UNIDENTIFIED

Found in Windham, Connecticut; c. 1840

Oil on canvas; 29×38 inches

Private collection

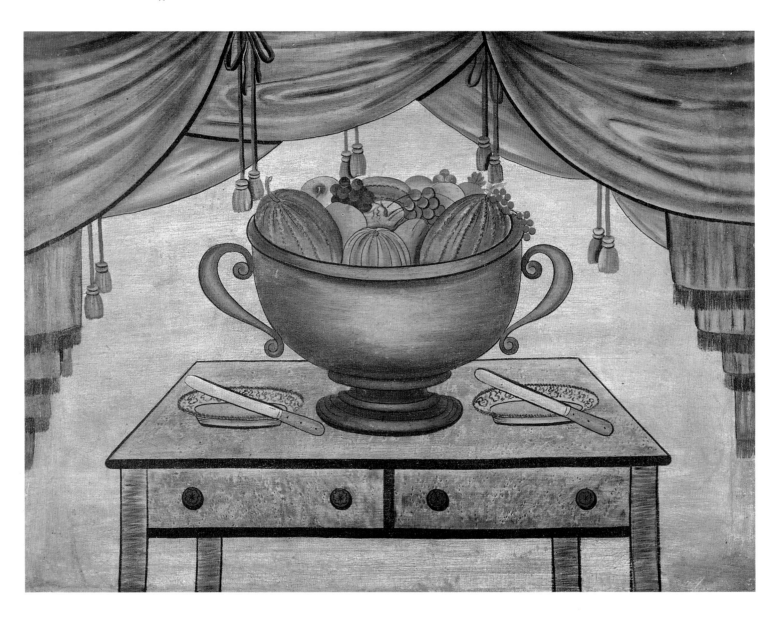

turned, they direct attention to the center of the painting. Only the center pair breaks the regimentation by holding hands instead of rifles. At the bottom, the men stand in the same three-quarters pose, while the women interject a staccato beat by facing straight forward. The two couples in the center are also dressed exactly alike, down to the cross-hatching on the ladies' dresses, and are presumably the honored pairs. Likewise, the two outer couples match. The tree in the center and, overhead, two trumpeting angels and two birds on tulips add to the probability that two unions blessed in heaven are here being celebrated.

Romance is also celebrated in the delightful *Heart and Hand Valentine* (fig. 46), a colorful collage of intricately woven papers. The heart-and-hand motif may have evolved from the Valentine's Day custom of giving a sweetheart gloves to be worn on Easter Sunday. In the late eighteenth century, designs with cut-paper hands and separate hearts decorated with woven paper strips made their appearance. By the middle of the nineteenth century, when this piece was done, publications such as *Godey's Lady's Book* and *Harper's Weekly* were suggesting verses and cut-paper projects for both men and women.

A favorite subject for women to paint was a bountiful bowl of fruit such as the one in *Still Life* (fig. 47). Usually these representations of the abundance of America were painted in watercolor on velvet or paper. This more elaborate, detailed example was done in oil on canvas and includes a beautiful grain-painted table, set with two spatterware plates and knives.

As the Pennsylvania Germans used frakturs to commemorate rites of passage, celebrations, and other events in their society, the Native Americans of the Plains tribes used a type of storytelling in pictures that we call pictography to record history, publicize autobiographical events, and communicate messages. Pictographs, such as *Husbands and Wives Going to a Dance* (fig. 48), frequently include symbols or shorthand drawings that would have been understood by tribes all across the Plains since a knowledge of these conventions and a mastery of techniques for their execution were part of a man's education:

In making a pictured robe, the old man who was to paint it spread the hide on the ground and the young men gathered around it. "The instructor did the work of painting, and the young men looked on and listened to the old man's instructions."

He taught that a horse should be drawn with a small head, an arching neck, and, in motion, widespread legs. Why did he depict a horse in this way instead of in a more naturalistic manner? . . . A man drew it this way because this was the way to draw a horse.[23]

Before the Native Americans were confined to reservations, deeds of bravery were frequent subjects of their pictographic drawings. Warriors commonly recorded their battle or hunting exploits on buffalo robes, war shirts, tipis, and tipi liners. By the 1860s, however, when animal hides had grown scarce because white settlers had moved onto the Plains, the paper pages of ledger books obtained from whites by trade, raid, and gift began to be the predominant medium for pictography. The subject matter also began to change, and the book that contained the example of "ledger drawing" illustrated here (originally collected in the nineteenth century by artist Julian Scott) included representations of a wide range of activity besides warfare.[24] While the scene may be domestic in nature, *Husbands and Wives Going to a Dance*

exhibits the same stylistic traits as traditional warrior art. Typically, such drawings include overlapping figures, often creating an X-ray effect, heads drawn in profile, no indication of depth or shadowing, and no attempt to create an impression of background or a setting of the scene in either time or space. Overall movement within a composition is usually from right to left.[25] The use of detail is selective: the most distinctive features are emphasized to make recognition of a figure easy, and background information is provided only if it contributes to the understanding of a story.[26]

Clearly, the unidentified Kiowa artist who drew *Husbands and Wives* learned his lessons well. From the small heads of the horses to the X-ray view of the horse through the woman's striped dress, he has followed the artistic precepts of his culture. He was also a master of color and design. Alternating blocks of solid red and blue culminate in the gay parasol on the right, evidence of cross-cultural contact, and the striped dress of the woman who is holding it. Dots, dashes, squiggly lines, straight lines, and a variety of geometric shapes all add interest to the composition and more than compensate for the poor quality of the materials.

The *Calligraphic Drawing of Two Stags Being Attacked by Two Dogs* (fig. 49) is an example of an interest in line and design taken to a remarkable level. An outgrowth of the nineteenth-century interest in penmanship, most of these drawings were executed by writing masters, generally for use in advertising their talent and attracting students to their classes. Using a steel pen, which made possible more delicate and uniform lines than had been possible with quills, these teachers created elegant, often ethereal drawings that use the same techniques as were required for beautiful handwriting, and one can often detect loops and stems of letters in the lines used to outline or frame a figure. In this drawing, the bodies of the stags are left undecorated, emphasizing their central position. This restraint on the part of the unidentified artist adds to the power of the drawing and provides extra dimension to a composition that was completed using only black ink on paper.

Like the unknown Kiowa artist, the unknown writing master, and many folk artists, Martin Ramirez also created art using a very few, nontraditional materials. When art supplies were scarce at DeWitt State Hospital in northern California, where Ramirez, who drew *Black Antelope* (fig. 50), spent the last thirty years of his life, he often made his own paper out of envelopes, cups, and other scraps that he stuck together with a glue made of mashed potatoes and saliva. A paranoid schizophrenic, the artist was also mute for much of his life.

Ramirez was born in Jalisco, Mexico, and images from Mexican life and the Catholic iconography of his homeland can be found in his work. Other subjects were drawn from popular culture and the natural world, although he often treated mundane subjects as if they were icons. *Black Antelope*, for example, has been presented in the center of Ramirez's favorite motif, the proscenium stage. It has been noted that the frontality of his work and the stage format recall the stepped and symmetrical altars of most Mexican churches and those in most of the California missions."[27] The emphasis on the linear, seen in this elegant and moving drawing, is typical of Ramirez's work. Both the stage setting and the antelope are characterized by vertical and horizontal lines, drawn with some concept of perspective. Up the steps and onto the stage, the viewer is drawn into the artist's world, one that is made to seem all the more powerful by its simplicity.

48

Husbands and Wives Going to a Dance

UNIDENTIFIED KIOWA ARTIST

Oklahoma; before 1880

Pencil and colored pencil on lined paper; 7 1/2 × 12 1/2 inches

Courtesy Morning Star Gallery, Santa Fe, New Mexico

★

49

Calligraphic Drawing of
Two Stags Being Attacked by Two Dogs

ARTIST UNIDENTIFIED

Ohio; mid-nineteenth century

Ink on paper; 21 7/8 × 28 inches

Hirschl & Adler Folk, New York

★

50

Black Antelope

MARTIN RAMIREZ (1885–1960)

Auburn, California; c. 1953

Pencil and crayon on paper; 54 × 42 inches

Gregory Amenoff and Victoria Faust Collection

★

NEEDLEWORK AND MEMORIALS

★ ★ ★ ★ ★

Skill with a needle was a necessary accomplishment for women in pre-industrial America. Young girls usually learned plain sewing at home—basic mending and embroidery stitches that were needed for repairing and marking linens with the family name. Parents who could afford it sent their daughters to a dame school when very young or to a ladies' seminary when a little older. Their education usually included learning to make a sampler. The execution of a sampler served several purposes in the education of a young woman. It taught her the letters of the alphabet and the numerical system, and also functioned as a handy reference for frequently used needlework stitches and motifs. Samplers such as the elaborate pictorial example sewn by Mary Antrim (fig. 51), however, had still another purpose. These works, often the product of many months at an academy, were showpieces on which a girl exhibited her mastery of difficult embroidery stitches, and served as evidence of refinement and a proper education. Any family of the late eighteenth century or early nineteenth century who had a daughter would be considered uncultivated indeed if they did not have a sampler wrought by their child to hang in the parlor.

Also popular among young ladies at school in the second half of the eighteenth century and the first half of the nineteenth was "fancy" needlework. Girls who had graduated from making samplers were given special instruction and developed accomplishments that included the skills needed to stitch elaborate silk-on-silk pictorial embroideries, chair seats, and intricate crewelwork for bed hangings and curtains. The needlework pictures especially were related to current trends in popular taste, including Classicism and Romanticism, and often depicted scenes from the Bible or literary subjects as well.

Prudence Punderson, a young woman who lived in Connecticut in the second half of the eighteenth century, is remembered today for her needlework pictures, including a set of the *Twelve Disciples* and the unusual *First, Second, and Last Scene of Mortality* (fig. 52). Stitched some years before her marriage in 1783 to Dr. Timothy Wells Rossiter, the scene shows the artist herself in the three stages of human existence: as an infant in the cradle on the right; as a young woman with her needlework materials at the table in the center; and in her coffin, labeled "P. P.," on the left. The scene is remarkable not only for its powerful subject matter but also for its detailed depiction of life in a comfortable eighteenth-century New England household. The cradle, for example, is being rocked by a black servant. On the wall above it is a picture—possibly wrought in needlework—not unlike those stitched by girls at school and brought home for their parents to display in the parlor. The floor is covered in a checkerboard pattern, perhaps indicating a painted floor cloth. The looking glass above the coffin has been shrouded with cloth, as was customary in a house of mourning. Shown on page 96 are the mirror, the Chippendale tea table, and the inkwell portrayed in this picture. That they all survived with the embroidery proves their value to the needlewoman's descendants.

Needlework was probably the most important artistic outlet for women in seventeenth- and eighteenth-century America. The skills needed to create works of art with cloth and thread were necessary for proper household management as well as a valued social grace. Especially talented women like Prudence Punderson could manipulate these materials to surprising effect, selecting exactly the right type of thread and stitch to create changes in texture or shading. More important is

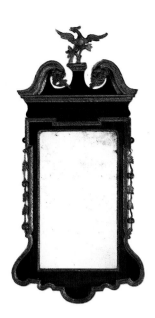

Looking Glass
Mahogany veneer on pine, gilt; 55 × 26 1/4 inches

Inkwell
Pewter; 1 7/8 × 6 3/8 × 4 5/8 inches

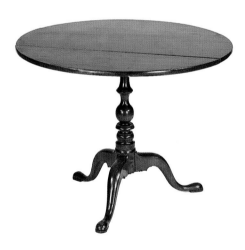

Tea Table
Cherry; 28 1/2 × 35 3/8 inches

MAKERS UNIDENTIFIED
Connecticut; c. 1775
The Connecticut Historical Society,
Hartford, Connecticut

★

the poignant statement that the artist is making about the brevity of life in eighteenth-century America. In her case, it was especially short; she died in 1784, at the age of twenty-six.

Mourning pictures, memorials to the dear departed, were stitched at the beginning of the nineteenth century; later in the century such subjects were painted, by girls at school. Once believed to be an indication of a girl's morbid fascination with death and dying, these pictures are now accepted as evidence of the fashionableness of sentimentality in the early nineteenth century. In general, mourning pictures, whether embroidered or painted, are composed of a number of standard motifs, all of which had symbolic meanings understood by nineteenth-century Americans. The most common motifs are mourning figures, usually female, bowed in the classical posture of grief, classical urns mounted on inscribed tombs, and weeping willows. While visual representations of mourning women at tombstones are known from ancient times, this specific combination of elements can be traced to the late eighteenth-century and early nineteenth-century European practice of memorializing public figures in textiles, ceramics, and prints. In particular, prints of the Swiss-born artist Angelica Kauffmann's painting *Shakespeare's Tomb* were widely circulated in this country, where in 1799 the composition was adapted to commemorate the death of the greatest American hero, George Washington.

In the following years, schoolgirls and their teachers drew on these and other sources to create pictures that memorialized relatives as well as national heroes. Silk embroideries were the vogue at the beginning of the century, but soon thereafter young women began to combine ink and watercolor with needlework on these elaborate, time-consuming creations, as is seen in the *Mourning Picture for Mrs. Ebenezer Collins* (fig. 53). Eventually, these were replaced by memorials executed entirely in watercolor, a medium that was easier and less expensive to use. Interestingly, needlework remained the inspiration for a number of watercolor artists, including the unidentified creator of the *Memorial for Polly Botsford and Her Children* (fig. 54), who painted some details with short precise strokes—note especially the foliage on the trees—that are clearly in imitation of embroidery stitches. This extraordinary memorial is often mentioned as an example of nineteenth-century art that in both concept and execution presages modern painting. The church, for example, has been reduced to its skeleton framework, suggesting more the idea of a house of worship than any specific edifice. The way the church has been painted, as a series of geometric shapes, and the general spareness of the composition add to the contemporary feeling of the piece.

Many memorials were created in honor of relatives or family friends the artist never knew, frequently long after they had died. *Memorial for Polly Botsford and Her Children* does not seem to be the work of an artist wallowing in sentimentality. The composition appears too well planned, the execution too precise for a schoolgirl overcome by grief to have achieved. The pointed arches of the church recur in this picture, in the cypress trees, the fence, the stylized branches and leaves of the large and small willows, and even the row of women and children dressed in high-waisted Empire-style gowns. Unreal scale and perspective do not detract from this composition, but actually add to it. The two children look like paper-doll cutouts that are joined to their mother by a "zigzag clasp of hands."[28]

52

The First, Second, and Last Scene of Mortality
PRUDENCE PUNDERSON ROSSITER *(1758–1784)*
Preston, Connecticut; c. 1778–83
Silk thread on silk; 12 3/4 × 17 inches
The Connecticut Historical Society, Hartford, Connecticut

★

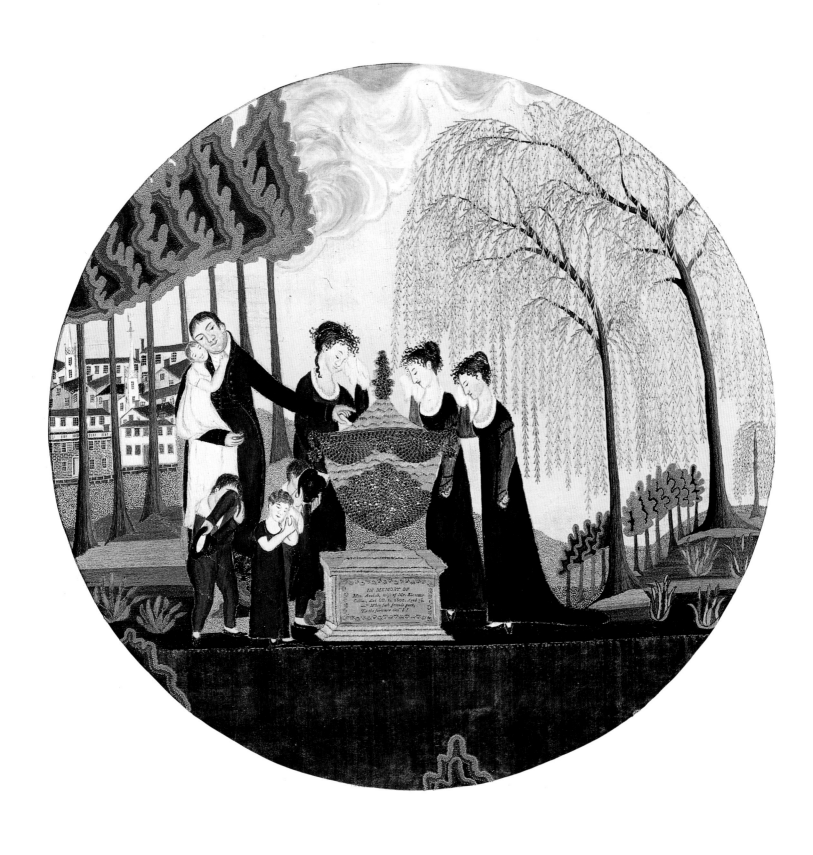

53
Mourning Picture for Mrs. Ebenezer Collins
PROBABLY LOVICE COLLINS (*c. 1793–1847*)
South Hadley, Massachusetts; 1807
Watercolor, silk thread, metallic chenille thread on silk,
and pencil on paper label; 18¹⁄₂ × 18 inches
Museum of American Folk Art, New York
Eva and Morris Feld Folk Art Acquisition Fund

★

54

Memorial for Polly Botsford and Her Children

ARTIST UNIDENTIFIED

Possibly Newtown, Connecticut; c. 1815
Watercolor and ink on wove paper; 18 × 23 1/2 inches
Abby Aldrich Rockefeller Folk Art Center,
Williamsburg, Virginia

★

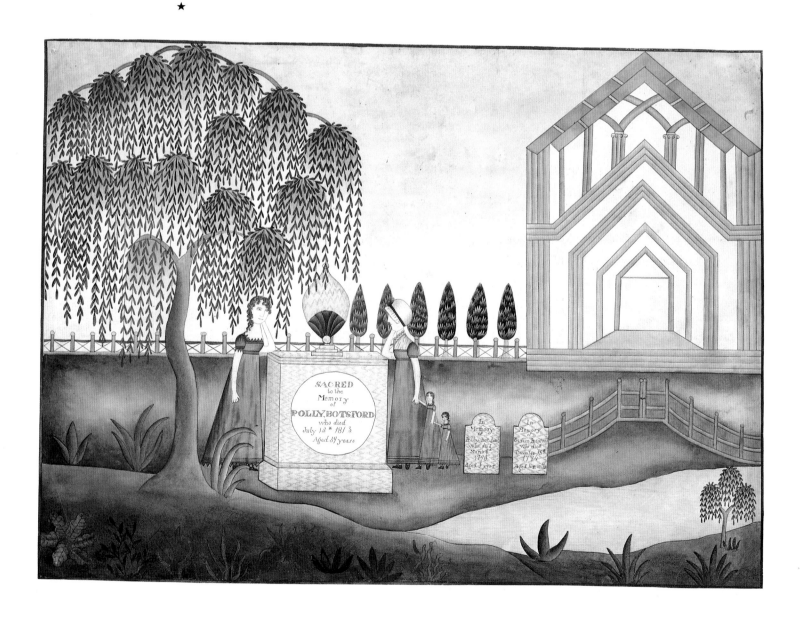

WORKS IN WOOD, METAL, AND STONE

Most of the objects included in this section were created with specific, albeit diverse, functions in mind: to commemorate the dead, appeal to a deity, forecast the weather, lure wildfowl, advertise a business, provide amusement. However, the completed works are so expertly designed and crafted and so imaginatively decorated that they transcend the purely functional and enter the realm of art. Many of the works shown here belong to well-established traditions, such as stonecutting or decoy carving. They are the products of artists who were highly regarded in their communities for their craftsmanship, and the objects are still deemed outstanding examples of their type. Other works, while clearly related to known traditions, impress us by their individuality and the ability of their creators to escape from and surpass the expected forms. And finally, some objects belong to no traditions that have as yet been identified. Perhaps further research will unearth roots and prototypes for works of art that are now considered idiosyncratic, appreciated today for the artist's unique vision and skilled hand.

★

GRAVESTONES AND RELIGIOUS CARVINGS
★ ★ ★ ★ ★

Caleb Brown Gravestone

DETAIL

★

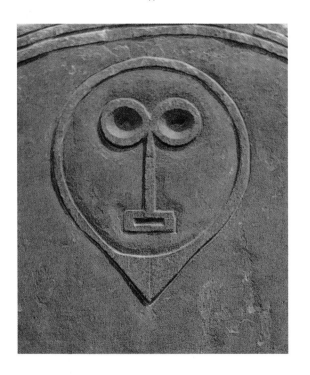

Almost as soon as permanent settlements were established in the New World, the folk carver found a substantial demand for his efforts. In the East, stone monuments and grave markers are the earliest dated examples of American folk sculpture. Essex County, Massachusetts, for example, has a tradition of stone carving that dates to the middle of the seventeenth century. By the middle of the eighteenth century, that tradition was established and, it is often stated, had been developed to its most powerful form by the carvers Jonathan Worster and his son, Moses, of Harvard, Massachusetts.[1]

The *Caleb Brown Gravestone* (fig. 55), carved by Moses Worster, is typical of the work of father and son. Both stonecutters preferred finely grained, dark slate to the coarser schist that had been popular for grave markers in the area, a change in material that permitted the more precise delineation of motifs that is seen in their work.[2] More significant than that change, however, is the way the Worsters developed the traditional motifs. Abstract representations of the human face were not uncommon on Essex County gravestones. On Caleb Brown's, the Worsters have improved upon such representations by making the eyes larger and rounder as well as deeper, creating shadows in the eye sockets and giving the face a haunted look. They also lengthened the nose to fill the circle of the countenance and added a pointed chin. Furthermore, space around the face was opened up, imbuing the image with a more iconic presence. The total effect was to "increase the mystery of death."[3]

The symbolism of this stone and the meaning of the design would have been clearly understood by eighteenth-century New England Puritans. While human mortality and the fate of the human soul, as represented by the face, remained shrouded in mystery, the symmetrical geometric motifs suggest a rational universe. These decorative motifs—rosettes, guilloche, etc.—bear strong similarity to those found on carved furniture of the area, suggesting that the artisans had both a common carving style and a common pool of designs, drawn from an English background.

Almost as stark and equally powerful as the visage on Caleb Brown's gravestone is the carving known as *The Preacher* (fig. 56). Originally believed to be a representation of the celebrated American pulpit orator

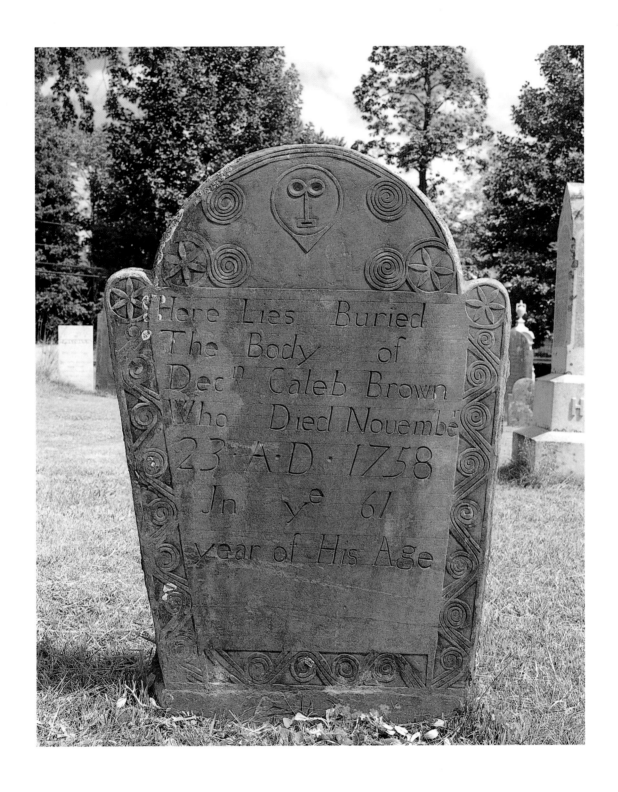

Caleb Brown Gravestone
MOSES WORSTER *(born 1739)*
Harvard, Massachusetts; 1758
Slate; 36 inches high
Photograph courtesy Daniel Farber
and Jessie Lie Farber

★

56

The Preacher

ARTIST UNIDENTIFIED

United States; c. 1870

Carved butternut and eastern white pine;

21 × 7 1/2 × 7 1/4 inches

Abby Aldrich Rockefeller Folk Art Center,

Williamsburg, Virginia

★

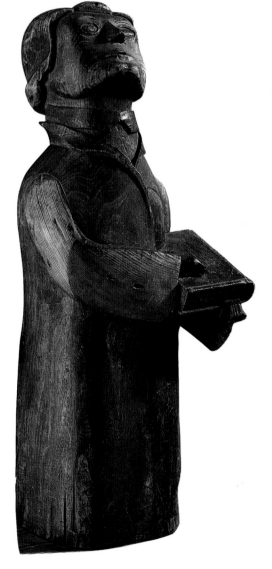

Henry Ward Beecher, the figure is actually very similar to a German monument to Martin Luther erected in Worms in 1868. By about 1870, Americans would have encountered the image through metal replicas and pictures.[4]

From the middle of the eighteenth century to the beginning of the twentieth, New Mexican *santeros,* artists who made images of saints, supplied the religious devotional figures that were important in the church and domestic life of the Southwestern Spanish Colonial settlements. Carved figures of saints, angels, crucifixions, and other biblical images, such as *San Ramón Nonato* by José Rafael Aragón (fig. 57), were usually fashioned from local cottonwood and then covered with gesso and painted. While these *bultos* are the continuation in America of a Spanish Baroque art form, the works produced in New Mexico tended to be freer, bolder, and more abstract than their Spanish or even their Mexican counterparts.

José Rafael Aragón was a prolific artist who was perhaps better known in nineteenth-century New Mexico for his *retablos* (religious paintings) and altar screens than for his carved figures. For the chapel of Our Lady of Talpa, Aragón created all the interior decorations, now preserved intact at the Taylor Museum of the Colorado Springs Fine Arts Center. Each saint represented in the chapel had its own specific role to play in the lives of the people, and each would be called upon at certain times of need. *San Ramón Nonato* (Saint Raymond the Unborn) was one of the saints whose role was to serve as intermediary in prayers and requests for divine mercy. He was a Spanish saint of the thirteenth century who served as a missionary among the Moors of North Africa. He was nearly martyred when a furious mob of Muhammadans, in an effort to silence him, pierced his lips with a red-hot iron and locked them shut with a padlock. Remarkably, he survived and returned to Spain, where he was made a cardinal. His name, Nonato (the unborn), refers to his cesarean birth, which took place while his mother was dying of the plague. The birth was therefore considered miraculous, and he was revered as the patron saint and protector of expectant women and midwives.[5] Not surprisingly, he is also venerated as the keeper of secrets.

Aragón depicted the saint as was most common in folk renditions, dressed in his cardinal's robes and holding a monstrance in his right hand and a palm or umbrella with three crowns in his left hand. The marks of his torture, above and below his lips, are plain to see. The composition of the sculpture has many stylistic similarities to Aragón's paintings: sculpted drapery here replaces painted examples that almost always envelop the figures on Aragón's *retablos,* and the trees on either side of the saint are three-dimensional versions of the plant forms that are often used as space fillers in his paintings. Even the way the figure has been framed suggests that this is a transformation of a painting into a different medium.

The *santero* created his artwork for a special purpose—to be the personification on earth of a specific holy personage. The spiritual qualities of that being had to be apparent in the representation, as did an intimation of efficacy: it had to appear that this *santo* had the ability to intercede on behalf of a petitioner or to provide divine guidance. In the rendition of the form, *San Ramón Nonato* displays the sensitivity that Aragón is known for, as well as an aura of power. The framework around the carving gives it an importance that the figure alone would

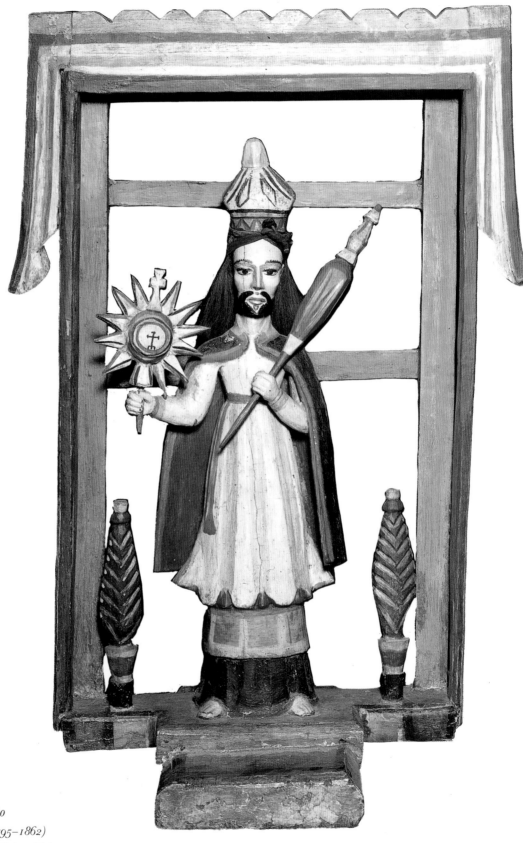

57

San Ramón Nonato

JOSÉ RAFAEL ARAGÓN (*c. 1795–1862*)
*From the Chapel of Our Lady of Talpa, Talpa,
New Mexico; 1834–38*
*Cottonwood, gesso, tempera, natural pigments,
pine base; 27 1/2 × 18 × 10 inches*
*Taylor Museum of the Colorado Springs Fine Arts Center,
Colorado Springs, Colorado*

★

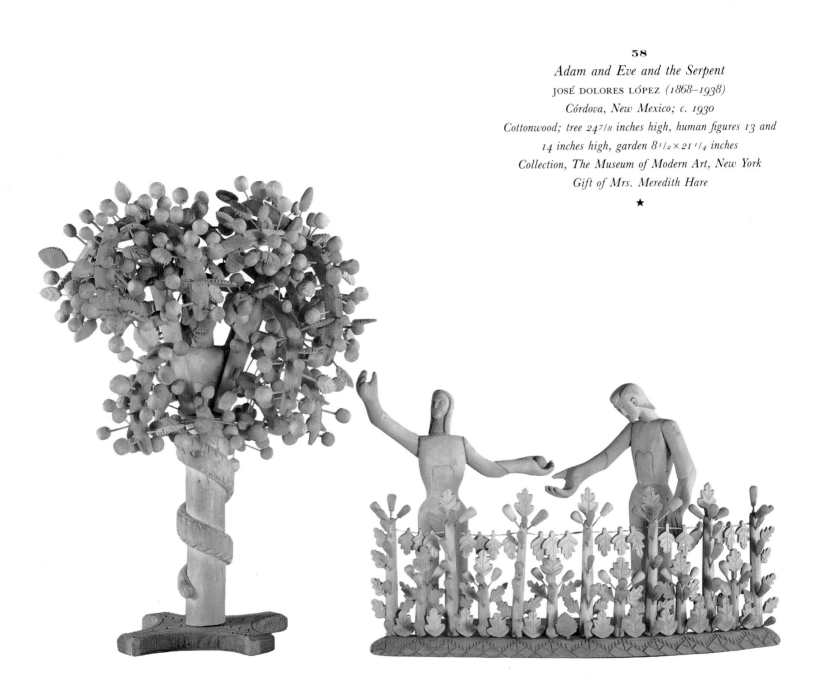

58
Adam and Eve and the Serpent
JOSÉ DOLORES LÓPEZ *(1868–1938)*
Córdova, New Mexico; c. 1930
Cottonwood; tree 247/8 inches high, human figures 13 and
14 inches high, garden 81/2 × 211/4 inches
Collection, The Museum of Modern Art, New York
Gift of Mrs. Meredith Hare

★

not have had. The saint stands on a platform or altar that is reached by two steps, an elevation also lending it lordliness. Even the static pose is one of authority and command. This is a *santo* meant to inspire confidence in a woman in need.

The tradition of the *santero* began to wane in New Mexico after the American occupation of 1848, when commercial religious prints and plaster statues, favored by the new French clergy, became available to the populace. It continued, however, in some areas well into the twentieth century.[6] José Dolores López, who carved *Adam and Eve and the Serpent* (fig. 58) approximately one hundred years after Aragón worked in the same New Mexican town of Córdova, was a member of a family that had carried on the tradition of wood carving for four generations. López, a carpenter by trade, began his carving career by making secular objects such as animals, picture frames, and furniture for his own amusement and as gifts for friends. He was also called upon to repair and repaint the sacred images in the local chapel. In the late 1920s, a group of patrons from Santa Fe persuaded López to change his subject matter and to produce representations of the saints, the Virgin, archangels, and biblical personages. The last years of his life were devoted to carving the religious figures for which he is primarily remembered today. Since his new clientele found López's style of painting too gaudy (he favored the bright colors of house paints and lively Mexican designs), he left his sacred images unpainted and concentrated instead on chip carving and incised designs.[7]

Adam and Eve and the Serpent and *San Ramón Nonato* are separated by one hundred years—they are completely different in both inspiration and purpose. López's decorative tableau did not have to provide comfort and hope to the pious or stand with other religious images in a rural chapel. Instead, the artist was free to explore form and to experiment with subject matter and types of decoration. The imagery used for this work, for example, may have been drawn from an old book of illustrations of the Garden of Eden printed in France.[8] López clearly enjoyed detailed carving—the many exquisitely crafted, tiny parts of this scene attest to his delight. His family reported that the artist was skilled in making filigree jewelry, and that the late nineteenth-century designs employed in jewelry making later influenced his style of chip carving.[9] He also had a sense of humor about his work: hidden deep in the tree is the grinning face of the devil. The figures in this group are stylized, not differentiated by many personal characteristics as were the traditional carvings of *santos*. Such treatment makes Adam and Eve symbolic of all men and women, rather than specific participants in a single event. Their hands, however, are expressionistically large, perhaps indicating that they are the instruments of the devil, caught in the act of plucking fruit from the tree.

★

WEATHER VANES AND WHIRLIGIGS
★ ★ ★ ★ ★

The weather vane is a form of folk art that, although originating in Europe, reached its greatest development in America. There are several basic types of weather vanes: handcrafted silhouette and three-dimensional wooden vanes; handcrafted silhouette and three-dimensional metal vanes; and factory-produced vanes. *Angel Gabriel* (fig. 59) is an example of a handcrafted three-dimensional wooden weather vane; *Rooster* (fig. 60) is a silhouette weather vane handcrafted of wood.

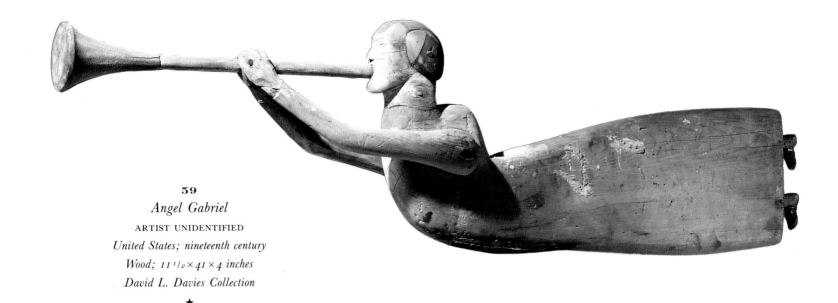

59
Angel Gabriel
ARTIST UNIDENTIFIED
United States; nineteenth century
Wood; 11 1/2 × 41 × 4 inches
David L. Davies Collection
★

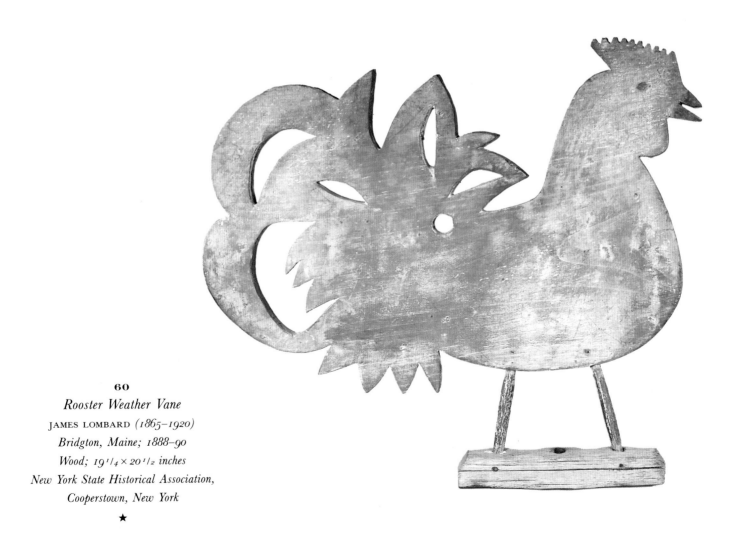

60
Rooster Weather Vane
JAMES LOMBARD *(1865–1920)*
Bridgton, Maine; 1888–90
Wood; 19 1/4 × 20 1/2 inches
New York State Historical Association,
Cooperstown, New York
★

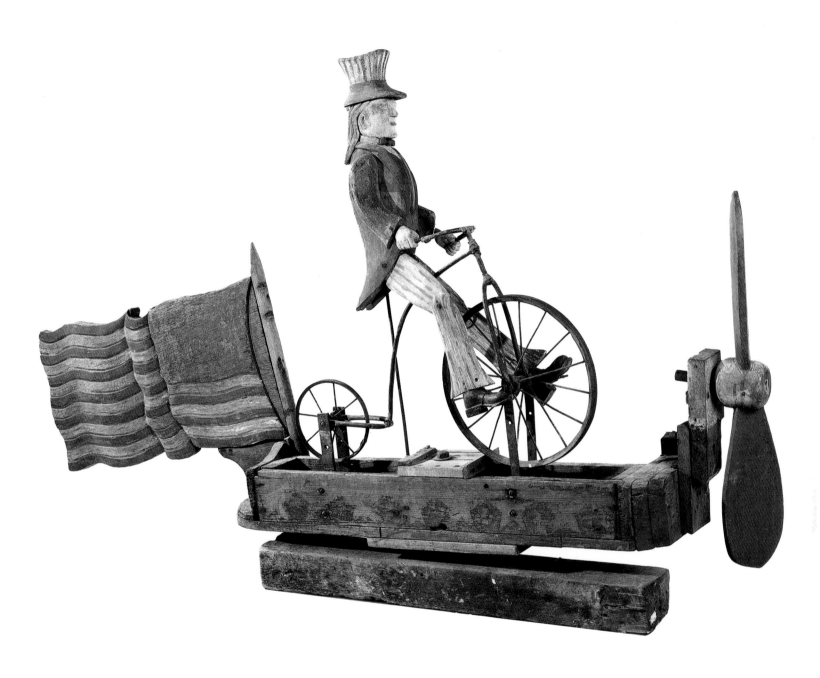

61

Whirligig: Uncle Sam Riding a Bicycle
ARTIST UNIDENTIFIED
Northeastern United States; 1880–1920
Carved and painted wood, metal; 37 × 55 1/2 × 11 inches
Museum of American Folk Art, New York
Promised bequest of Dorothy and Leo Rabkin

★

Like much folk sculpture, weather vanes had functional as well as decorative purposes. A vane could be used as a trade sign, indicating the type of business housed within the building it topped. A farmer might commission a weather vane in the shape of an animal raised on his farm. And church steeples—easily identified from a distance—were usually topped by Christian symbols: the rooster, the fish, and the angel Gabriel. But, most important, a weather vane was used to indicate the direction of the wind. Farmers, sailors, travelers, and anyone else whose work depended on the weather used weather vanes as forecasters.

The rooster was probably the most popular figure for a weather vane. The weathercock, a symbol of vigilance, topped bell towers of European churches throughout the Middle Ages.[10] Papal decree had proclaimed the rooster a symbol of the betrayal of Christ, and viewing it daily was meant to remind Christians not to repeat this sin. The crowing rooster also reminded the faithful that they had an obligation to pray every morning.[11] Roosters may also have been popular forms for weather vanes for a purely practical reason: the shape of the bird in profile is "ideal as a vane, for it has direction, windfoil, and perfect balance."[12] A rooster is a common animal with a distinctive shape that can be easily simplified and its features exaggerated so that it is readily recognizable from a distance.

James Lombard, a nineteenth-century Maine wood-carver, made a number of stylized rooster weather vanes, including the one seen in fig. 60, that are distinguished for their imaginative treatment of the tail feathers. Lombard's weather vanes were sawed from pine planks to which wooden legs were attached. Many were painted yellow to simulate the gold leaf that was applied to the more expensive metal vanes of the time. The example shown here, probably once brightly painted, has now weathered to a mellow silvery gray. The treatment of the tail is the most eye-catching part of this rooster. The openwork pattern provides visual interest while permitting the wind to turn the vane without meeting resistance that would break the wood. A series of curves defines the dramatic shape of this bird: the puffed-out breast is balanced by the arch of the tail; the U-shape between the head and the tail is seen in reverse in the openwork of the tail. Even the short feathers at the top of the tail are balanced by those at the bottom.

Although some eighteenth-century European examples are known, the whirligig, or wind toy, reached its fullest development in America. While some whirligigs are simple figures with propeller-type arms that flail in the wind, other examples, including *Uncle Sam Riding a Bicycle* (fig. 61), are more complex devices. This fascinating figure, which features two large carved and painted flags—American on one side and Canadian on the other—was constructed so that when the wind blew, the propeller in front activated a series of gears and connecting rods that caused Uncle Sam to pedal vigorously.

★

DECOYS
★ ★ ★ ★ ★

Archaeologists have determined that waterfowl decoys were probably first used in the New World by Native Americans in the Southwest. Combining tightly bound reeds with feathers, Native Americans living in what is now Nevada created a remarkable imitation of a canvasback duck about 1000 A.D., and perhaps earlier. Tribes in eastern North America stacked small stones on top of larger ones to form visual imitations of resting ducks, which would lure waterfowl within striking

62

Pair of Red-Breasted Mergansers
LOTHROP T. HOLMES *(1824–1899)*
Kingston, Massachusetts; 1860–70
Painted wood; drake 11×16×6 inches,
hen 9×15 1/4×5 1/2 inches
Guennol Collection

★

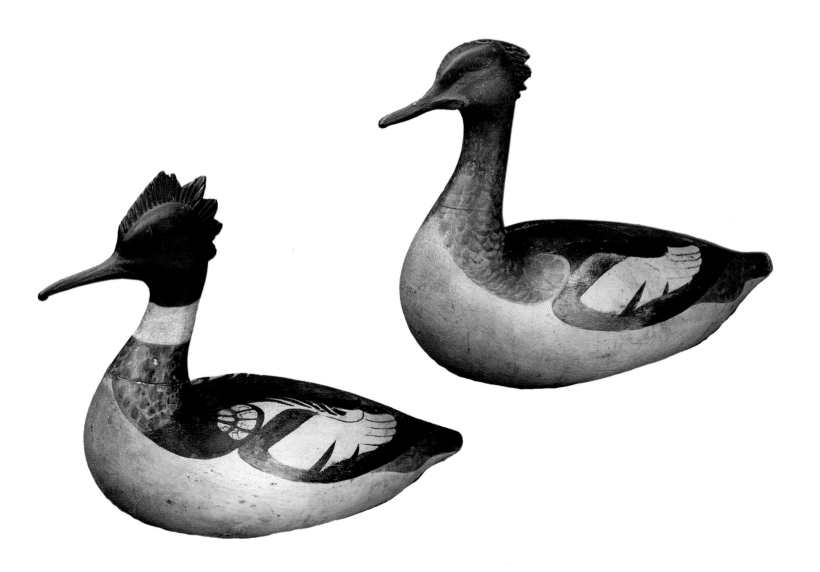

range of the bow and arrow. Early American colonists quickly recognized the value of the decoy and began to use it—by 1840, birds carved from wood (for permanence and buoyancy) were widespread. In Europe, caged birds were used to attract wildfowl: the word *decoy* is believed to derive from the Dutch for "the cage."

During the second half of the nineteenth century, improved firearms, an increased demand for food for a larger population, and a seemingly inexhaustible supply of birds gave rise to the sport and business of hunting wild ducks with floating decoys, such as the *Pair of Red-Breasted Mergansers*, made by Lothrop T. Holmes (fig. 62). Regional types of decoys developed because of local hunting conditions, and it even became financially profitable to manufacture wooden decoys in specialized factories.

Lothrop T. Holmes was a ship's carpenter from Kingston, Massachusetts, who loved sailing and woodworking and in his spare time hunted and made decoys. The pair of red-breasted merganser decoys shown here were made in the middle of the nineteenth century, apparently for some special occasion, as they show no sign of extensive use. Holmes's personal stamp and a lead weight on the bottom of the decoys, however, identify the pair as true working decoys and not mere ornamental carvings.[13]

While the basic shape and colors of a decoy are dictated by the need to portray a species with some accuracy, individual makers varied in their skill and interest in details. Much of the care they lavished on these birds, exemplified by the realistic painting on this pair, was provided to enchant the human, rather than to attract the avian species: some very plain carvings have been known to work well as decoys. Mergansers are particularly appealing to humans because of their elegant bodies, distinctive crests, and especially vivid plumage, all of which have been reproduced with extreme delicacy in this pair. The carving is smooth and sinuous, creating an elegant line from beak to tail feathers. The painting is equally proficient. The stylized wing pattern has an almost three-dimensional quality, while the small feathers (particularly visible on the necks) look as if, were one to stroke them, they would feel as soft and downy as the real thing.

★

TRADE FIGURES
★ ★ ★ ★ ★

When education was a privilege and literacy rarer than it is today, the ideal trade sign immediately caught the attention of the passerby and, because of its design, was totally self-explanatory. Three-dimensional carved trade signs were often produced in the same workrooms as the figureheads and other carvings that once graced America's sailing ships, and they usually displayed the same broad-planed style that typified American ship carvings. When steam-powered vessels began to replace sailing ships in the mid-nineteenth century, ship carvers lost an important segment of their business. To make up for this lost commerce, some ship carvers turned to creating shop figures and trade signs, especially for those businesses that served the shipping and shipbuilding industries. *Ship Chandler's Sign: A Merchant Seaman* (fig. 63), for example, is attributed to Jeremiah Dodge, the son of a shipwright and one of the best-known carvers of figureheads and other shipboard decorations in the early nineteenth century. With his red scarf and pocket handkerchief, crisp white ducks, gold buttons, and shiny black shoes, Dodge's figure of a well-turned-out merchant seaman was a

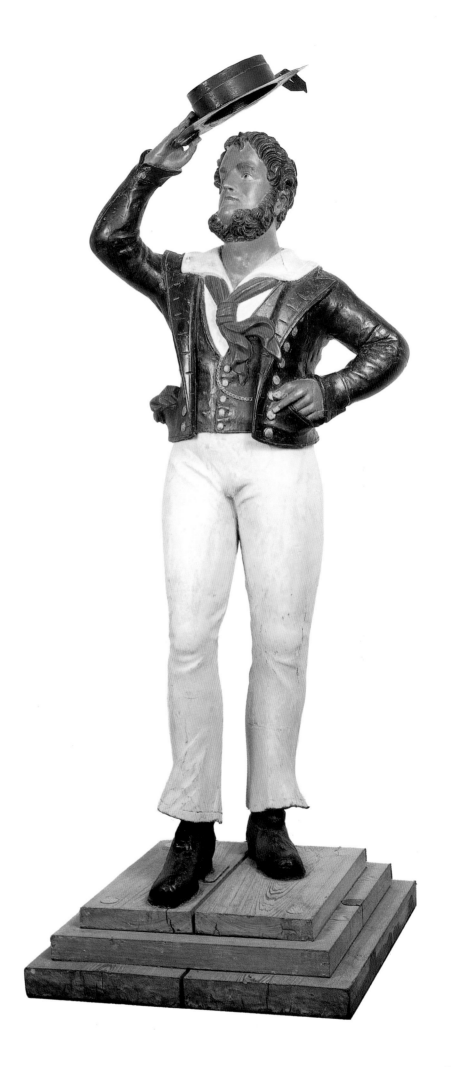

63
Ship Chandler's Sign: A Merchant Seaman
ATTRIBUTED TO JEREMIAH DODGE *(died 1860)*
New York, New York; c. 1840
Painted wood and tin; 86¹/₂ × 33¹/₂ × 20 inches,
including deck
Hirschl & Adler Folk, New York
★

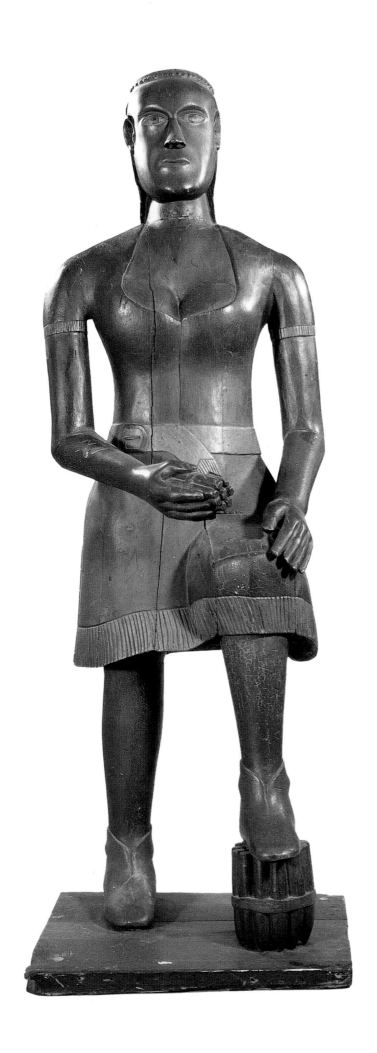

64
Afro-American Cigar-Store Indian
ATTRIBUTED TO JOB
Freehold, New Jersey; 1800–1825
Carved and painted wood; 48×16¹/₂×16 inches
New York State Historical Association, Cooperstown,
New York

★

65

Indian Scout and Indian Squaw

ARTIST UNIDENTIFIED

United States; nineteenth century
Carved, turned, painted, and stained wood with metal;
scout 62×19 inches; squaw 48 1/2 × 16 1/2 inches
National Museum of American Art, Smithsonian Institution,
Washington, D.C.
Gift of Herbert Waide Hemphill, Jr., and Museum Purchase
made possible by Ralph Cross Johnson

★

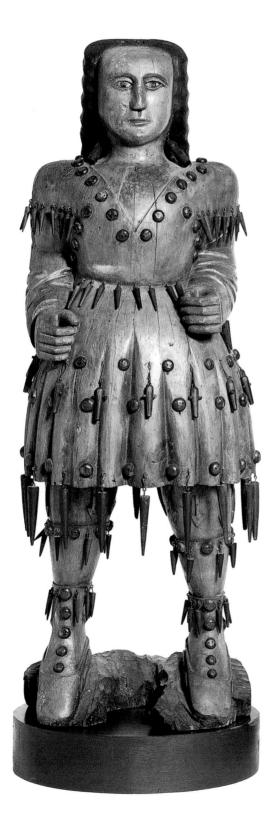
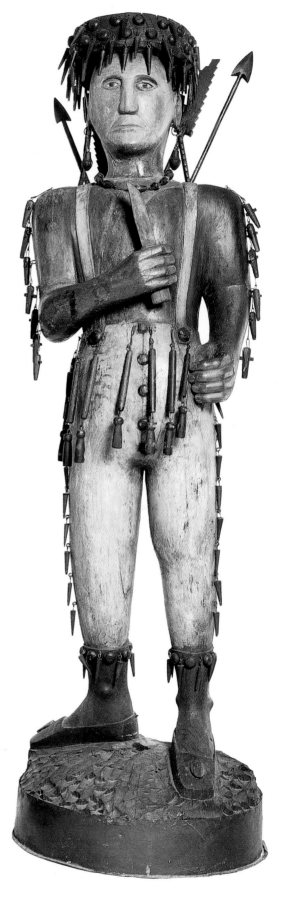

splendid advertisement for a ship chandler, or marine outfitter. It must also have caught the eye of many a lad longing for a life of adventure at sea.

The most readily identifiable of all American trade signs is the cigar-store Indian. From the middle of the nineteenth century until the early twentieth century, when electrified signs that could advertise an establishment after dark replaced them, a picturesque assortment of wooden figures stood along the sidewalks of American cities. Most often these represented Native Americans, such as the *Afro-American Cigar-Store Indian* (fig. 64), attributed to a slave named Job, and the *Indian Scout and Indian Squaw* (fig. 65), by an unidentified folk artist. However, a great variety of other figures—including soldiers, sailors, fashionable ladies, popular heroes, Turks and Egyptians, characters out of literature, and even patriotic symbols such as Uncle Sam—were also produced in urban shops to advertise cigar stores and other businesses.

The identification of Native Americans with tobacco appears to have originated in seventeenth-century England, where they were first depicted as "Virginians" with negroid features, feathered headdresses, and kilts made of tobacco leaves. This odd New World character reflected the fact that the English had confused the American Indian, who introduced tobacco to the Europeans, the Virginian, from whom it was imported, and the plantation slave, who raised it.

None of the cigar-store figures illustrated here was carved by an individual working in the urban shop tradition. *Afro-American Cigar-Store Indian* is particularly interesting because it combines the features of African-Americans and Native Americans in much the same way the seventeenth-century English prototypes did—but not for the same reason. Probably the face of Job's "Indian" maiden has an African cast of feature because it was carved by an African-American slave.

It has been said that "the talents of carver and cabinetmaker have been happily united" in this sculpture, as the head was carved as one piece, then the rest assembled from many different pieces of wood.[14] The face, especially, has a powerful, masklike intensity that recalls African sculpture. In African sculpture, too, the head is often considered more important than the body and may therefore be larger or more embellished.[15] Though the artist was probably not familiar with early European sculpture, the stiff frontal pose and monumentality of his work are reminiscent of ancient Egyptian statues and Greek *korai* of the sixth century B.C. Whatever the varying cultures one may recall in viewing this figure, it is clear that the artist created a sculpture of exceptional power and strength that far surpasses the conventional carvings of trade figures produced in the workshops.

In contrast to the stiff, monumental *Afro-American Cigar-Store Indian*, *The Newsboy* (fig. 66) has been forever frozen in motion. He is shown selling an 1879 edition of the *Pawtucket Record*, the newspaper he once hawked in front of the offices of the *Record*. Every part of this boy's body—arms, legs, feet—is moving; even his jacket is flying away from his body, and his mouth is open as if at the moment of yelling "Extra!" There are no sharp angles here to impede the figure's progress through the air; all is smooth and rounded. Even though they are bent, the elbows and one knee are curved, furthering the impression that the boy is gliding through space. His body twists, with arms, legs, and torso all turned so that they fill the planes around the figure, and that dramatic torsion adds to the excitement of the carving.

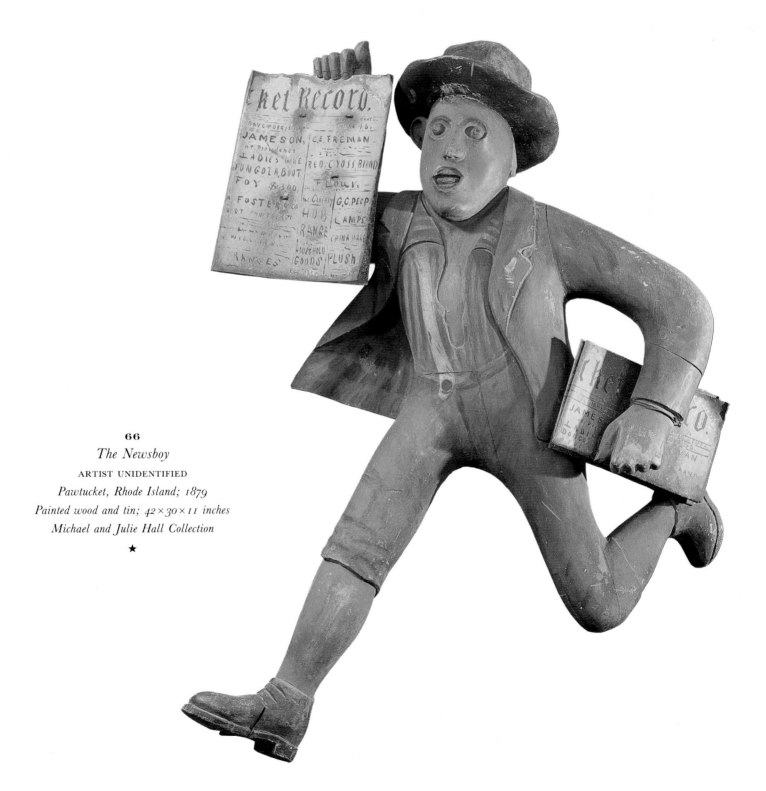

66
The Newsboy
ARTIST UNIDENTIFIED
Pawtucket, Rhode Island; 1879
Painted wood and tin; 42 × 30 × 11 inches
Michael and Julie Hall Collection

★

67
Knife Grinder
ARTIST UNIDENTIFIED
Northeastern United States; c. 1875
Painted tin; 13×15¹/₂×3 inches
Private collection
★

Trade figures were not only used outside a building but also often placed in shop windows or on countertops. The small figure of the *Knife Grinder* (fig. 67), articulated so that the wheels turn when his right leg pushes down, may have been such a window or counter display. The arresting *Man with Grapes* (fig. 68) is believed to have stood on top of a bar in Wells, Maine, where he advertised that the "fruit of the vine" was available. His face is hauntingly dramatic above the gracefully sculpted body. A similar tradition and style of carving are represented by the staunchly patriotic figure of *Miss Liberty* (fig. 69), a decorative sculpture that, according to tradition, was originally installed in a boathouse in New Hampshire. It remains to be determined exactly what was the function of the impressive *Father Time* (fig. 70), but as the carving was once articulated so that the right arm moved and the sickle hit the suspended bell, it may have been installed to notify a shopkeeper that a customer had opened the door—while warning the rest of the world that time is fleeting.

The dapper *Man in a Top Hat with a Cane* (fig. 71) was probably a window or countertop display, possibly for a haberdashery. Though just under two feet high, this figure has a monumental presence. His modish attire, self-important pose with thrust-out torso, and statue-like position atop a painted base all contribute to the impression that this is a man of consequence.

A similar costume and pose characterize a truly monumental trade figure, *Tin Man* (fig. 72), made by David Goldsmith.[16] Goldsmith, an Austrian immigrant and tinsmith by trade, founded the West End Sheet Metal and Roofing Works of Long Island City, New York, in 1929. During the Depression, when business was slow, Goldsmith decided to create a tin replica of Uncle Sam dressed in top hat and tails to place in his window. He felt that making such an object would serve the double purpose of passing the time and, he hoped, attracting customers to his shop. *Tin Man* was constructed from sheets of galvanized iron, and the artist used his own clothing as the model for the sculpture's attire. Goldsmith started with the shoes and proceeded upward, hand-working each part so that the details would be accurate. The hat and cane, however, were never finished. For balance and weight, concrete was poured into each leg so that the figure could stand on its own. *Tin Man* did stand in the window of the West End Sheet Metal and Roofing Works until 1964, when Goldsmith retired and the shop, including the window display, was sold.

In his formal evening wear, the *Tin Man* does not resemble Uncle Sam so much as he does a patron of a New York nightclub in the 1920s or 1930s. His boxy, square-jawed style—a combination of sharp edges and rounded forms—is also typical of the Art Deco period in the decorative arts. Much of the look of this figure, for which the uniformly tubular shapes of arms, legs, head, and hat are responsible, is attributable to the rigid nature of the material. The expressionless face, similar to a snowman's or scarecrow's, adds to the figure's eerie unnaturalness. However, the details of the clothing—the perfectly tailored suit, the buttons on the shirt, the laces in the shoes—provide those unexpected elements that delight the viewer and make *Tin Man* a most approachable sculpture. Stiff as he may first appear, one is left with the impression that, with a little bit of oil and encouragement, he could step off his pedestal and start dancing.

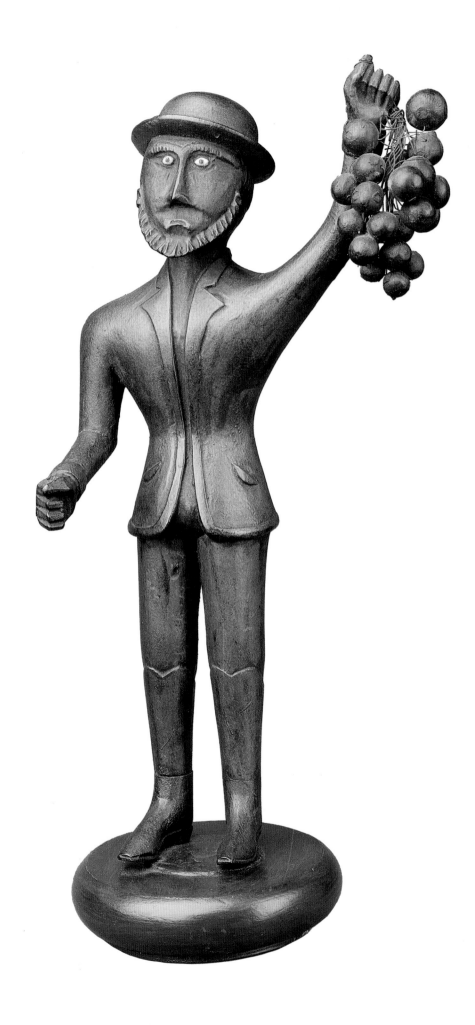

68
Man with Grapes
ARTIST UNIDENTIFIED
Wells, Maine; c. 1850
Painted pine; 16⁵/₈ × 7¹/₂ × 4⁵/₈ inches
Guennol Collection
★

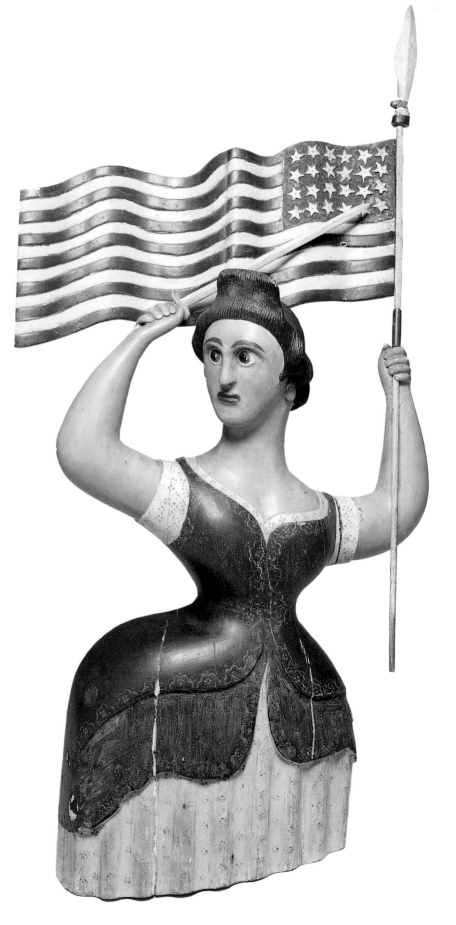

69
Miss Liberty
ARTIST UNIDENTIFIED
Tuftonborough, New Hampshire; c. 1875
Painted wood; 29 × 14 × 5 inches
Courtesy of Sotheby's, Inc., New York

★

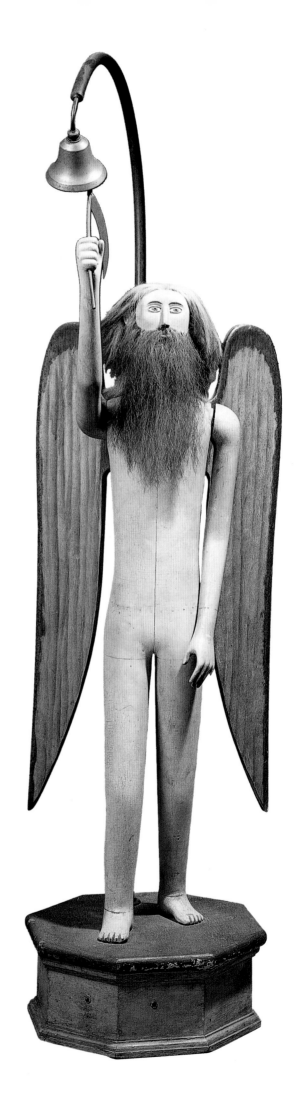

70

Father Time

ARTIST UNIDENTIFIED

Mohawk Valley, New York; c. 1910
Carved and painted wood, metal, and
hair; 52 1/8 × 13 7/8 × 14 1/2 inches
Museum of American Folk Art, New York
Gift of Mrs. John H. Heminway

★

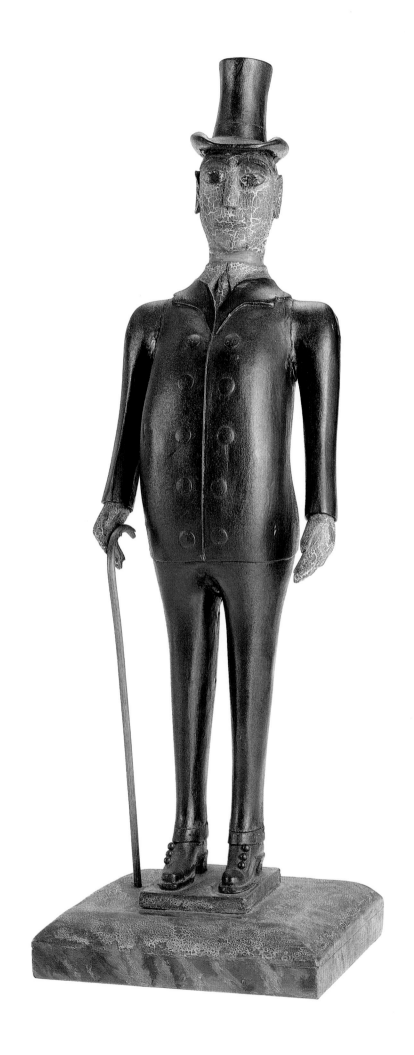

71

Man in a Top Hat with a Cane

ARTIST UNIDENTIFIED

Northeastern United States; c. 1890
Carved and painted wood, painted and
smoke-decorated base;
23¹/₂ × 7¹/₂ × 7¹/₂ inches
Museum of American Folk Art, New York
Joseph Martinson Memorial Fund,
Frances and Paul Martinson

★

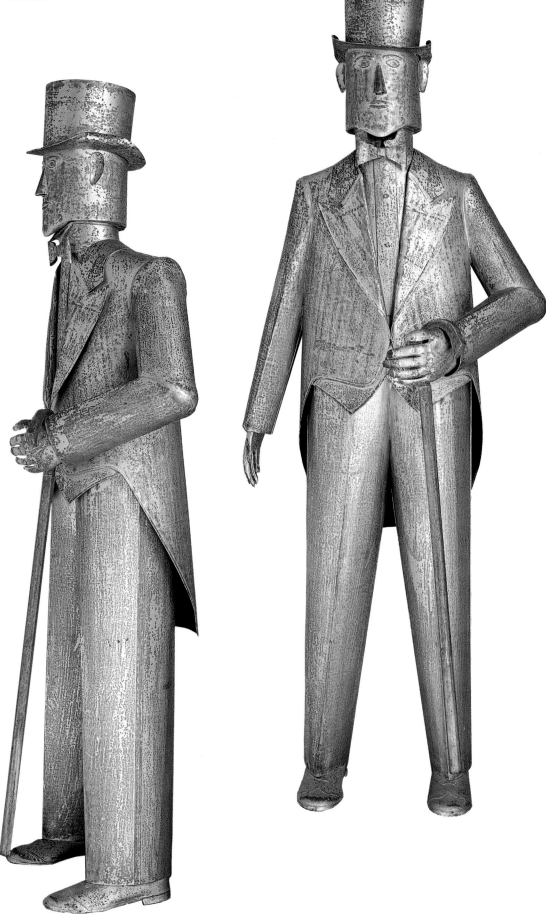

72
Tin Man
DAVID GOLDSMITH *(1901–1980)*
Long Island City, New York; c. 1930
Galvanized iron; 72 × 25 × 11 1/2 inches
Private collection
★

CAROUSEL CARVINGS

★　★　★　★　★

During the second half of the nineteenth century and the early twentieth century, wood-carvers, many of them German and Russian immigrants employed in shops located primarily in New York and Philadelphia, created carousel horses, circus wagons, and other ornamented utilitarian carvings. Like the shop-made cigar-store figures, these carvings were produced by hand, but assembly-line production techniques were used and more than one artisan was employed in the manufacture of a piece.

Generally, a master carver drew the pattern for an animal and then carpenters assembled the basic block of the body. Each carver would bring his own style to the detailing required to create an exciting figure. Hand-carved wooden figures such as *Carousel Horse* (fig. 73), and a menagerie of other animals, continued to be made in great numbers until the Depression forced most of the major companies to shut down or sharply curtail their production. Unfortunately, the figures were expensive to produce and maintain, and eventually metal, plastic, and fiberglass animals fashioned in molds replaced the glorious hand-carved wooden beasts.

Solomon Stein and Harry Goldstein, both Russian immigrants, specialized in carving large, exciting horses like the one shown here, in their workshop at Coney Island in Brooklyn, New York. The partners, who met while they were working for another Coney Island firm, the William F. Mangels Company Carousel Works, carved the heads themselves, often leaving the rest of the anatomy to other carvers and the painting to professional decorators.[17] Stein and Goldstein horses are characterized by elongated bodies, oversized saddles, and short legs drawn close to the body. Prominent buckles, flowing tassels, and garlands of large, boldly carved cabbage roses were also typical of their work.[18] The large-scale steeds carved by the partners had a distinctive mien. These were not sweet-tempered ponies but aggressive beasts with bared teeth, glaring high-set eyes, and an impression of brute strength that promised an exciting ride.

Carousel Horse is an especially successful example of the breed produced by Stein and Goldstein's company, the Artistic Caroussel Manufacturers. The assertive posture is enhanced by the saddle, itself a snarling animal skin. Muscles bulge and the nervous energy of a lively mount seems barely contained. The colorful paint, which was usually touched up every season, adds another dimension of excitement. Bright gold enlivens the mane, tail, and hooves, as well as the trappings. A whirling carousel composed of five or six rows of these remarkable animals, plus chariots and other decorative carvings, would have been an impressive sight indeed.

★

VISIONARY AND ENVIRONMENTAL WORKS

★　★　★　★　★

Although he had never had any experience or instruction in stone carving, William Edmondson began his career as a sculptor during the 1930s as a result of a vision from God: "I was out in the driveway with some old pieces of stone when I heard a voice telling me to pick up my tools and start to work on a tombstone. I looked up in the sky and right there in the noon daylight He hung a tombstone out for me to make." Edmondson's first works, carved with his handyman's tools, some of them homemade, were memorials, many embellished with sheep and

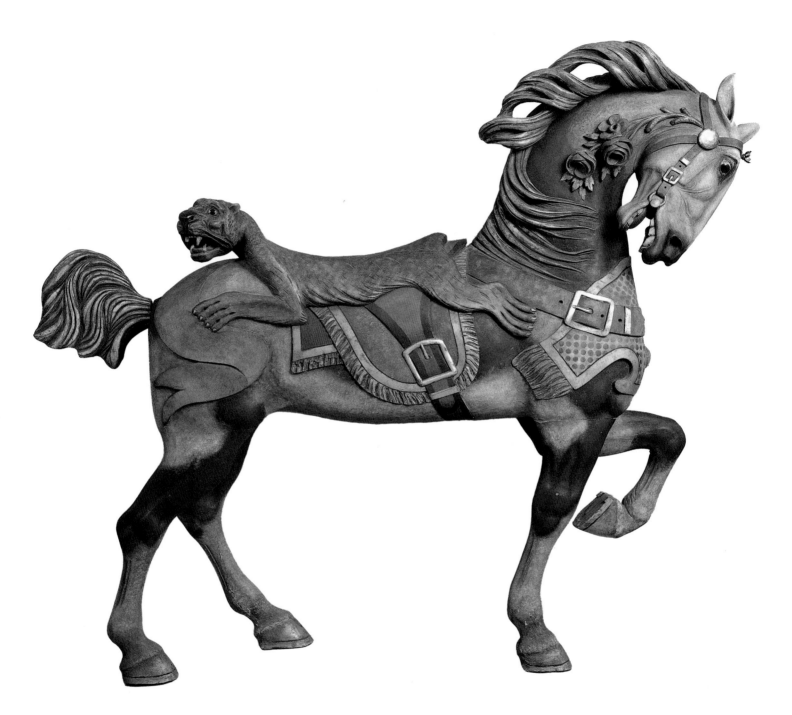

73

Carousel Horse

STEIN AND GOLDSTEIN; ARTISTIC CAROUSSEL MANUFACTURERS

Brooklyn, New York; 1912–16

Carved and painted wood; 58¹/₂ × 71 × 13 inches

National Museum of American History,

Smithsonian Institution, Washington, D.C.

The Eleanor and Mabel Van Alstyne Folk Art Collection

★

doves, commissioned by fellow African-Americans in the congregation of his church. Within a short period of time, Edmondson also began to carve animals, angels, crucifixions, and human figures—such as *Little Lady* (fig. 74). A series of visions and an ongoing dialogue with his "heavenly daddy," as Edmondson called his God, inspired this change of subject matter: "God was telling me to cut figures. First He told me to make tombstones; then He told me to cut the figures."[19]

Edmondson worked solely in limestone, as his God commanded him. Moreover, limestone was the only stone readily available to him, for it was easily acquired from demolished city buildings and rebuilt streets around his home in Nashville, Tennessee. The size and shape of the stones he obtained, at little or no cost, dictated the rectangular block form of most of his carvings—many had previously been used as sills, lintels, steps, building foundations, or street curbs.[20]

Little Lady, like all of Edmondson's work, was carved not from nature but from a vision the artist saw in the sky. To bring his visions to life, Edmondson carved "stingily," supplying only as much detail as was absolutely necessary to make the subject recognizable.[21] His work, therefore, is highly stylized, with the same formulas used repeatedly. *Little Lady*, for example, with her chinless face emerging as a flat plane from a mass of textured hair, has many similarities to his other small, standing figures of women. Her feet, indicated by two circles near the base of the statue, the absence of a neck or shoulders, and the protruding breasts leading to a mere indication of a waistline are typical of Edmondson's ponderous carvings of women.

As can be seen in *Little Lady*, however, these sculptures have a presence and a power that belie their small size. In part this impression derives from the blocklike form and the resemblance to iconic tombstones. The artist's minimalist, or "stingy," approach to his carving—*Little Lady* is essentially composed of simple, geometric forms—also creates an impregnable, dignified image. Edmondson thought of himself as a "disciple" and his occupation as the "Lord's work." His carving was an act of devotion, and he never doubted either his ability or his results: "It's wonderful when God gives you something—you've got it for good, and yet you ain't got it. You got to do it and work for it. God keeps me so busy He won't let me stop to eat sometimes. It ain't got much style. God don't want much style. But He gives you wisdom and speeds you along."[22] Edmondson's sublime confidence in his God and his profound joy in doing His work come through in the strength of his carvings.

Another type of "visionary" art is the *Patent Model for Flying Device* (fig. 75) by Reuben Spalding. While unsuccessful in his careers as a prospector for gold and inventor of a functional flying machine, Spalding, nevertheless, unknowingly succeeded in creating a unique and exciting work of folk sculpture.

Sometimes an artist's vision is not limited to single works of art but encompasses a series of objects that form an entire environment. Clark Coe, for example, created *Man on a Hog* (fig. 76) as part of a waterwheel-operated environment that included approximately forty almost life-size, articulated figures now called the *Killingworth Images*. Using tree limbs, old basket slats, handles, staves, and other found materials, Coe constructed the figures to amuse his crippled nephew who had come to live with Coe in Killingworth, Connecticut, when the boy was orphaned.

74

Little Lady

WILLIAM EDMONDSON *(c. 1882–1951)*

Nashville, Tennessee; 1932–47

Limestone; 12 1/2 × 3 1/4 × 7 inches

Leon M. Marlowe Collection

★

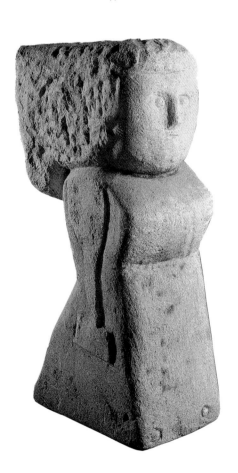

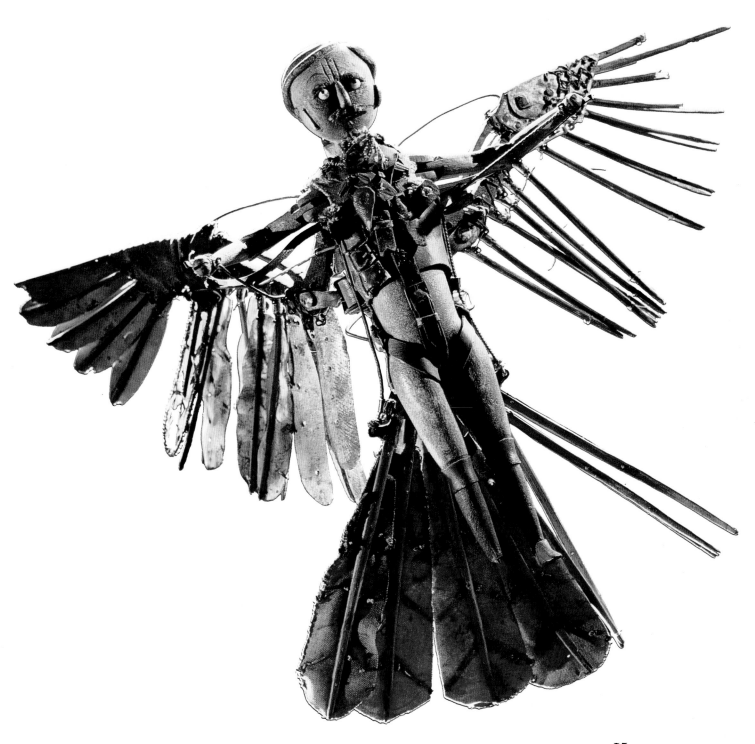

75
Patent Model for Flying Device
REUBEN SPALDING
Rosita, Colorado; 1889
Wood, metal, leather, and feathers; 14 inches high
Photograph by Bill Ray
Location unknown

★

Killingworth Image: Man on a Hog
CLARK COE (*1847–1919*)
Killingworth, Connecticut; c. 1890
Carved, assembled, and painted wood, metal,
and textile remnants; 37 × 38 × 21 3/8 inches
National Museum of American Art,
Smithsonian Institution, Washington, D.C.
Gift of Herbert Waide Hemphill, Jr., and Museum Purchase
made possible by Ralph Cross Johnson

★

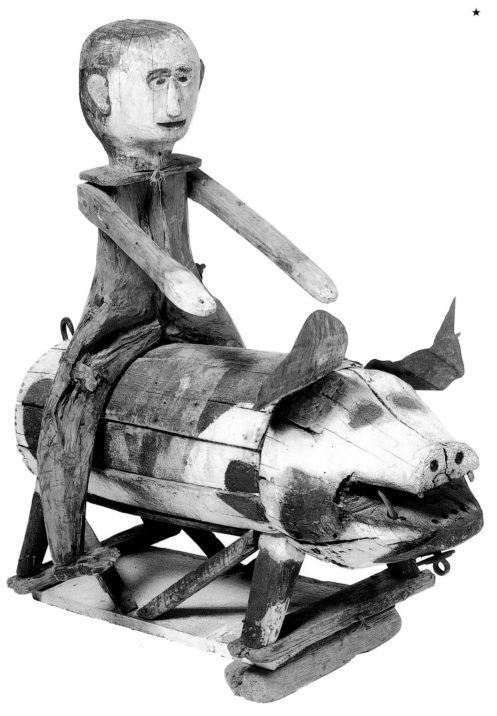

Simon "Sam" Rodia's vision was even larger. For thirty-three years Rodia built his Watts Towers (fig. 77), fantastic structures of steel and concrete (including one almost one hundred feet tall), in the yard adjacent to his house. An Italian immigrant who was born in the vicinity of Naples, Rodia settled in Watts, then a rural community between Los Angeles and Long Beach, California, in the early 1920s. He was employed as a construction laborer, but devoted an average of eight hours every day for thirty-three years to building his towers. In 1954, Rodia sold his property, complete with his masterpiece, to a neighbor for the price of a bus ticket and moved to Martinez, California, where he had some family. He died in 1965 without ever having returned to see his towers.[23]

The towers are made of bar metal, bent by hand, then overlapped or butted together, wrapped by hand with wire, and enclosed in cement. Tiles, seashells, pieces of glass and pottery, bottles, and other objects that Rodia found or that were given to him by neighbors were embedded in the concrete as decoration. An incredible feat of engineering, the towers are held together without a single bolt, weld, or rivet.[24]

For many years, Rodia was considered an idiosyncratic artist, a man who was building a fantasy world unrelated to the art forms of any known tradition. Recently, however, it has been shown that the towers bear great similarity to the processional towers, or *gigli*, that are part of an annual religious celebration in Nola, an Italian village near Naples; moreover, the boat-shaped form, or "ship of Columbo," as the artist called it, that Rodia built into the center of his environment bears a striking resemblance to the medieval-style galleon that plays an important part in the Italian festival, which reenacts the miracle of Paulinus, the patron saint of Nola, returning to his people on a boat. The *giglio*, a structure that represents the "mountains of lilies" with which the joyous villagers greeted Paulinus, stands about six stories high and weighs over three tons. Both the *giglio* and the large boat, carried by more than one hundred men, are annually danced through the streets in Nola and, today, in Brooklyn, New York, as part of the celebration of the Feast of Saint Paulinus. Rodia was probably working within an established folk tradition of both form and construction that he most likely remembered from his boyhood in Italy. However, his motives for building the towers—whether they were religious or biographical—remain to be determined.[25]

Simon Rodia's Towers in Watts is an amazing accomplishment on many levels. It is a monument to human perseverance: a single man working with no help, no plans, and almost no money achieved his vision by spending every available moment for thirty-three years on completing it. It is also a work of art that is equally exciting viewed from a distance, as a complete environment, or experienced close up so that the details of its embellishment are visible.

From afar, the openwork construction permits the viewer to see the shapes of the towers and ancillary constructions against the blue sky of southern California. Up close, one can admire the colors and combinations of the various applied decorations with which Rodia gilded his superb "mountain of lilies."

Simon Rodia's Towers in Watts

DETAIL

★

77

Simon Rodia's Towers in Watts

SIMON "SAM" RODIA *(1879–1965)*

Los Angeles; 1921–54

Mixed media; tallest tower 99 feet 6 inches high

Photograph courtesy © Seymour Rosen, SPACES

★

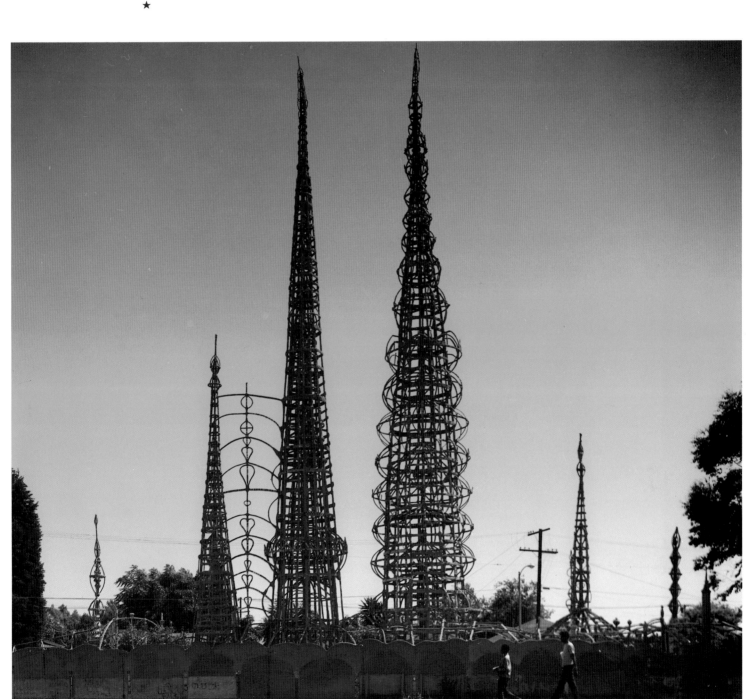

FURNISHINGS

While the five-star furnishings chosen to illustrate this book are all representative of forms that served practical purposes—furniture, pottery, other household accessories, and floor- and bedcoverings—it is unlikely that many of these items were put to hard, daily use. These are the objects that furnished the best room in the house, the pieces that were saved for company or were given as treasured gifts and were therefore highly valued and preserved by the original owners and, in many cases, their descendants. These are the necessities of daily life that were created with such care and such attention to decorative detail that their function goes beyond practical, everyday use. Their purpose was—and remains—the enhancement of the home. Many of these objects, which were often considered status symbols, were made by professional craftsmen who were working full-time in either well-established or newly created traditions, to satisfy the basic human need for objects of luxury and beauty. Others—particularly the textiles—were produced by people (primarily women) who made the time in their busy and often highly regimented lives to create things that would adorn their homes or those of their friends and relatives.

★

DECORATED FURNITURE

★ ★ ★ ★ ★

The examples of furniture considered to be in the folk tradition that are included in this section are remarkable less for their forms or techniques of construction than for their painted—and, in the case of the cabinet shown here (fig. 85), applied—decoration. Until the end of the nineteenth century, American furniture designs were derived from European models, primarily English prototypes. Styles first in vogue at a continental or English court would filter down to the lesser nobles and finally to the lower classes.

Immigrants then brought these styles with them to the New World. The designs first enjoyed popularity in Colonial cities, where they were incorporated into the patterns of the leading cabinetmakers. Finally the basic styles were adopted by rural craftsmen, who also adapted the designs to the needs of their clientele and the materials they had available. In these rural areas, basic furniture forms usually remained popular for a longer period of time than in the cities because of the essentially conservative nature of country people.

A tradition of painted furniture can be established in England as early as the medieval period.[1] This tradition crossed the Atlantic with the earliest colonists, and seventeenth-century New England homes of the well-to-do often contained "sumptuously decorated" pieces of painted furniture, particularly chests.[2] At first the decoration combined painting with carving and applied split-spindles. By the turn of the eighteenth century, painted decoration, often in imitation of earlier carving, began to predominate. The "SW" Chest with Drawers (fig. 78), for example, is one of a number of case pieces made in or near Hadley, Massachusetts, notable for a style of painting that shows a clear transition from earlier carved decoration.[3]

On the "SW" Chest, vines and other motifs have been painted in a rigid, contained manner. In contrast, the Harvard Chest (fig. 79), also one of a group of similarly decorated pieces, shows a more relaxed, naturalistic style of painting. Both the primarily red-on-black color scheme

78

"SW" Chest with Drawers

ARTIST UNIDENTIFIED

Vicinity of Hadley, Massachusetts; 1710–25

Painted red oak with yellow pine;

43 1/2 × 44 3/4 × 19 1/2 inches

Pocumtuck Valley Memorial Association

Memorial Hall Museum, Deerfield, Massachusetts

★

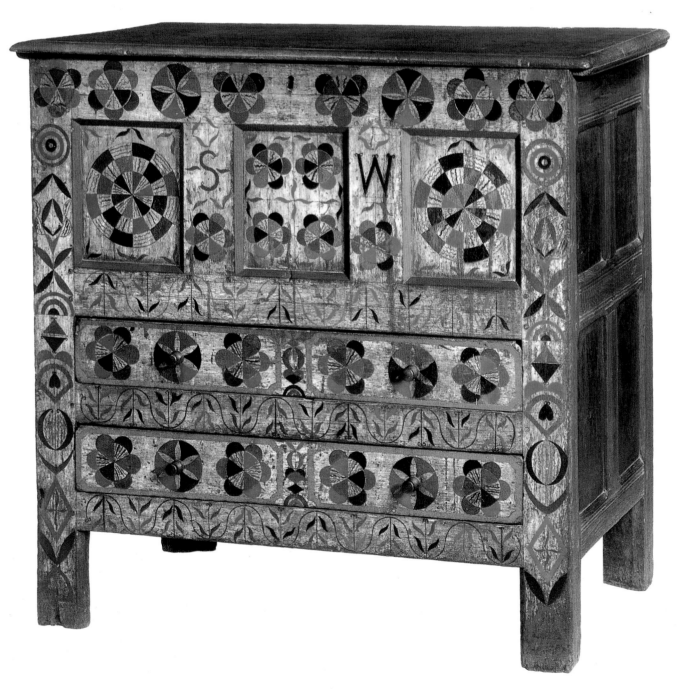

79

Harvard Chest

ARTIST UNIDENTIFIED

Eastern Massachusetts; 1710–50

Painted pine; 44 × 38 1/2 × 20 1/2 inches

Shelburne Museum, Shelburne, Vermont

★

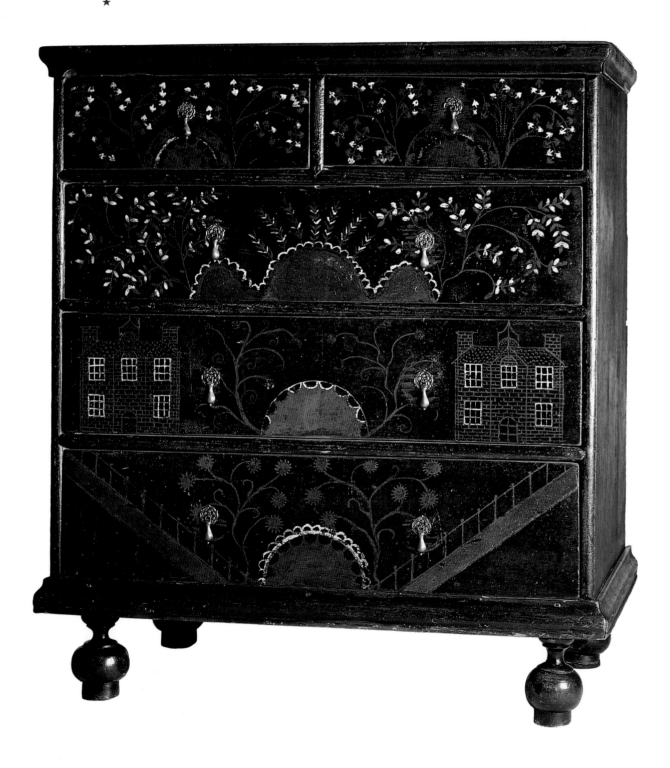

and the style of decoration resemble the "Japan work" that was popularized by John Stalker and George Parker in their *Treatise of Japanning and Varnishing*, published in Oxford in 1685. Inspired by lacquered furniture made in the Orient, japanned work, which usually featured such exotic motifs as whimsical flowers, animals, birds, and people, was introduced to America at the beginning of the eighteenth century.[4]

The painter of the *Harvard Chest*, which is believed to have been made in a rural area of eastern Massachusetts in the early eighteenth century,[5] was clearly influenced by the new style of decoration that was becoming so popular in nearby Boston. The painting on this chest is balanced without being rigidly symmetrical. The decoration is confined to the drawers. Each drawer, including the two small ones at the top, has a semicircle in the center, all but one possibly representing the rising sun, and on each of the four levels the motif is surrounded by a different pattern. These designs of vines and trees—executed in a different style on each level—flow to edges of the drawers. While the Georgian-style brick buildings painted on one of the drawers are not the pagodas commonly found on urban examples of japanned furniture, they are topped by pagoda-like cupolas that may be the folk painter's way of Orientalizing the structures. On the bottom drawer diagonal stairs, leading down to the setting sun, are also reminiscent of the bridges often seen in Oriental art.

Throughout the eighteenth and much of the nineteenth century, nearly all country furniture made in America was painted, either to hide the fact that it was made from inexpensive types of wood, such as pine, or to disguise the fact that a number of different woods were used in the construction. Frequently, furniture decorators would paint *faux* (false) finishes on a piece in imitation of the more expensive varieties of wood, often creating a beautiful grain on lumber that had an unremarkable one to begin with, as has been done in an especially bold manner on the blanket chest attributed to Thomas Matteson (fig. 80).

The elegant little *Federal Sideboard Table* (fig. 81) has been painted to give the illusion that a number of different types of wood have been used as inlays, as they would have been in a formal piece of Federal-style furniture. Trompe l'oeil painting on the front of this table faithfully imitates the medallion insets often found on furniture made at the beginning of the nineteenth century. On the splashboard and on the top of the table, however, the painter was wildly exuberant, using a variety of bright colors and lively styles of decoration that are not found either in nature or other styles of furniture.

Furniture might also be painted by using a number of techniques employing sponges, putty, leaves, combs, feathers, corncobs, or the artist's fingers to apply the paint in a variety of imaginative ways. The *Tall-Case Clock* (fig. 82), for example, was painted with a sponge or other such implement that provided the decorative "paw prints" that cover the piece.

In some areas, especially in communities with strong ethnic ties to the Old World and its traditions or those with special religious affiliations, the same motifs that are found on fraktur, tombstones, samplers, printed documents, and other forms of painting and needlework are also found on painted and decorated furniture. One such community is the Schwaben Creek Valley, an isolated area of east central Pennsylvania settled late in the eighteenth century by second-generation Ger-

80

Blanket Chest

ATTRIBUTED TO THOMAS MATTESON

Vicinity of South Shaftsbury, Vermont; c. 1825

Painted wood; 40 × 81 × 18 inches

Howard and Jean Lipman Collection

★

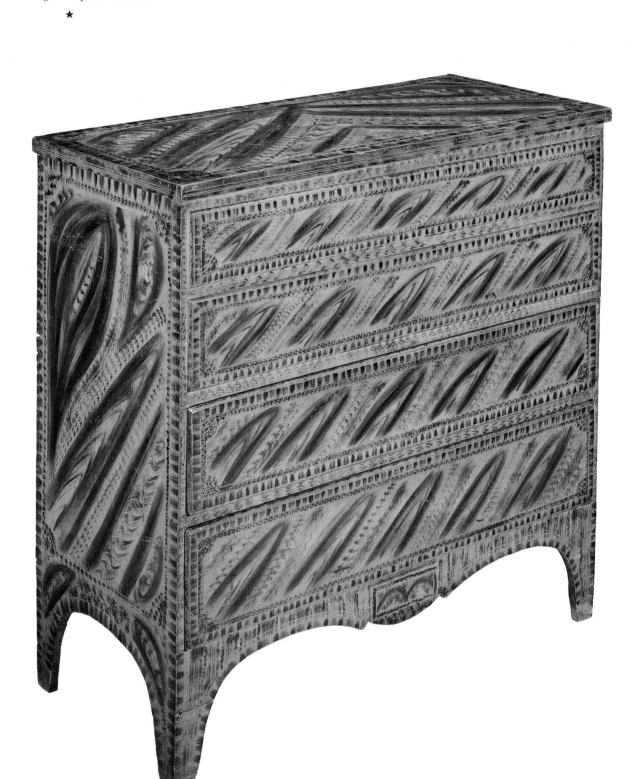

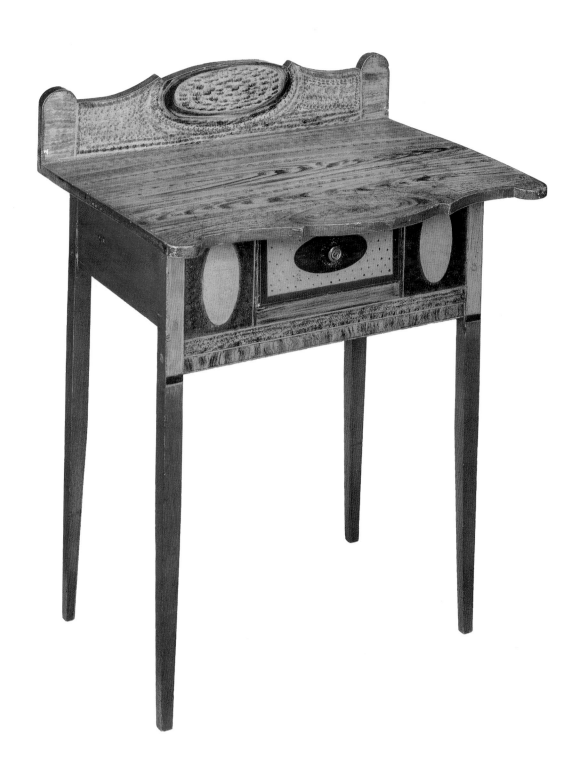

81

Federal Sideboard Table

ARTIST UNIDENTIFIED

New England; 1820–35

Grain-painted and decorated wood, brass knobs;

34 7/8 × 26 × 20 inches

Museum of American Folk Art, New York

Eva and Morris Feld Folk Art Acquisition Fund

★

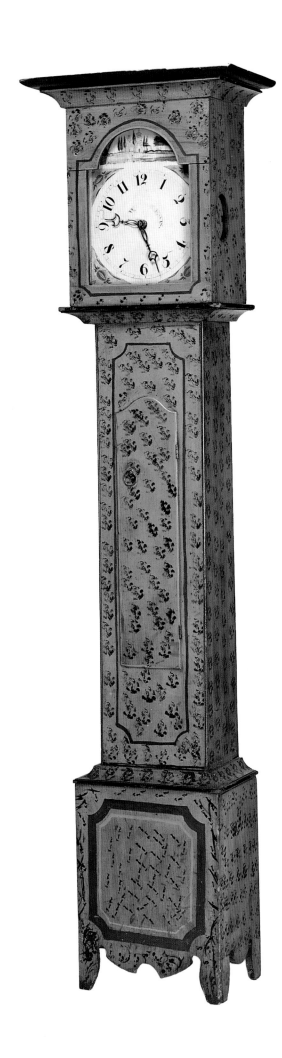

82

Tall-Case Clock

CABINETMAKER UNIDENTIFIED; DIAL SIGNED "L. W. LEWIS"

Probably Connecticut; 1810–35

Painted and decorated pine case, iron works;

87 × 21 1/2 × 12 3/4 inches

Museum of American Folk Art, New York

Eva and Morris Feld Folk Art Acquisition Fund

★

man Americans from southeastern Pennsylvania communities as well as new immigrants from Germany. From about 1798 to about 1840, artists in this closely knit community decorated case pieces with motifs (including birds, flowerets, hearts, and stars) that also appear on many other Pennsylvania-German objects.[6] The figures of Adam and Eve on the Schwaben Creek Valley *Blanket Chest* (fig. 83), for example, were derived from a printed broadside.[7]

The "*Jacob Maser*" *Slant-Top Desk* (fig. 84) has become the best-known piece of furniture made in the valley.[8] Like many other examples of Schwaben Creek Valley furniture, it was inscribed with a name and a date. It has not been determined, however, whether Jacob Maser was the maker or the painter of this desk—or, since 1834 was the year of his marriage to Catherine Christ, if he received it as a gift.[9]

Using a distinctive color palette—red, yellow, and green—and stylized motifs that are typical of the area, the painter of this desk achieved an effect of extraordinary variety and excitement. Many of the motifs on the desk have their origin in contemporary and earlier European and American furniture decoration. Alternating red and yellow rosettes, perhaps related to the stenciling found on Empire-style furniture, parade up the stiles and around the sides. Red and yellow also alternate on the stylized pieces of fruit, the birds, the heart on the center drawer, and the quarter-fans on the drawers, sides, and lid. These fan motifs suggest the neoclassical designs usually found in the marquetry on veneered Adam-style furniture. The drawers and the slanted desk top have been bordered in black, a Classical treatment that was revived during the Renaissance and then continued for inlaid decoration on English furniture of the eighteenth century. This outlining provides a framework for the decoration contained within, and, indeed, each drawer front and the desk top are treated as separate surfaces, with the decorative devices scaled and placed accordingly. The geometric devices seen on the front and sides of the piece may be the forerunners of the painted hex signs that begin to appear in Pennsylvania in the second half of the nineteenth century.[10] An unusual motif that provides particular delight is the pair of red horses that prance across the desk top.

In some areas, the merging of two cultures yielded new, vigorous furniture forms that drew on the strength of both heritages. Northern New Mexico in the late nineteenth century was one such area, where in the aftermath of the Mexican War, the army of occupation and Anglo-American civilians contributed to a change in the Hispanic tradition of cabinetmaking. The tools the newcomers brought—frame saw, molding plane, lathe—and the forms and styles of furniture they carried with them and required to be made for their new homes led to experimentation with different combinations of shape and decoration among the local cabinetmakers. The result was the development of an exciting new vernacular style.[11]

The lively red and green cabinet (fig. 85) illustrates one of the most important innovations of the new style, the frequent use of applied decoration. This technique, which was seldom used by traditional Hispanic cabinetmakers, is seen here in the hearts and diamond-shaped pieces of wood that have been attached to the front of the cupboard. As they were not common in local crafts, these decorative motifs and also the painted stars (possibly derived from the American flag or other military regalia) were probably added to this piece to

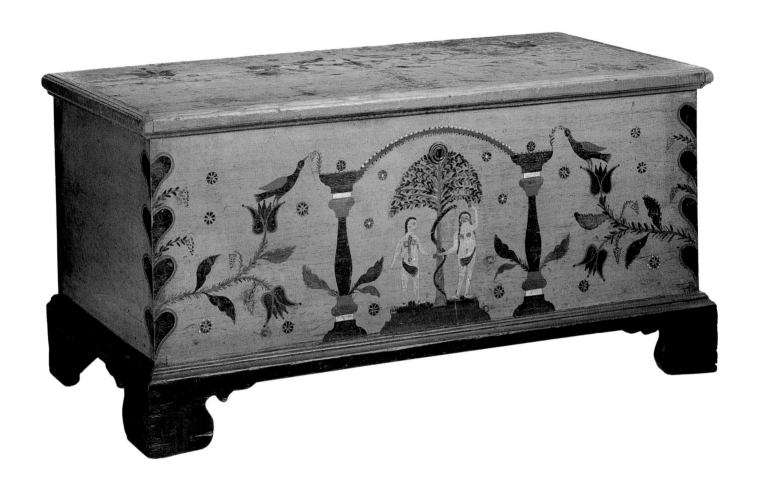

83

Blanket Chest

ARTIST UNIDENTIFIED

Schwaben Creek Valley, Northumberland County,
Pennsylvania; 1830
Painted white pine; 24³/₄ × 50 × 21 ¹/₂ inches
Courtesy, The Henry Francis du Pont Winterthur Museum,
Winterthur, Delaware

★

84

"Jacob Maser" Slant-Top Desk

ARTIST UNIDENTIFIED

Schwaben Creek Valley, Northumberland County,
Pennsylvania; 1834
Painted tulipwood; 49 1/8 × 39 × 9 3/4 inches
Courtesy, The Henry Francis du Pont Winterthur Museum,
Winterthur, Delaware

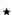

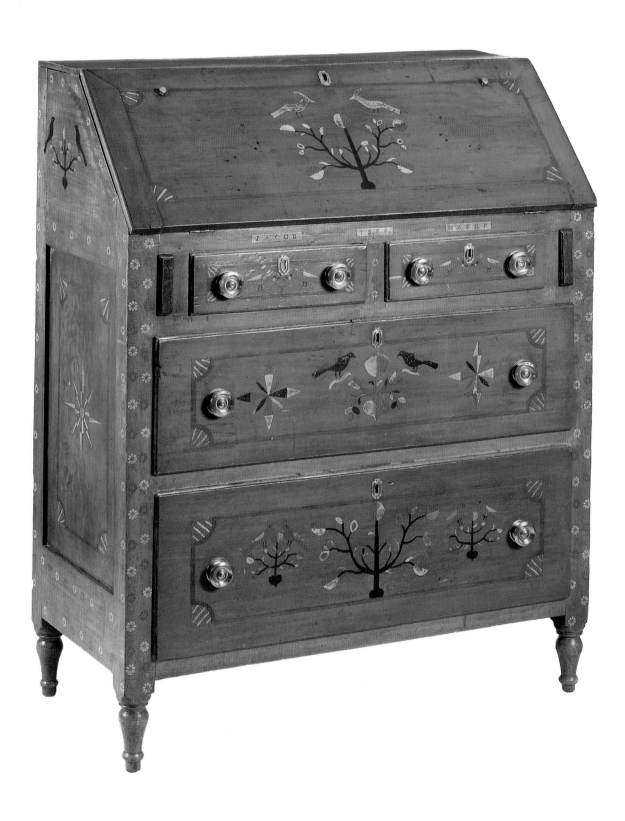

85
Cabinet
ARTIST UNIDENTIFIED
Peñasco, New Mexico; early twentieth century
Painted pine; 61 × 32 1/4 × 17 inches
Ray and Judy Dewey Collection
★

increase its appeal to Anglo customers from the north. These painted and applied motifs, the attached "wings" on either side of the cabinet (which do resemble the decorative carving on traditional Hispanic furniture), and the pediment on top of the piece combine to invigorate an otherwise unimportant furniture form. These attached pieces make the cupboard appear lighter and less boxy. The bright colors differentiate it from its likely progenitor—the New England step-back cupboard—and mark it as the product of a new tradition.

★

HOUSEHOLD ACCESSORIES

★　★　★　★　★

Until the Industrial Revolution, the potter was an important person in every community, producing the sturdy, plain ware meant for everyday use as well as fancier decorated objects that were made as presentation pieces or for use on special occasions. Redware objects, such as the *Schimmelreiter Plate* (fig. 86), were often commissioned as gifts among the Pennsylvania Germans. The sgraffito decoration on this plate is an ancient technique in which a liquid clay slip of one color is superimposed on a barely wet clay body of another color, and the design is produced by scratching through the slip. In Pennsylvania, sgraffito-decorated pottery characteristically employs a cream-colored slip that reveals the native red clay when incised with a sharp tool.

The Schimmelreiter—a ghostly rider on a white horse—is a motif derived from ancient European folklore that was obviously still popular in Pennsylvania at the turn of the nineteenth century. Tradition maintains that this figure is one of the Four Horsemen of the Apocalypse, based on Saint John's *Revelation* (19:11–16)—the rider on the white horse who "was called Faithful and True," who bore a sharp sword and ruled with a rod of iron, and who was the king of kings and lord of lords. Early in European folklore this motif of a ghostly rider on a ghostly horse is encountered leading "armies which were in heaven" following on white horses.[12] In the eighteenth and nineteenth centuries, European rulers and military leaders were often depicted as soldiers on horseback, and engravings of their portraits would have been available as models for potters.[13] In America, the rider on the white horse was often adopted as a fitting image for George Washington.

Sgraffito decoration is often characterized by the simple lines and clarity of expression this plate exhibits. With a minimum number of strokes, the potter created a dashing, elegant figure that would have been instantly recognized as a traditional motif in his community. Corresponding to the round shape of the plate, there are only curved lines in the decoration—nothing is straight. The tree bends, the ground meanders, and the horse and rider have been rendered in a series of complementary curves that travel from the horse's neck to its tail and from the rider's back to his sword arching overhead.

A similar economy of line and effective use of cyma curves can be seen in the delicate *Sea Horse Jagging Wheel* (fig. 87). Probably made as a gift by a seaman on a whaling voyage, this jagging wheel is an example of scrimshaw, objects crafted from the teeth, bones, or baleen of a whale. An unwritten law of the sea gave the lower jaw of the sperm whale, with its teeth and bone, to the crew, who turned it into a wide variety of items, such as jagging wheels for cutting pastry into ornamental shapes and pie crimpers for edging crusts, busks for corsets, swifts for winding

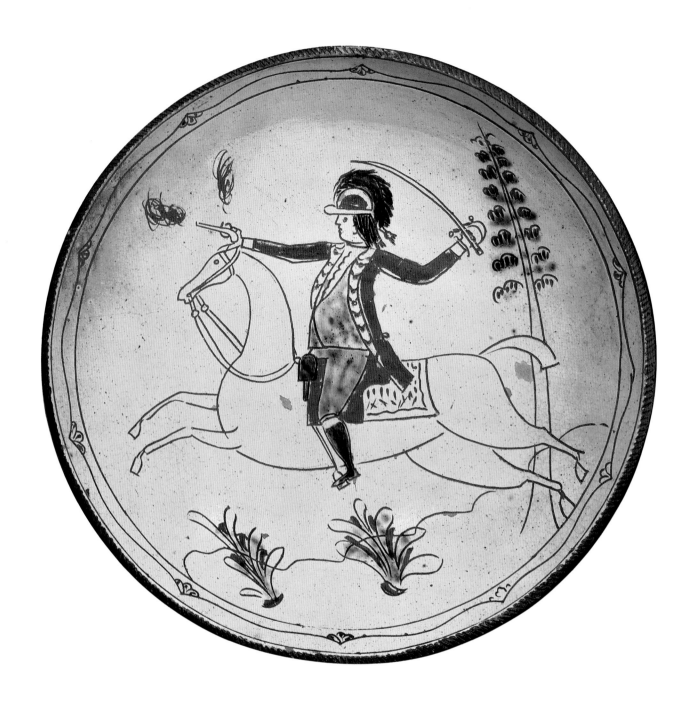

86

Schimmelreiter Plate

PROBABLY MADE BY DAVID SPINNER *(1758–1811)*

Bucks County, Pennsylvania; c. 1800

Glazed red earthenware with sgraffito decoration;
diameter 11 3/4 inches

The Metropolitan Museum of Art, New York

Gift of Mrs. Robert W. de Forest. 1933 (34.100.121)

★

87

Sea Horse Jagging Wheel

ARTIST UNIDENTIFIED

New England; c. 1870

Whale ivory and ebony, silver pins; $2\frac{3}{4} \times 8$ inches

Private collection

★

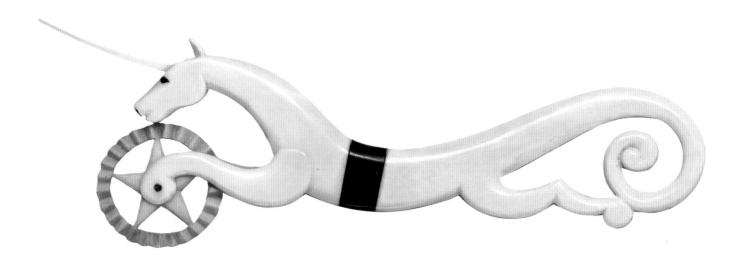

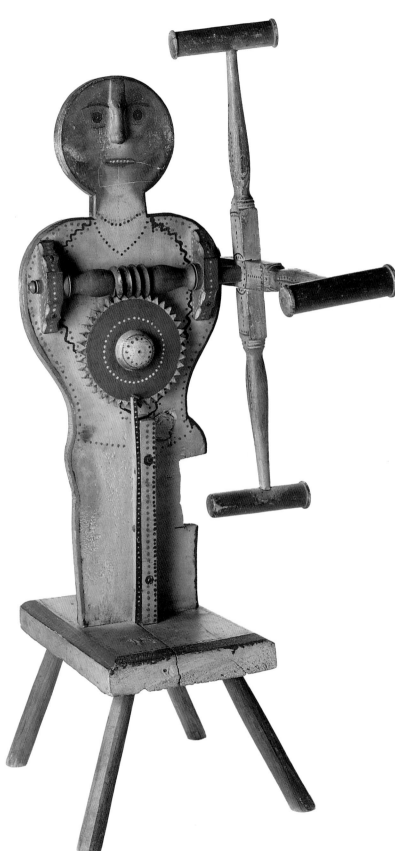

88
Yarn Reel
ARTIST UNIDENTIFIED
Possibly Connecticut; c. 1850
Carved, turned, and painted wood; 39 1/4 × 16 × 26 1/8 inches
Museum of American Folk Art, New York
Eva and Morris Feld Folk Art Acquisition Fund

★

89

Flag Gate

ARTIST UNIDENTIFIED

Jefferson County, New York; c. 1876

Painted wood, iron, brass; 39 1/2 × 57 × 3 3/4 inches

Museum of American Folk Art, New York

Gift of Herbert Waide Hemphill, Jr.

★

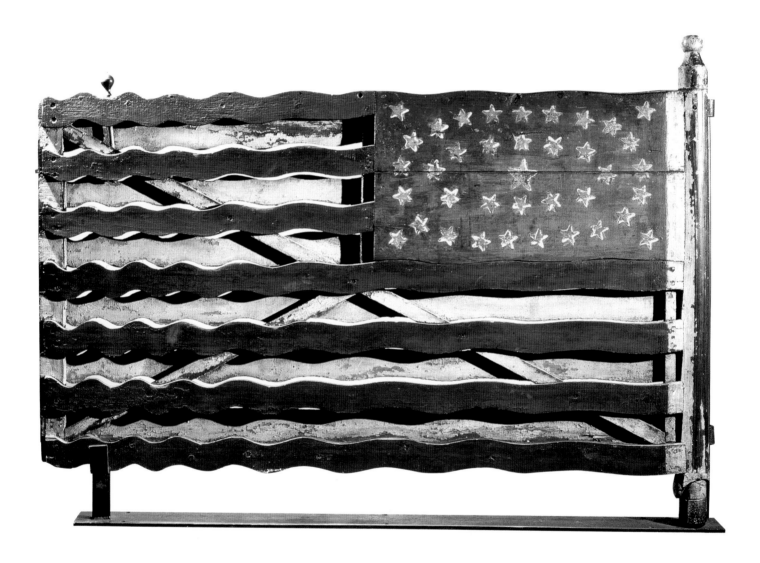

yarn, watch stands, candlesticks, game boards, and boxes. The addition of a contrasting ebony band around the waist of this spirited "whale ivory" sea horse makes it more visually exciting.

The *Yarn Reel* (fig. 88) may also have been intended as a gift for a busy nineteenth-century housewife. A yarn reel is a winding device used to gather yarn into skeins or hanks for subsequent knitting or weaving. A wide variety of forms—although none as imaginative as this example—were made from Colonial times until the introduction of factory-produced yarn made them obsolete. The yarn reel shown here is both unusual and appealing because of its anthropomorphic shape. In its minimal presentation of the human body, the piece is reminiscent of a dressmaker's form. But much has been added: a lollipop-shaped head, painted and carved to show a face; painted decoration to suggest jewelry or clothing; even the functional parts of the device have been painted and decorated so that one is scarcely aware of its practical purpose.

Another unique object is *Flag Gate* (fig. 89), originally a working gate on the Darling Farm in Jefferson County, New York. Possibly inspired by the American Centennial celebration in 1876, this piece is an example of the wealth of patriotic folk art that abounds in this country. Both sides of the gate have been painted to represent the thirteen-stripe American flag with thirty-eight stars, and the construction has been devised to give the illusion that those flags are rippling in the breeze. The red stripes (seen against a solid background that serves as the white stripes) have been carved as wavy rather than straight lines, to provide a sense of movement. On the reverse, white stripes wave against a solid red background. Even the necessary hardware attached to this piece is consistent with the design and at the top was made to resemble the finial of a flagpole.

★

TEXTILES
★ ★ ★ ★ ★

Caswell Carpet
DETAIL
★

Textiles have traditionally been considered the American women's folk art. While men were involved in the production of some forms (most coverlets, for example, were woven by professional male weavers), the overwhelming majority of handmade rugs, bedcovers, and other textiles used in the home were produced by women.

According to family tradition, Zeruah Higley Guernsey did indeed intend her handmade embroidered rug—known today as the *Caswell Carpet* (fig. 90) after her married name—for the seldom-used best room in the house. History also reports that every aspect of the making of the rug, from the shearing of the sheep to the embroidering of the designs on each square, was done with "her own hands, or the hands of persons in her own home."[14]

A tour de force of patience, craftsmanship, and design, the *Caswell Carpet* serves as a mosaic sampler of early nineteenth-century motifs. The carpet contains seventy-six squares, each embroidered in chain stitch with a different design, as well as a removable hearth section, outlined with a red sawtooth border. This separate section could be stored during the winter, when it was removed to protect it from flying sparks from the fireplace, and then replaced to cover the hearth during the warm summer months. Most of the motifs, sewn on a dark background, depict the flowers, leaves, birds, basket of fruit, and heart designs that can also be found on nineteenth-century appliquéd quilts and certain types of watercolor paintings (including theorems) that

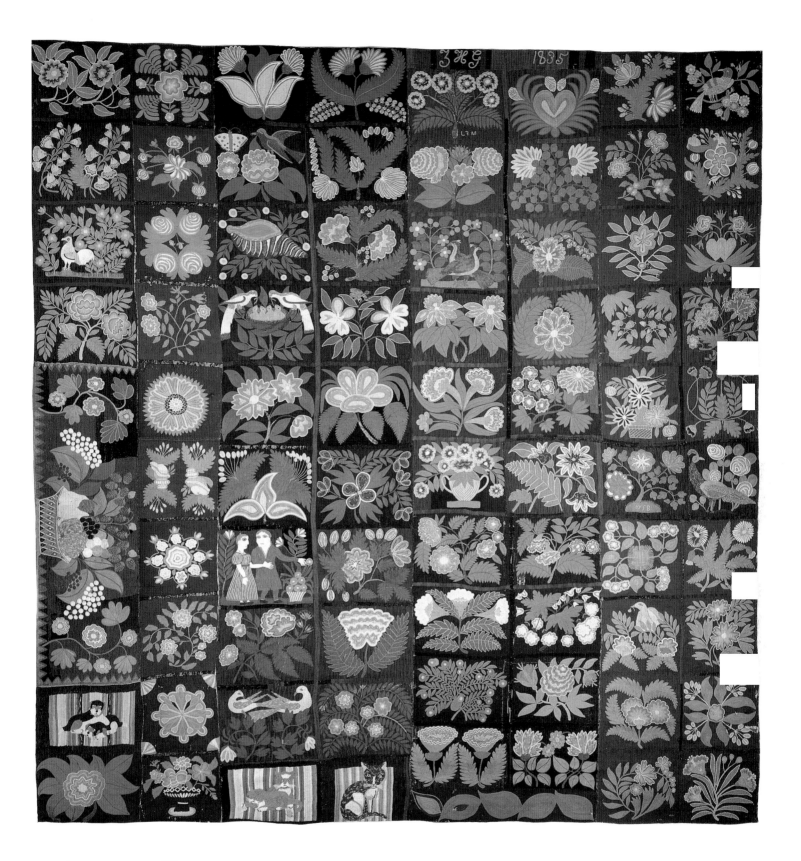

90

Caswell Carpet

ZERUAH HIGLEY GUERNSEY CASWELL *(born 1805)*

Castleton, Vermont; 1832–35

Colored woolen yarns embroidered on twill-weave

woolen fabric; 13 feet 4 inches × 12 feet 3 inches

The Metropolitan Museum of Art, New York

Gift of Katherine Keyes, in memory of her father,

Homer Eaton Keyes. 1938 (38.157)

★

were commonly done by young ladies at school during this period. A blue cat, a beige cat, and a pair of puppies are shown on striped grounds that probably represent the striped rag rugs often found in nineteenth-century homes. The most notable square of the carpet portrays a man and a woman strolling arm in arm in a garden. At one time, this motif was kept covered with another design, perhaps to protect it until the day in 1846 that the maker married Mr. Caswell.

Bedcovers are the largest category of American textiles, and by the end of the eighteenth century included bed rugs, linsey-woolsey coverlets, printed whole-cloth spreads, candlewick spreads, woven coverlets, and hand-embroidered spreads, such as the elaborate floral-design example (fig. 91). Quilts, however, in many different types, are the most numerous and best-known forms of American textile art. A quilt is essentially a textile "sandwich," made by joining three layers of cloth—top, interlining, and backing—with stitches, or "quilting," holding them together. Quilted bedcovers are generally divided into three main groups: whole-cloth quilts, usually sewn so the top forms a continuous pattern; pieced quilts; and appliquéd quilts. Both pieced and appliquéd quilts are frequently referred to as patchwork. Many quilters combine piecing and appliqué to achieve a final design, as, for example, in the quilt made by Harriet Powers (fig. 97).

The *Virginia Ivey Appliqué and Figural Stuffed-Work Quilt* (fig. 92) combines appliqué with stuffed work, also called trapunto. This intricate sewing technique, which results in designs in high relief, is accomplished by the insertion of soft cotton or cording through fine partings of the backing of the quilt. When the quilt is washed, the tiny holes close up and the textile maintains a three-dimensional, sculptural quality. In this quilt, stuffed work has been used to create a rendering of a statue of Henry Clay (his name is sewn beneath the figure) and a second man on horseback who is thought to be Andrew Jackson. Also depicted are horses, cows (including one labeled "Young Cow"), dogs, birds, ducks, pigs, and floral motifs. The quality of Virginia Mason Ivey's workmanship has rarely been matched in the history of American needlework—one of the few equals of this quilt is the spectacular stuffed, all white *Fair Ground Quilt*, also made by Mrs. Ivey, now in the collection of the Smithsonian Institution.

Pieced quilts were often considered utilitarian, and most were made as everyday bedcovers. Piecework, the technique of sewing together bits of fabric (often salvaged from other uses) to form a top in an overall pattern, made it possible to produce an astonishing array of geometric quilts in an almost endless variety of patterns. The designs were often contained within a series of blocks or patches that could be more easily worked; the blocks were later joined to form the quilt top.

The earliest bedcover shown here is the *Harlequin Medallion Quilt* (fig. 93), an example of a pieced quilt. Made of a warm, coarse linen-and-wool fabric blend, the *Harlequin Medallion* is a nineteenth-century descendant of the linsey-woolsey spread that was one of the earliest types of quilted bedcovers in the American colonies. While traditional linsey-woolseys (the name is derived from Middle English *lynsy wolsye*, referring to Lindsay, a village in Suffolk, England, where the woolen fabric originated) were usually whole-cloth spreads in a single color, this quilt has been pieced in a center-medallion style that foreshadows the great number of pieced, repetitive-pattern, block-style quilts that were produced in the nineteenth century. The central design of this brilliantly

91

Bedcover

ARTIST UNIDENTIFIED

Possibly New York; 1835–70

Wool embroidery on black wool; 101 × 88 inches

From the collections of Henry Ford Museum

and Greenfield Village, Dearborn, Michigan

★

92
Virginia Ivey Appliqué and Figural Stuffed-Work Quilt
VIRGINIA MASON IVEY *(born 1828)*
Logan County, Kentucky; c. 1850
Quilted and stuffed cotton; 92×78 inches
The J. B. Speed Museum, Louisville, Kentucky

★

colored quilt is composed of sixteen "four-patch" blocks, arranged in equal rows of four. Each block is composed of four triangles arranged in color and tone so the pattern produces an optical illusion: rows of triangles pieced point to point can also be seen in the center of the design as rows of diamonds. The double borders of the quilt, in pink and black, have been pieced in a large, zigzag pattern that echoes the triangles of the center. Even the quilting stitches, which follow the shape of the triangle pieces, conform to this geometric motif.

Two other pieced bedcovers included here, the *Bars Quilt* (fig. 94) and the *Crazy Patch Quilt* (fig. 95), are examples of the distinctive textiles produced by Amish women from the middle of the nineteenth century until the middle of the twentieth century.[15] The pieced quilts made by the Amish in Pennsylvania and in the Midwest are distinctively designed and have their own color schemes and quilting motifs. The "Plain People" living in agrarian communities in Lancaster County, Pennsylvania, tended to produce quilts that were conservative in design, adhering to simple geometric patterns executed primarily in solid-colored wool. In the Midwest, as well as in Mifflin and other counties of Pennsylvania, Amish needleworkers likewise quilted geometric patterns, but in these areas the range and complexity of designs were much greater since the quilters tended to be more influenced by their non-Amish neighbors. Amish quilts from outside of Lancaster County were also made of solid-colored fabrics—printed fabrics were considered far too "worldly" for Amish women to use—plain cotton was the preferred material.

The *Bars Quilt* is an example of an archetypal Lancaster County pattern. As in all Amish quilts the pattern is geometric, since naturalistic decoration is forbidden by their religion. Until well into the twentieth century, Lancaster County quiltmakers favored a few, large-scale patterns, such as Bars, Diamond in the Square, and Sunshine and Shadow. As is characteristic of many Amish quilts made before the early 1940s, the stitching on this quilt is exceptionally fine. While they rejected the appliqués of their "gay Dutch" (Pennsylvania German) and "English" neighbors because the designs served no practical purpose, the Amish women could stitch many of the same fruits, flowers, wreaths, and vines into their quilts with a clear conscience, satisfied by the knowledge that their tiny, precise stitches were necessary to hold the backing, filling, and top together. On this quilt, an elaborate Princess Feather stitchery motif decorates the outer border, while pumpkin-seed designs are found on the inner border. The tops of quilts such as this were often pieced on a treadle-powered sewing machine, but they were always quilted by hand, often by a group of women at a quilting bee.

Not only is the stitching on this quilt exceptional but the color combination—purple, pink, and two shades of green—would be considered highly sophisticated today. The colors of Amish quilts are often bold and unexpected from people who are commonly seen wearing black. However, since the Amish *Ordnung* (rules of conduct) does not specifically refer to quilts, the women were not prevented from combining the deep jewel tones and vivid pastels they obviously favored with the earth shades that might be considered more typical by outsiders. The intensely colored fabrics were often purchased specially for quiltmaking, but the bright hues were also used for clothing, particularly for children's apparel, although they were often worn under dark outer clothing.

93
Harlequin Medallion Quilt
ARTIST UNIDENTIFIED
New England; 1800–1820
Pieced calamanco (linen and wool); 86 3/4 × 96 inches
Museum of American Folk Art, New York
Gift of Cyril Nelson in loving memory of his grandparents
John Williams and Sophie von Hack Macy
★

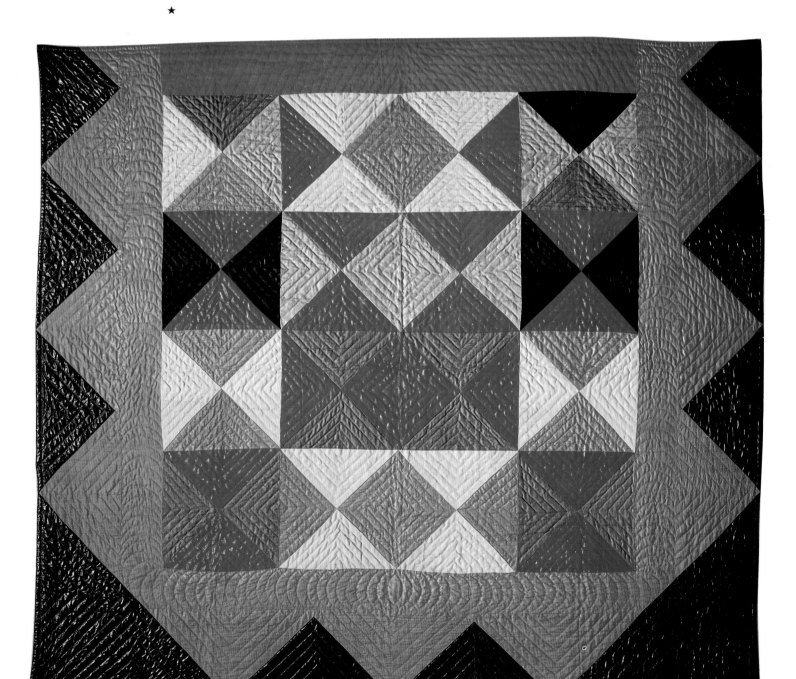

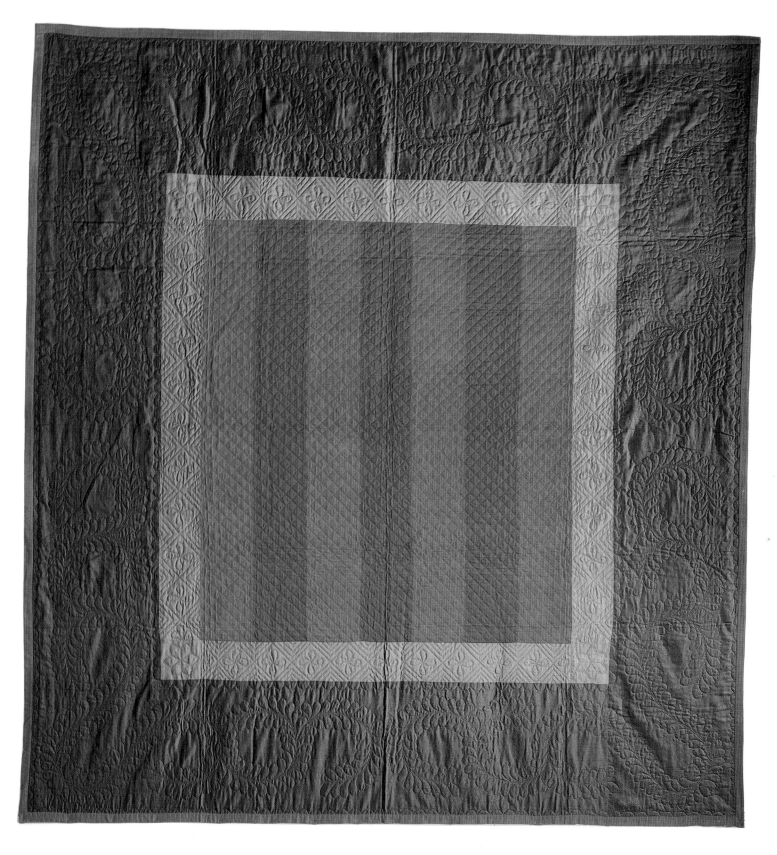

94

Bars Quilt

UNIDENTIFIED AMISH ARTIST

Lancaster County, Pennsylvania; c. 1900

Pieced wool; 82 × 74 inches

Thos. K. Woodard: American Antiques and Quilts,
New York

★

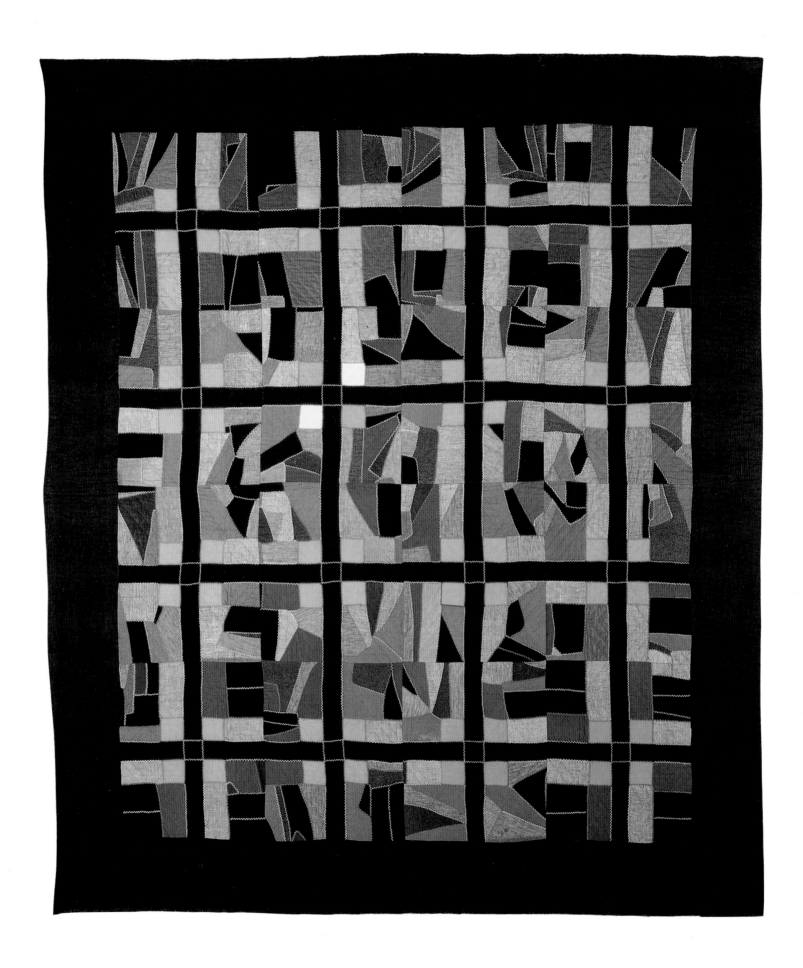

Crazy Patch Quilt is remarkable for its combination of a pattern popular in the outside world with the color and design sensibilities of the Amish and such restrictions inherent in Amish quiltmaking as geometric designs, solid-color fabrics, dark backgrounds, and wide borders, but no appliqués. While obviously influenced by the silk-and-velvet crazy quilts popular at the end of the nineteenth century, the Amish quilter has imposed order and regularity on what is by definition a disordered and asymmetrical design. The crazy patches are neatly set off by pumpkin-colored squares at the corners, and on close examination it can be seen that even the crazy patches themselves are ordered by a traditional Mifflin County four-patch pattern.[16]

The appliqué technique, often used for the "best" quilts in a house, involves sewing a piece cut from one fabric onto a ground fabric, such as an individual block, or directly onto the full-sized background fabric. After all of the appliqués have been secured to the background, or after the appliquéd blocks have been stitched together, the blank areas or "white spaces" left between the designs are usually quilted in decorative patterns.

The *Bird of Paradise Quilt Top* (fig. 96), named for the brightly plumed bird in the center, is an example of an appliquéd bedcover that was never finished—that is, never attached with quilting stitches to a backing and lining. Cut from newsprint and other papers dated from 1858 to 1863, the patterns shown on page 156 were found with the quilt. Because they included the figure of a man who does not appear on the appropriate spot next to the woman on the quilt top, this bedcover may have been made in anticipation of a wedding that did not take place, and for that reason was never quilted and completed. The many symbols of life and fertility on this quilt top—the pairs of animals, the nesting birds, the fruits and flowers—add weight to the supposition that this was intended as a bridal quilt. Often, a woman prepared a number of quilt tops (a baker's dozen was traditional) to be turned into finished bedcovers at a quilting bee in honor of her impending marriage.

Besides domestic animals, the *Bird of Paradise Quilt Top* contains a number of unusual representations, including several well-known nineteenth-century racehorses that are identified by name; "Hanible" the elephant, with a trainer; and ostriches and peacocks—as well as the bird of paradise. Contemporary periodicals with pictures of these creatures, or possibly a traveling circus, must have influenced the maker's unconventional designs.

The quilt is arranged as a series of blocks surrounded by a border, with the two center rows of blocks obviously the most important, a fact that makes the omission of a man at the top of the left center row, to balance the woman at the top right center, even more obvious. Each block is different, yet in keeping with the others in terms of style and motifs. By not imposing strict symmetry on her design, the seamstress has made it more interesting and joyous. Even the border is irregular in its design, providing something new to look at in every section. The choice of fabrics is in keeping with the motifs: the patterned calicoes of the leaves and branches, for example, provide the illusion of texture, while the bird of paradise is decked out in an appropriate array of colorful period cottons.

The quilting tradition, though probably first practiced in America in the Northeast, has never been limited to any particular region or cultural group, Like the Amish in Pennsylvania and the Midwest,

African-Americans in the South and Hawaiians in the Pacific also created distinctive textiles that combined aspects of their own cultural and artistic heritage with traditional Anglo-American quilting techniques and patterns.

Harriet Powers, the creator of the pieced and appliquéd *Pictorial Quilt* (fig. 97), was born a slave in Georgia in 1837. *Pictorial Quilt*, one of only two known textiles by this talented woman, shows how important both religion and the narrative folk tradition were (and remain) in the African-American community. The fifteen squares of the quilt depict biblical tales as well as local legends and meteorological and astronomical events, with special emphasis on Bible heroes, such as Job and Jonah, who succeeded against overwhelming difficulties.[17]

This quilt was commissioned in the last years of the nineteenth century by the wives of Atlanta University professors as a gift for the Reverend Charles Cuthbert Hall, president of Union Theological Seminary and for many years chairman of the board of trustees of Atlanta University. The women had seen and admired a quilt made by Harriet Powers that had probably been exhibited by its owner, Jennie Smith, in the Colored Building at the 1895 Cotton States and International Exposition in Atlanta.[18]

While the narrative quilt form has American origins, the appliqué technique practiced by Harriet Powers may have roots in African culture. This knowledge of appliqué, which in Dahomey was executed by men but in America by women, was brought to the South by slaves carried there from Africa. Motifs and sewing techniques that have been studied on Harriet Powers's quilts are similar to those on Dahomean tapestries.[19] Other elements found on this bedcover (as well as on other African-American quilts) that have been related to African textile traditions include strip piecing, large design elements, bright colors, asymmetry, multiple patterns, improvisations, and symbolic forms.[20]

The unregimented look of Harriet Powers's quilt delights viewers today as much as it must have pleased the Atlanta faculty wives in 1898. The original motifs on this quilt were not made from preprinted, or probably even precut, patterns or influenced by designs in contemporary periodicals. They are not enhanced by elaborate trailing vines or other stylistic devices of the period or made of luxurious fabrics in confusing configurations, like the popular crazy quilts of the day. Rather, these fifteen delightfully animated squares are the product of the quilter's own imagination and hand, doubtless guided by her African-American heritage. Her figures are unrestrained and free within their squares, not bound to any rigid lines or notions of "correct" placement, giving a lively sense of movement to the quilt. Her designs are straightforward, meant to be understood by all, and to ensure this Harriet Powers dictated the story of each square to Jennie Smith. Square two (reading from the top, left to right), for example, records a spectacular meteorological event—a "dark day" in May 1780, when the atmosphere was so polluted with smoke from forest fires that day was turned into night—an event still talked about more than one hundred years after it occurred: "The seven stars were seen 12 N. in the day. The cattle all went to bed, chickens to roost and the trumpet was blown. The sun went off to a small spot and then to darkness."[21]

Na Kihapai Nani Lua 'Ole O Edena a Me Elenale (The Garden of Eden and the Garden of Elenale) (fig. 98) combines elements of traditional Hawaiian textile production with an original design and an Anglo-American

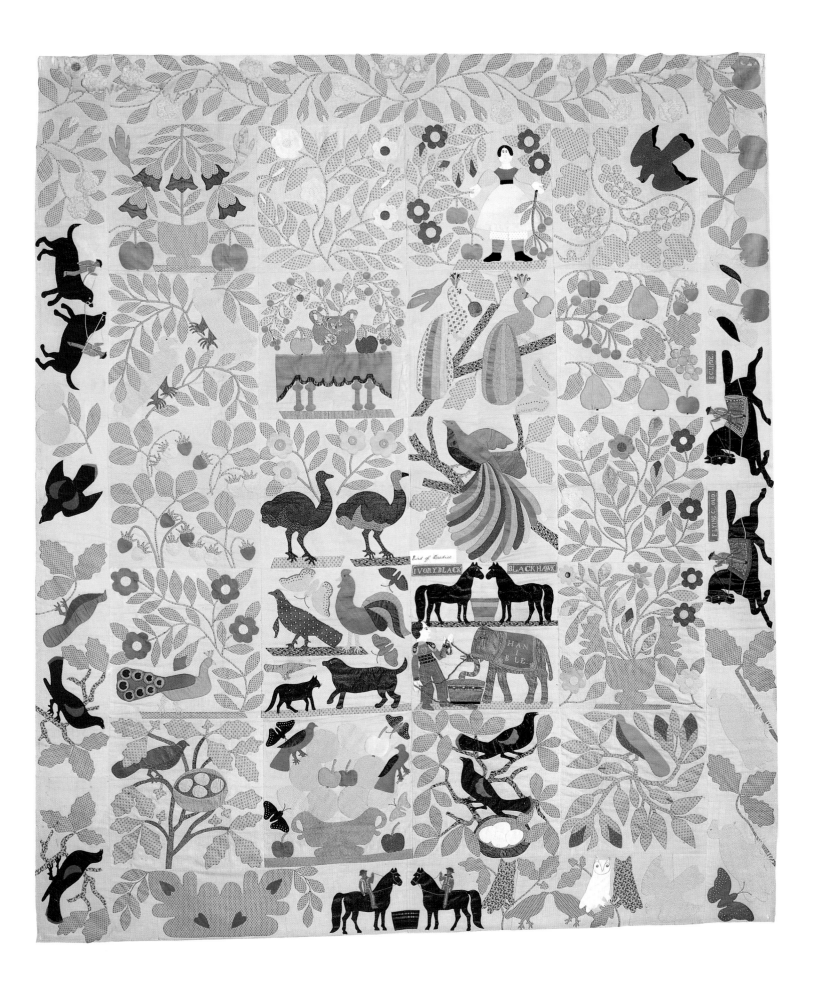

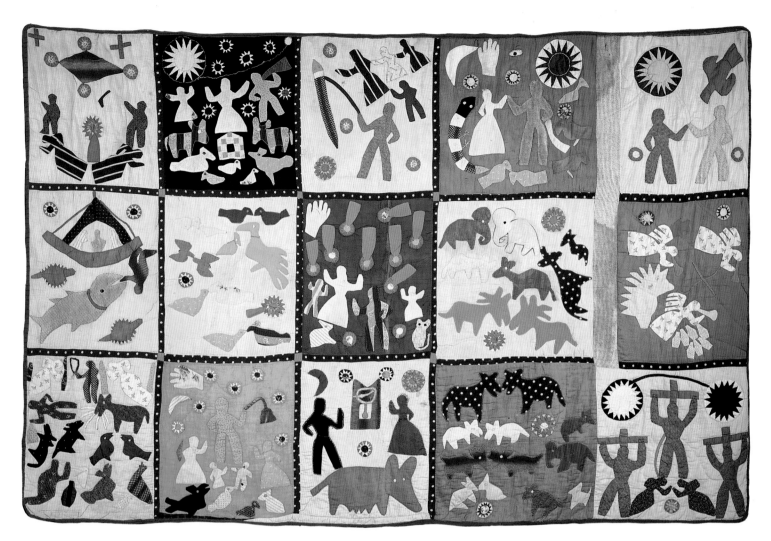

97

Pictorial Quilt

HARRIET POWERS (*1837–1911*)

Athens, Georgia; 1895–98

Appliquéd and pieced cotton embroidered with

plain and metallic yarns; 69×105 inches

Courtesy, Museum of Fine Arts, Boston

Bequest of Maxim Karolik Collection

★

98

Na Kihapai Nani Lua 'Ole O Edena a Me Elenale
(The Garden of Eden and the Garden of Elenale)

ARTIST UNIDENTIFIED

Hawaiian Islands; before 1918

Appliquéd cotton; 86×98 inches, including fringe

Honolulu Academy of Arts, Honolulu, Hawaii

Gift of Mrs. Charles M. Cooke, 1929

★

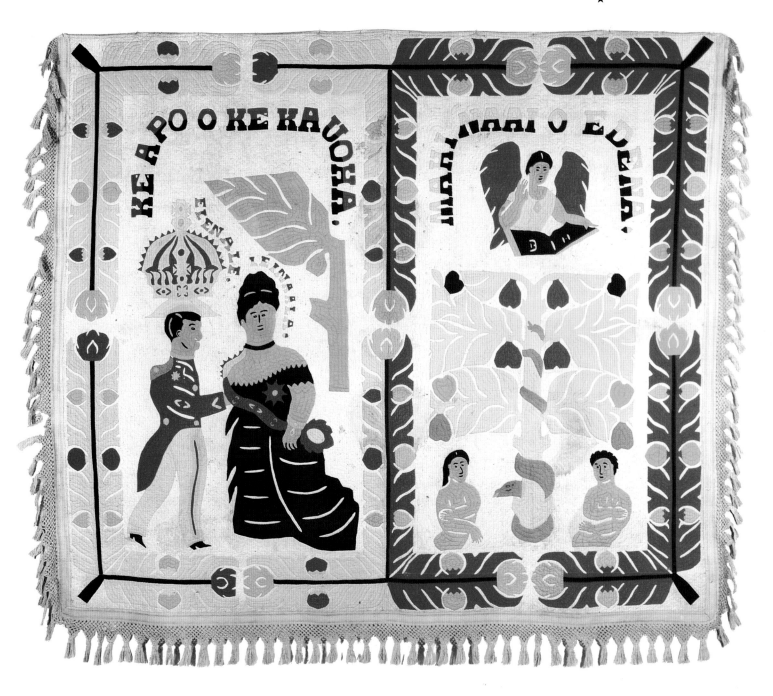

concept,—quilted bedcovers. Cloth quilts were introduced to the Hawaiian Islands in the early nineteenth century by missionaries from New England. Before the arrival of the missionaries, clothes and bedding in Hawaii were made of layers of tapa, the pounded bark of the paper mulberry or breadfruit tree, which did not require sewing. It is believed that the bold, large-scale naturalistic designs the Hawaiians appliquéd on quilts—very different from the typical New England patterns—were derived from the stamped tapa patterns on the native bedding.[22]

Rarely do representational figures, such as are seen here, appear on Hawaiian quilts as they were generally considered unlucky.[23] In this striking piece, however, the unidentified artist—possibly a man, according to oral history[24]—has used a quilt to draw an analogy between Adam and Eve in the Garden of Eden and the romantic Hawaiian folk heroes Elenale and Leinaala. There are many different versions of the folktale of Elenale, the otherworldly hero raised in a magical garden, and his earthly lover, Leinaala, often depicted as a princess, who, in this design, strongly resembles photographs of an actual Hawaiian monarch, Queen Emma.[25] The story tells of the rescue of Leinaala from captivity by Elenale, who takes her to live with him in his own beautiful garden.[26] In Hawaii, the garden of Elenale and the Garden of Eden were popularly considered to be "the two most beautiful gardens ever known."[27]

Typically, a Hawaiian quilt is square, with an unbroken or slightly broken border. A large central design and borders are cut out of tapa or paper that has been folded four or eight times to obtain an overall repetitive pattern—much as children cut out paper-lace valentines today. In this manner the design, usually a solid color appliquéd onto fabric of a second solid color, is repeated without variation across the top of the quilt.[28] This common type of Hawaiian design can be seen on the borders of this quilt and in the center of the Garden of Eden, on the right side. Other references to the traditional type of naturalistic decoration can be seen on Leinaala's dress and the wings of the angel, both of which resemble the leaflike appliqués commonly found on quilts in the Islands.

In contrast to the majority of Hawaiian quilts, this late nineteenth-century or early twentieth-century textile is treated as two separate but complementary panels. The two representational scenes were designed to be opposite, yet equal. On the left side, inscribed "Ke Apo O Ke Kauoha" (The Embrace of a Commandment), a yellow border with red highlights surrounds the figures; on the right, inscribed "Mahina 'ai O Edena" (Garden of Eden), the reverse color scheme prevails. This positive-negative, dark-light interplay lends balance and vibrancy to the quilt. Even the letters of the inscriptions carry out the motif of contrasting colors: red and black on the left, yellow and black on the right. Scale has also been distorted on both sides, possibly to provide aspects of characterization. On the left, the over-large crown atop Elenale's head shows his importance, relates him to the Hawaiian monarchy, and, though the figure is smaller, suggests that he is larger than Leinaala. On the right, the menacing snake appears proportionally larger than either Adam or Eve, but the angel hovering overhead makes it clear that their union, like that of Elenale and Leinaala, has been blessed in heaven.

Pictograph Quilt
UNIDENTIFIED SIOUX ARTIST
Crow Creek Reservation, South Dakota; c. 1900
Appliquéd cotton; 78×70 inches
Private collection

★

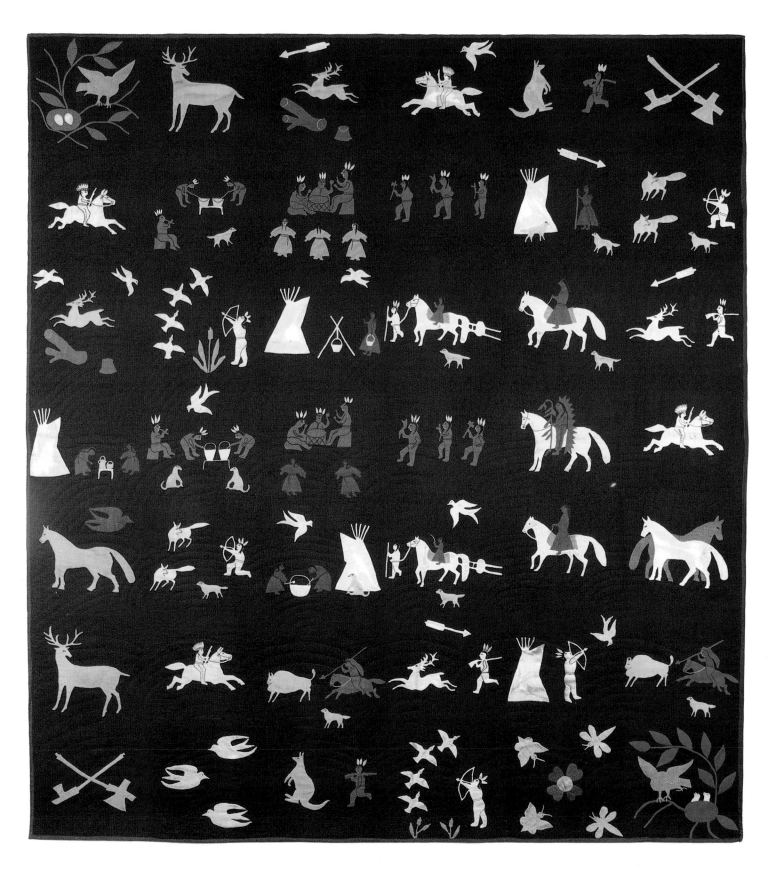

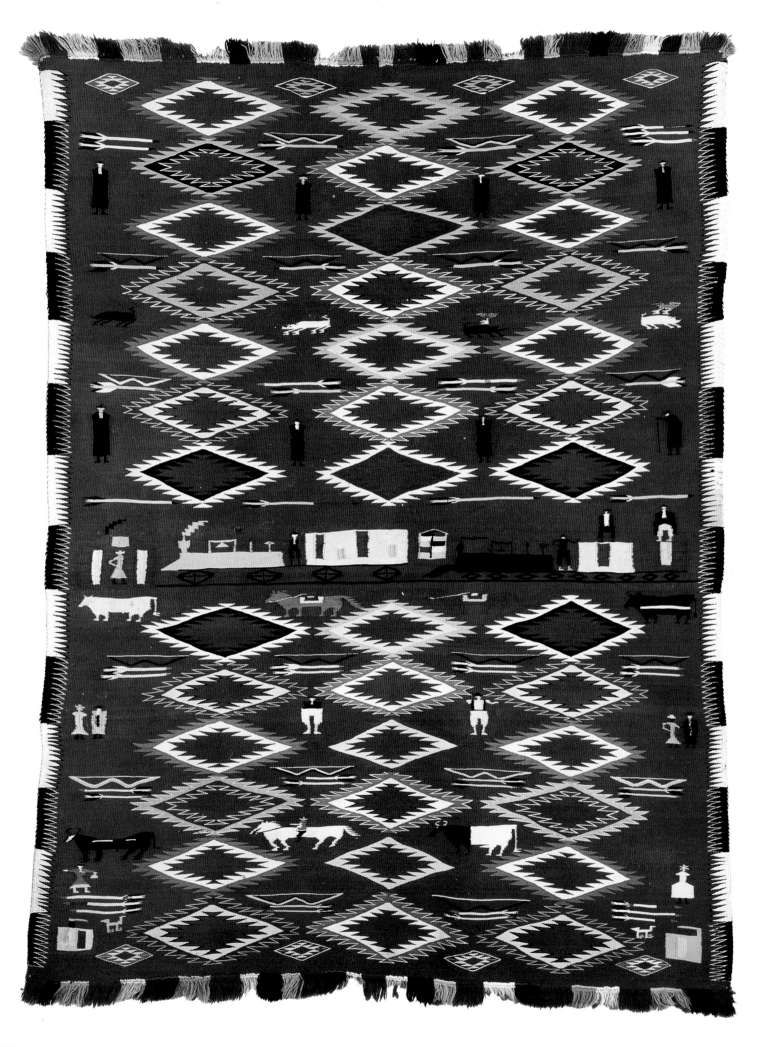

162

Another unusual bedcover, the *Pictograph Quilt* (fig. 99), was appliquéd about the turn of this century in a style that resembles the pictographic drawings of the Plains Indians (such as the Kiowa artist's drawing, fig. 48). Believed to have been made by a Sioux woman as a gift of friendship to a South Dakota homesteader, this quilt shows scenes of traditional daily life among Native Americans, including hunting buffalo and birds and cooking the game. A clue to the supposition that a seasonal round of activities is illustrated can be found in the unhatched eggs in a nest at the top left that have turned into baby birds in the bottom right.

Navajo Pictorial Germantown Blanket (fig. 100) is another important Native American textile that shows the effects of acculturation on traditional Indian arts. The Navajos' weaving has customarily been adaptable to change, and the variety of patterns and colors in their textiles over three centuries reflects a succession of foreign influences.[29] The three decades that followed the Navajos' forced exile at Bosque Redondo (Fort Sumner), New Mexico—the "Transition Period" of 1865 to 1895—were years of major change in their textiles. The weavers were influenced by new materials (including commercially produced Germantown wool), new visual inspiration (including the coming of the railroad, in 1882), and a new market of Anglo-American buyers, with its own aesthetic demands.

Pictorial blankets, such as this one, that were produced in the latter part of the nineteenth century, show a variety of design sources. The combination of Navajo tapestry-weaving technique and the range of aniline colors newly available in commercial yarn, as well as the precision available with such wool, gave the weavers, typically women in this society, the technology to produce a wide range of motifs.[30] The serrated diamond motif that decorates this textile can be traced back to Mexican *saltillos* (wearing blankets). The representational figures, including the train, horses, cattle, people, and bows and arrows, are not traditional with the Navajos but were introduced during the last quarter of the nineteenth century, possibly to make the textiles more appealing to Anglo customers.

Characteristic of the Navajo aesthetic of the Transition, however, is the balanced design seen here. The overall patterning is almost, but not quite, symmetrical. As a Navajo weaver characteristically worked from designs in her head, exact symmetry is usually interrupted by irregularities in pattern or color.[31] In this example, the bottom row breaks with the rhythm established above and includes extra figures. Nor is every figure in every row exactly alike: one of the black-coated men in the top section leans on a cane, and each man has a very slightly different size and shape. Unexpected figures, such as the rider on one of the horses, add delightful variety. The diamond patterns are also varied with almost exact regularity. It is this use of balance and imbalance, symmetry and asymmetry, combined with a variety of design elements and excellent craftsmanship, that gives special excitement to this Navajo blanket.

AFTERWORD: BACK TO THE FUTURE

★ ★ ★ ★ ★

Robert Bishop

When we first discussed possibilities for a *Five-Star Folk Art* book and exhibition, I was very excited about the idea, for I saw it as a means by which the Museum of American Folk Art could reflect upon more than fifty years of discovery and scholarship in the field. Not only could we test the validity of widely held assumptions but we could also consider the directions now being taken by "revisionist" scholars and folklorists. More than anything else, we could take a long look and attempt to understand what it is about the art of folk art that moves us so deeply. At the heart of the project is the issue of quality. An object's excellence as a work of art has been the primary reason for our interest in it in the past and, we believe, will continue to be so in the future.

My hopes for *Five-Star Folk Art* have been fulfilled. The undertaking has not only provided a vantage point from which to look at and analyze the history of the field of folk art, as well as the scholarship done by researchers and collectors from the early days of folk-art appreciation, but has also provided the impetus for an expanded view of folk expression in the work of self-taught artists of our own time.

Formal art history should be scrutinized by successive generations. In their effort to categorize and formalize ideas about the nature of art, and especially folk art, some early scholars selected a historical perspective and developed myths that made the art fit the ideas that they presented as fact. "Demystifying" the myths accepted and promoted by early folk-art enthusiasts is an important part of current research.

That myth and inaccuracy exist in the folk-art field was recently driven home by an extensive project initiated by the Museum of American Folk Art. Don Yoder, Professor of Folk Life Studies and Religious Studies, University of Pennsylvania, was commissioned by the Museum to undertake a definitive study of Pennsylvania hex signs. Thomas E. Graves, whose dissertation on the subject had been directed by Yoder, was to assist and provide photographs of hex signs remaining on barns throughout rural Pennsylvania Dutch country. Under a grant from the Museum, Yoder traveled through Germany in 1986, but his extensive research led him up one blind alley after another.

Where was the primary evidence that would confirm the popular idea that hex signs painted on barns were intended to keep away demons, witches, and evil spirits? To be sure, there were frakturs, decorated furniture, pottery, textiles, and ironware of German origin with designs similar or identical to those painted on Pennsylvania barns, but sparse indeed was proof supporting the notion that the use of these designs meant more than an attractive way of decorating or making a successful farmstead appear more important. Evidence now points to the conclusion that the supernatural meanings ascribed to hex signs may have been little more than a twentieth-century invention by business interests hoping to lure tourists to Pennsylvania. Yoder and Graves's book, *Hex Signs: Pennsylvania Dutch Barn Symbols and Their Meaning* (1989), and the accompanying photo-panel exhibition of the same name provide vivid documentation of the purely decorative function of hex signs; this is just one example of how looking at a folk-art tradition objectively, without the trappings of romanticized scholarship and preconceived ideas, often leads to new conclusions or the reaffirmation of forgotten truths.

Even Holger Cahill, to whom this book is dedicated, contributed to folk-art mythology. In the catalogue for the Museum of Modern Art's exhibition "American Folk Art: The Art of the Common Man in

America, 1750–1900" (1932), he helped propagate the myth that folk portraitists spent the slow winter season painting headless torsos, which were then completed for commissions during the limners' itinerant summer months. It has been noted in recent literature that no headless torsos on canvas survive to support this now dismissed theory.

During the 1960s, a critical step affecting the whole field of folk art was taken. Led by Herbert W. Hemphill, Jr., a founder and now trustee emeritus of the Museum of American Folk Art, a farsighted group of collectors decided to devote their attention to the twentieth-century artists who were creating paintings, sculpture, and other objects that would have been called folk art had they been fashioned in the nineteenth century. Most of these artists were self-taught, and their work was highly individual and, most important, of superior aesthetic quality. Other collectors have rejected out of hand the classification of this twentieth-century material as folk art, assuming that since contemporary conditions differ from those of an earlier time, folk expression has come to an end. One purpose of this book and exhibition has been to encourage collectors of folk art to look at the art of every period and to consider it openly and without prejudice.

We encourage recognition, at every level, of the *art* of folk art. In selecting one hundred five-star examples, we reviewed countless books and periodicals and consulted many photographic archives. We also visited a great many private and public collections in our quest for unpublished as well as familiar works. That many of our examples are repetitions from past selections strongly suggests that quality is a constant in these objects of American folk art.

We believe the concept of quality prevails. For a decade or more, exhibitions have been organized under the auspices of separate state folk-art agencies that have emphasized the processes of creating crafts, the communities and ethnic environments in which those crafts are produced, and the life and times of craftspersons. Almost universally, these exhibitions have been the work of folklorists and have skirted the issue of quality. Too often, the resulting exhibitions were rich in context but poor in works of art. Faced with the task of organizing an exhibition, however, these folklorists not infrequently had to reconsider the definition of folk art under which they themselves worked. Thus, "memory pictures" by twentieth-century folk artists, revival crafts, and work by idiosyncratic artists created outside of a true community context have been included in such presentations. Though the folklorists have greatly expanded their own limited definition of folk art quantitatively, they still have very little interest in qualitative distinctions.

Five-Star Folk Art demonstrates that there is art in folk art, art that can inspire and move us, art that is important and exciting, art that will stand the test of time. Having made these observations, I recognize that this book represents a single moment·in the folk-art field. Future generations of scholars, curators, and collectors will offer fresh perspectives that will alter many of the ideas we now believe in. The consensus of future opinion may even decree that there is no such category as "American folk art." Perhaps the best of the Americana we have collected, exhibited, and so rightly celebrated is simply a style of art— American art that should not be singled out by art historians as a field in itself. When an object is great, its greatness transcends questions of how to name it, who made it and why, or under what social, economic, or ethnic conditions it came into being. It stands forever, as art.

Situation of America, 1848
DETAIL
figure 31

★

HOLGER CAHILL, AN APPRECIATION

★ ★ ★ ★ ★

Sharon L. Eisenstat

In the long-running debate over a definition of "folk art," the opposing sides still disagree about where the emphasis belongs—on "folk" or on "art." The debate is not solely over a definition of these two conjoined words, but about which side receives and controls funding for exhibitions and research. Those who would emphasize "folk" share an orientation and methodology based on the social sciences; they are the folklorists, who study material culture for its insights into the social and political aspects of thought and behavior. Those who give more importance to "art" focus on the object and its intrinsic spiritual, emotional, and creative impact; they are the art historians and connoisseurs, who have an aesthetic criterion as the basis for their definition. For the art historians, time and place are not unimportant and are recognized as relevant to the appreciation and understanding of the art object. As Jean Lipman has aptly stated, "Time is important, but a great work of art is timeless."[1] In the art-historical approach, aesthetics are crucial.

Among art historians, Holger Cahill (1887–1960) has long been recognized as an eloquent spokesman who contributed greatly to an awareness and appreciation of folk art. His exhibitions in the 1930s on folk painting and sculpture for the Newark Museum and the Museum of Modern Art in New York have become landmarks, symbolizing the aesthetic approach to the study of folk art. It is because of his recognition of the significance of aesthetics that *Five-Star Folk Art* is dedicated to his memory.

Cahill traveled to Sweden and central Europe in 1922 to write about Scandinavian crafts for the Swedish-American News Exchange, and it was on that trip that he was introduced to arts and crafts as presented in folk museums abroad.[2] In 1926 Cahill visited the acclaimed Ogunquit School of Painting and Sculpture, founded in Maine in 1913 by Hamilton Easter Field to provide contemporary artists with studio space for the summer months.[3] Field had furnished these studio cottages with antiques and the decorative accessories that we now acknowledge as folk art. Following Field's initiative, the sculptor Robert Laurent assembled his own collection of folk art, and when in 1922 Laurent inherited the Ogunquit property, he continued to rent to summering artists. These modernists found in folk-art objects a validation of the abstract qualities in their own art, which they then identified as part of a continuing American artistic tradition. While visiting Laurent's home, Cahill also recognized the same emotional versus visual realism inherent in the objects collected at Ogunquit.

Cahill solidified his emerging viewpoints in the published catalogues that accompanied his three influential folk-art exhibitions. The first, "American Primitives: An Exhibit of the Paintings of Nineteenth Century Folk Artists," included works belonging to several of the collectors from Ogunquit. In preparation for the show, Cahill and his fellow organizers had traveled to locate additional entries; among these were three objects in wood, metal, and stone that were shown with the exhibition on paintings. The second exhibition, "American Folk Sculpture: The Work of Eighteenth and Nineteenth Century Craftsmen," featured some pieces borrowed from Abby Aldrich Rockefeller, whom Cahill had assisted as a consultant when she was assembling her prime collection of American folk art. This collection, with one exception, comprised the Museum of Modern Art's exhibition, "American Folk Art: The Art of the Common Man in America, 1750–1900," which Cahill, as the Modern's Director of Exhibitions, presented in 1932. It

was a synthesis of Cahill's previous discoveries and thoughts on folk art. In recognition of his achievements and abilities, Cahill in 1935 was appointed a director of the Works Progress Administration's Federal Art Project (FAP) for which he supervised the monumental Index of American Design.

For Cahill, "folk" in this country did not refer to a specific ethnic group or peasant class as it did in the European folk museums he had visited. As John Vlach has noted, Cahill's leanings were populist and democratic; the folk, whether creator or clientele, were America's "common men," an inclusive, not exclusive, category. The creators were either the preindustrial artisans or pre– as well as post–machine-age amateurs. In "Artisan and Amateur," Cahill wrote that he "separated folk art into these two categories: the work of the artisan who inherited an immemorial tradition of shop practice; and the amateur whose simple self-training might include the study of the work of others, and in some instances a little training in shop or school." Cahill did interject a cautionary note, however: "not all amateurs are folk artists."[4] Artisan and amateur alike were "house painters, sign painters, portrait limners, carpenters, cabinet-makers, shipwrights, woodcarvers, stone-cutters, metal workers, blacksmiths, sailors, farmers, business men, housewives, and girls in boarding school."[5] Cahill's descriptions of the two categories did not address class or gender distinctions: they were defined by looking first at the objects and then at their makers. Most importantly, Cahill saw folk art in terms of an aesthetic accomplishment, "for folk art goes straight to the fundamentals of art, rhythm, design, balance, proportion, which the folk artist feels instinctively,"[6] and because "the work of the best of [the folk artists] has a directness, a unity, and a power which one does not always find in the work of standard masters."[7]

Always at issue is the fact that judgments are made within the time frame of those doing the judging. Some critics condemn what they perceive as a bias in evaluating these objects by twentieth-century standards instead of the standards of the individuals who created the work and the individuals for whom the work was created. John Wilmerding addressed this criticism succinctly in his essay in an *Antiques* symposium: "The point is, we can enjoy a work equally for what it once was and what it now is."[8] Art, and even art collecting, can be discussed in terms of social, economic, political, spiritual, and emotional issues. Some folklorists now embrace Holger Cahill as one of their own, or at least as sympathetic to their philosophy; art historians have long laid claim to him. Perhaps Cahill's approach—inclusive rather than exclusive—will become a meeting ground between the two viewpoints. Cahill saw folk art as both an aesthetic and a social expression. Obviously, folklorists and art historians often study the very same objects, and each group has insights that could be of value to the other. The art historians do consider the importance of the social history behind the objects they admire primarily for their aesthetic quality. The folklorists might reconsider the importance of aesthetics without reducing their interest in social history. Folklorist and art historian can define and contribute to a shared body of knowledge while each maintains a different emphasis and approach to the study of folk art in particular and the human experience in general.

For his broad talents and pioneering contributions, the authors of *Five-Star Folk Art* thank Holger Cahill for leading the way.

The Quilting Party
DETAIL
figure 16

★

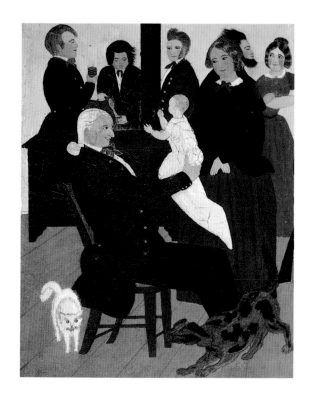

NOTES

PICTURES
★ ★ ★ ★ ★

Titles cited in the Bibliography have sometimes been abbreviated in the Notes.

1. For a discussion of how eighteenth- and nineteenth-century folk portraits reflect the taste and aesthetic demands of the subjects, see Charles Bergengren, " 'Finished to the Utmost Nicety': Plain Portraits in America, 1760–1860," in John Michael Vlach and Simon J. Bronner, eds., *Folk Art and Art Worlds* (Ann Arbor, Mich., 1986), pp. 85–120.

2. Robert F. Trent, "The Concept of Mannerism," in Jonathan L. Fairbanks and Robert F. Trent, *New England Begins: The Seventeenth Century* (Boston, 1982), vol. 3: *Style,* p. 368.

3. Susan E. Strickler, "Recent Findings on the Freake Portraits," *Worcester Art Museum Journal,* vol. 5 (1981–82), pp. 51–52.

4. Lanci Valentine, *Rufus Hathaway: Artist and Physician, 1770–1822* (exhib. cat.; Duxbury, Mass., 1987), p. 24.

5. Nina Fletcher Little, *Paintings by New England Provincial Artists 1775–1800* (exhib. cat.; Boston, 1976), p. 80.

6. John Wilmerding, *American Masterpieces from the National Gallery of Art* (New York, 1980), p. 169.

7. Little, *Paintings,* p. 80.

8. Nina Fletcher Little, "John Brewster, Jr.," in Jean Lipman and Tom Armstrong, eds., *American Folk Painters of Three Centuries* (New York, 1980), p. 21.

9. See Mary Black, "Ammi Phillips: The Country Painter's Method," *The Clarion,* Winter 1986, pp. 32–37, for a discussion of Ammi Phillips's portraits of children dressed in red.

10. Marianne E. Balazs, "Sheldon Peck," in Lipman and Armstrong, eds., *American Folk Painters,* p. 136.

11. See Richard Miller, "Itinerant Artists and Roving Photographers: The Impact of Photography on Folk Portraiture," *Heritage,* vol. 3, no. 5 (June 1987), for a comparison of the paintings of Sheldon Peck before and after the introduction of photography to America.

12. Leon Anthony Arkus, *John Kane, Painter* (Pittsburgh, 1971), p. 124.

13. Mrs. Almira Hart Lincoln Phelps, *The Fireside Friend or Female Student* (Boston, 1840).

14. Maude Southwell Wahlman, "The Art of Bill Traylor," in *Bill Traylor (1854–1947)* (exhib. cat.; Little Rock, Ark., 1982), n.p.

15. Beatrix T. Rumford, ed., *American Folk Paintings: Paintings and Drawings Other Than Portraits from the Abby Aldrich Rockefeller Folk Art Center* (Boston, 1988), pp. 121–22.

16. Ruth Wolfe, "Hannah Cohoon," in Lipman and Armstrong, eds., *American Folk Painters,* p. 64.

17. Rumford, ed., *American Folk Paintings,* p. 274.

18. Hicks, quoted ibid.

19. Roderic H. Blackburn and Ruth Piwonka, *Remembrance of Patria: Dutch Arts and Culture in Colonial America 1609–1776* (exhib. cat.; Albany, N.Y., 1988), p. 119.

20. A. J. Peluso, Jr., "James Bard's *Thomas Hunt & America:* An Appreciation" (manuscript in collection of Museum of American Folk Art, New York).

21. Janney, quoted in Sidney Janis, "Joseph Pickett," in Lipman and Armstrong, eds., *American Folk Painters,* p. 212.

22. Pastor Frederick S. Weiser, "I A E S D: The Story of Johann Adam Eyer (1755–1837), Schoolmaster and Fraktur Artist, with a Translation of His Roster Book 1779–1787," in *Ebbes fer Alle—Ebber Ebbes fer Dich: Something for Everyone—Something for You* (Breiningsville, Pa., 1980), p. 464.

23. Karen Daniels Petersen, *American Pictographic Images: Historical Works on Paper by the Plains Indians* (exhib. cat.; New York, 1988), p. xvi. The quotation in this excerpt is from George Bird Grinnell, *The Cheyenne Indians* (New Haven, 1923), vol. 2, p. 19.

24. Ronald McCoy, *Kiowa Memories: Images from Indian Territory, 1880* (exhib. cat.; Santa Fe, 1987), pp. 3–4.

25. Ibid., p. 3.

26. Petersen, *American Pictographic Images*, p. xvi.

27. Michael D. Hall, "The Problem of Martin Ramirez: Folk Art Criticism as Cosmologies of Coercion," *The Clarion*, Winter 1986, p. 59.

28. From a poem by Stanley Kunitz, quoted in Jean Lipman and Helen M. Franc, *Bright Stars: American Painting and Sculpture Since 1776* (New York, 1976), p. 58.

<div align="center">★</div>

WORKS IN WOOD, METAL, AND STONE

<div align="center">★ ★ ★ ★ ★</div>

1. Dickran Tashjian and Ann Tashjian, *Memorials for Children of Change: The Art of Early New England Stonecarving* (Middletown, Conn., 1974), p. 201; and Allen I. Ludwig, *Graven Images: New England Stonecarving and Its Symbols, 1650–1815* (Middletown, Conn., 1966), p. 373.

2. Tashjian and Tashjian, *Memorials*, p. 201.

3. Ibid., p. 203.

4. Beatrix T. Rumford and Carolyn Weekley, *Treasures of American Folk Art from the Abby Aldrich Rockefeller Folk Art Center* (exhib. cat.; Boston, 1989), p. 108.

5. William Wroth, *The Chapel of Our Lady of Talpa* (Colorado Springs, 1979), p. 67.

6. The Hispanic wood-carving tradition continues in the Southwest today in a different form. Contemporary wood-carvers, as exemplified by Felipe Benito Archuleta, are primarily producing animal scupltures and other secular figures for sale to collectors.

7. Charles Briggs, *The Wood Carvers of Córdova, New Mexico* (Knoxville, Tenn., 1980), pp. 52–53.

8. C. Kurt Dewhurst, Betty MacDowell, and Marsha MacDowell, *Religious Folk Art in America: Reflections of Faith* (New York, 1983), p. 24.

9. Briggs, *Wood Carvers*, p. 31.

10. Robert Shaw, "Weather Vanes & Whirligigs," in *An American Sampler: Folk Art from the Shelburne Museum* (exhib. cat.; Washington, D.C., 1987), p. 114.

11. Charles Klamkin, *Weather Vanes: The History, Design and Manufacture of an American Folk Art* (New York, 1973), p. 72.

12. Ibid., p. 73.

13. Ida Ely Rubin, ed., *The Guennol Collection* (New York, 1982), vol. 2, pp. 255–56.

14. John Michael Vlach, *The Afro-American Tradition in Decorative Arts* (exhib. cat.; Cleveland, Ohio, 1978), pp. 36–37.

15. Ibid., p. 37.

16. In a number of earlier publications, *Tin Man* has mistakenly been attributed to J. Krans, owner of the very similarly named West End Sheet Metal and Roofing Company, in Brooklyn. Letters from the family of David Goldsmith to Elizabeth V. Warren have made it clear that Goldsmith was the sculptor of *Tin Man*.

17. Frederick Fried, *A Pictorial History of the Carousel* (New York, 1964), p. 133.

18. Charlotte Dinger, *Art of the Carousel* (Green Village, N.J., 1983), pp. 175–89.

19. Edmondson's remarks are quoted in Edmund L. Fuller, *Visions in Stone: The Sculpture of William Edmondson* (Pittsburgh, 1973), pp. 8, 19.

20. Ibid., pp. 14–16.

21. Ibid., p. 16.

22. Edmondson, quoted ibid., pp. 10, 20.

23. I. Sheldon Posen and Daniel Franklin Ward, "Watts Towers and the *Giglio* Tradition," in *Folklife Annual 1985*, ed. Alan Jabbour and James Hardin (Washington, D.C., 1985), p. 153.

24. Seymour Rosen, *In Celebration of Ourselves* (San Francisco, 1979), p. 14.

25. Posen and Ward, "Watts Towers," pp. 143–57.

★

FURNISHINGS

★　★　★　★　★

1. John T. Kirk, *American Furniture and the British Tradition to 1830* (New York, 1982), p. 44.

2. Ibid., p. 70.

3. Dean A. Fales, Jr., *American Painted Furniture 1660–1880* (New York, 1972), p. 20.

4. Ibid., p. 59.

5. The title *Harvard Chest* is a misnomer. It was once believed that the buildings shown on the front of the chest of drawers represented Harvard College, but they have since been shown to be typical Georgian-style structures and not based on any specific prototypes. See Fales, ibid., p. 37.

6. Pastor Frederick S. Weiser and Mary Hammond Sullivan, "Decorated Furniture of the Mahantango Valley," *The Magazine Antiques*, vol. 103, no. 5 (May 1973), p. 933.

7. Beatrice B. Garvan and Charles F. Hummel, *The Pennsylvania Germans: A Celebration of Their Arts 1683–1850* (exhib. cat.; Philadelphia, 1982), p. 171.

8. Weiser and Sullivan, "Decorated Furniture," p. 933.

9. Garvan and Hummel, *Pennsylvania Germans*, p. 65.

10. Benno M. Forman, "German Influences in Pennsylvania Furniture," in Scott T. Swank et al., *Arts of the Pennsylvania Germans* (New York, 1983), p. 131.

11. Lonn Taylor and Dessa Bokides, *New Mexican Furniture, 1600–1940* (Santa Fe, 1987), pp. 137–42.

12. John Joseph Stoudt, *Early Pennsylvania Arts and Crafts* (New York, 1964), pp. 211–13.

13. Arlene Palmer Schwind, "Pennsylvania German Earthenware," in Scott T. Swank et al., *Arts of Pennsylvania Germans*, p. 192.

14. Mary Gerrish Higley, "The Caswell Carpet," *The Magazine Antiques*, vol. 9, no. 6 (June 1926), pp. 396–98.

15. For a general introduction to the subject of Amish quilts, see Elizabeth V. Warren, "Amish Quilts in the Museum of American Folk Art," *The Magazine Antiques*, vol. 132, no. 3 (September 1987), pp. 514–23.

16. For a discussion of quilts made by the Amish in Mifflin County, Pennsylvania, see Connie Hayes and Evelyn Gleason, "Nebraskan Quilts: The Discovery of a Distinctive Style of Amish Quilts," *Antique Collecting*, January 1979, pp. 21–28.

17. Gladys-Marie Fry, "Harriet Powers: Portrait of a Black Quilter," in *Missing Pieces: Georgia Folk Art 1770–1976* (exhib. cat.; [Columbus], Georgia, 1976), p. 17.

18. Ibid., p. 19.

19. Ibid., p. 18.

20. Maude Southwell Wahlman, "African-American Quilts: Tracing the Aesthetic Principles," *The Clarion*, Spring 1989, p. 44.

21. Powers, quoted in Fry, "Harriet Powers," p. 21.

22. Thomas K. Woodard and Blanche Greenstein, "Hawaiian Quilts: Treasures of an Island Folk Art," *The Clarion*, Summer 1979, p. 18.

23. Ibid., p. 24.

24. Honolulu Academy of Arts catalogue files.

25. Ibid.

26. C. Kurt Dewhurst, Betty MacDowell, and Marsha MacDowell, *Religious Folk Art in America: Reflections of Faith* (New York, 1983), p. 88.

27. Honolulu Academy of Arts catalogue files.

28. Woodard and Greenstein, "Hawaiian Quilts," pp. 18, 23.

29. Kate Peck Kent, *Navajo Weaving: Three Centuries of Change* (Santa Fe, 1985), p. 107.

30. Ibid., p. 79.

31. Ibid., p. 109.

<div align="center">★</div>

HOLGER CAHILL, AN APPRECIATION

<div align="center">★ ★ ★ ★ ★</div>

1. Jean Lipman, in Frank J. Miele, ed., "Folk or Art? A Symposium," *The Magazine Antiques*, vol. 135, no. 1 (January 1989), p. 280.

2. John Michael Vlach, "Holger Cahill as Folklorist," *Journal of American Folklore*, vol. 98 (1985), p. 150.

3. Beatrix T. Rumford, "Uncommon Art of the Common People: A Review of Trends in the Collecting and Exhibiting of American Folk Art," in Ian M. G. Quimby and Scott T. Swank, eds., *Perspectives on American Folk Art* (New York, 1980), p. 23.

4. Holger Cahill, "Artisan and Amateur in American Folk Art," *The Magazine Antiques*, vol. 59, no. 3 (March 1951), reprinted in Jack T. Ericson, ed., *Folk Art in America: Paintings and Sculpture* (New York, 1979), pp. 22, 23.

5. "American Folk Art," in Holger Cahill, *American Folk Art: The Art of the Common Man in America, 1750–1900* (exhib. cat.; New York, 1932), p. 3.

6. "American Folk Sculpture," in [Holger Cahill], *American Folk Sculpture: The Work of Eighteenth and Nineteenth Century Craftsmen* (exhib. cat.; Newark, N.J., 1931), p. 13.

7. Introduction to [Holger Cahill], *American Primitives: An Exhibit of the Paintings of Nineteenth Century Folk Artists* (exhib. cat.; Newark, N.J., 1930), pp. 8–9.

8. John Wilmerding, in Miele, ed., "Folk or Art?" p. 278.

BIBLIOGRAPHY

An American Sampler: Folk Art from the Shelburne Museum (exhibition catalogue). Washington, D.C.: National Gallery of Art, 1987.

Ames, Kenneth L. *Beyond Necessity: Art in the Folk Tradition* (exhibition catalogue). Winterthur, Del.: Henry Francis du Pont Winterthur Museum, 1977.

Arkus, Leon Anthony. *John Kane, Painter.* Pittsburgh: University of Pittsburgh Press, 1971.

Armstrong, Thomas N., III. *Pennsylvania Almshouse Painters* (exhibition catalogue). Williamsburg, Va.: Colonial Williamsburg, 1968.

Armstrong, Tom, et al. *200 Years of American Sculpture.* New York: David R. Godine in association with the Whitney Museum of American Art, 1976.

Bates, Elizabeth Bidwell, and Jonathan L. Fairbanks. *American Furniture 1620 to the Present.* New York: Richard Marek, 1981.

Bill Traylor, 1854–1947 (exhibition catalogue). New York: Hirschl and Adler Modern, 1985.

Bishop, Robert. *American Folk Sculpture.* New York: E. P. Dutton, 1974.

Bishop, Robert, and Patricia Coblentz. *A Gallery of American Weathervanes and Whirligigs.* New York: E. P. Dutton, 1981.

Black, Mary. "Ammi Phillips: The Country Painter's Method." *The Clarion,* Winter 1986, pp. 32–37.

⸺. "Contributions toward a History of Early Eighteenth-Century New York Portraiture: The Identification of the Aetatis Suae and Wendell Limners." *American Art Journal,* vol. 12, no. 4 (Autumn 1980), pp. 4–31.

⸺. *Erastus Salisbury Field: 1805–1900* (exhibition catalogue). Springfield, Mass.: Museum of Fine Arts, 1985.

⸺. "A Folk Art Whodunit" [Jacob Maentel]. *Art in America,* vol. 53, no. 3 (June 1965), pp. 96–105.

Black, Mary, and Jean Lipman. *American Folk Painting.* New York: Clarkson N. Potter, 1966.

Blackburn, Roderic H., and Nancy A. Kelley, eds. *New World Dutch Studies: Dutch Arts and Culture in Colonial America 1609–1776.* Albany, N.Y.: Albany Institute of History and Art, 1987.

Blackburn, Roderic H., and Ruth Piwonka. *Remembrance of Patria: Dutch Arts and Culture in Colonial America 1609–1776* (exhibition catalogue). Albany, N.Y.: Albany Institute of History and Art, 1988.

Boyd, Elizabeth. *Popular Arts of Spanish New Mexico.* Santa Fe: Museum of New Mexico Press, 1974.

Brewington, Marion Vernon. *Ship Carvers of North America.* New York: Dover Publications, 1972.

Briggs, Charles. *The Wood Carvers of Córdova, New Mexico.* Knoxville: University of Tennessee Press, 1980.

Cahill, Holger. *American Folk Art: The Art of the Common Man in America, 1750–1900* (exhibition catalogue). New York: Museum of Modern Art, 1932.

⸺. "Artisan and Amateur in American Folk Art." *The Magazine Antiques,* vol. 59, no. 3 (March 1951), pp. 210–11.

⸺. "What Is American Folk Art?" *The Magazine Antiques,* vol. 58, no. 5 (May 1950), pp. 355–62.

[Cahill, Holger]. *American Folk Sculpture: The Work of Eighteenth and Nineteenth Century Craftsmen* (exhibition catalogue). Newark, N.J.: Newark Museum, 1931.

⸺. *American Primitives: An Exhibit of the Paintings of Nineteenth Century Folk Artists* (exhibition catalogue). Newark, N.J.: Newark Museum, 1930.

Christensen, Erwin O. *The Index of American Design.* Introduction by Holger Cahill. New York: Macmillan, 1950.

Craven, Wayne. *Colonial American Portraiture.* New York: Cambridge University Press, 1986.

D'Ambrosio, Paul S., and Charlotte M. Emans. *Folk Art's Many Faces: Portraits in the New York State Historical Association.* Cooperstown: New York State Historical Association, 1987.

Davidson, Marshall B. *Life in America.* 2 vols. Boston: Houghton Mifflin in association with the Metropolitan Museum of Art, 1951.

DePauw, Linda Grant, and Conover Hunt. *"Remember the Ladies": Women in America 1750 to 1815* (exhibition catalogue). New York: Viking Press in association with the Pilgrim Society, 1976.

Dewhurst, C. Kurt, Betty MacDowell, and Marsha MacDowell. *Artists in Aprons: Folk Art by American Women.* New York: E. P. Dutton in association with the Museum of American Folk Art, 1979.

―――. *Religious Folk Art in America: Reflections of Faith.* New York: E. P. Dutton in association with the Museum of American Folk Art, 1983.

Dinger, Charlotte. *Art of the Carousel.* Green Village, N.J.: Carousel Art Inc., 1983.

Dresser, Louisa. *Seventeenth Century Painting in New England* (exhibition catalogue). Worcester, Mass.: Worcester Art Museum, 1935.

Ebert, John, and Katherine Ebert. *American Folk Painters.* New York: Charles Scribner's Sons, 1975.

Ericson, Jack T., ed. *Folk Art in America: Painting and Sculpture.* New York: Mayflower Books, 1979.

Fairbanks, Jonathan L., and Robert F. Trent. *New England Begins: The Seventeenth Century.* 3 vols. Boston: Museum of Fine Arts, 1982.

Fales, Dean A., Jr. *American Painted Furniture 1660–1880.* New York: E. P. Dutton, 1972.

Finore, Diane. "Art by Bill Traylor." *The Clarion,* Spring-Summer 1983, pp. 42–48.

"A Folk Copyist." *The Magazine Antiques,* vol. 124, no. 1 (July 1983), p. 117.

Fried, Frederick. *A Pictorial History of the Carousel.* New York: A. S. Barnes, 1964.

Fry, Gladys-Marie. "Harriet Powers: Portrait of a Black Quilter." In *Missing Pieces: Georgia Folk Art 1770–1976* (exhibition catalogue), pp. 16–23. [Columbus]: Georgia Council for the Arts and Humanities, 1976.

Fuller, Edmund L. *Visions in Stone: The Sculpture of William Edmondson.* Pittsburgh: University of Pittsburgh Press, 1973.

Garvan, Beatrice B., and Charles F. Hummel. *The Pennsylvania Germans: A Celebration of Their Arts 1683–1850* (exhibition catalogue). Philadelphia: Philadelphia Museum of Art, 1982.

The Gift of Inspiration: Shaker and American Folk Art (exhibition catalogue). New York: Hirschl and Adler Galleries, 1979.

Glueck, Grace. "Tastemakers." *New York Times Magazine,* 30 August 1987.

The Great River: Art and Society of the Connecticut Valley, 1635–1820. Hartford, Conn.: Wadsworth Atheneum, 1985.

Hall, Michael D. "The Problem of Martin Ramirez: Folk Art Criticism as Cosmologies of Coercion." *The Clarion,* Winter 1986, pp. 56–61.

The Heart of Creation: The Art of Martin Ramirez (exhibition catalogue). Philadelphia: Moore College of Art, 1985.

Hemphill, Herbert W., Jr., and Julia Weissman. *Twentieth Century American Folk Art and Artists.* New York: E. P. Dutton, 1974.

Higley, Mary Gerrish. "The Caswell Carpet." *The Magazine Antiques,* vol. 9, no. 6 (June 1926), pp. 396–98.

Holdridge, Barbara, and Lawrence B. Holdridge. Introduction by Mary Black. *Ammi Phillips: Portrait Painter 1788–1865* (exhibition catalogue). New York: Clarkson N. Potter for the Museum of American Folk Art, 1969.

Janis, Sidney. *They Taught Themselves: American Primitive Painters of the 20th Century.* New York: Dial Press, 1942.

Johnson, Philip. *Deconstructivist Architecture* (exhibition catalogue). New York: Museum of Modern Art, 1988.

Johnson, Theodore E., Brother. *In the Eye of Eternity: Shaker Life and the Work of Shaker Hands.* Gorham, Maine: United Society of Shakers and the University of Southern Maine, 1983.

Kent, Kate Peck. *Navajo Weaving: Three Centuries of Change.* Santa Fe: School of American Research Press, 1985.

Klamkin, Charles. *Weather Vanes: The History, Design and Manufacture of an American Folk Art.* New York: Hawthorn Books, 1973.

Lipman, Jean, and Tom Armstrong, eds. *American Folk Painters of Three Centuries.* New York: Hudson Hills Press in association with the Whitney Museum of American Art, 1980.

Lipman, Jean, and Helen M. Franc. *Bright Stars: American Painting and Sculpture Since 1776.* New York: E. P. Dutton, 1976.

Lipman, Jean, and Alice Winchester. *The Flowering of American Folk Art (1776–1876).* New York: Viking Press, 1974.

Lipman, Jean, Elizabeth V. Warren, and Robert Bishop. *Young America: A Folk-Art History.* New York: Hudson Hills Press in association with the Museum of American Folk Art, 1986.

Little, Nina Fletcher. *American Decorative Wall Painting, 1700–1850.* New York: E. P. Dutton, 1972.

———. "John Brewster, Jr., 1766–1854." *Connecticut Historical Society Bulletin,* vol. 25, no. 4 (October 1960).

———. *Land and Seascape as Observed by the Folk Artist* (exhibition catalogue). Williamsburg, Va.: Colonial Williamsburg, 1969.

———. *Paintings by New England Provincial Artists 1775–1800* (exhibition catalogue). Boston: Museum of Fine Arts, 1976.

Livingston, Jane, and John Beardsley. *Black Folk Art in America 1930–1980.* Jackson: University Press of Mississippi and Center for the Study of Southern Culture for the Corcoran Gallery of Art, 1982.

Ludwig, Allan I. *Graven Images: New England Stonecarving and Its Symbols, 1650–1815.* Middletown, Conn.: Wesleyan University Press, 1966.

Mather, Eleanore Price, and Dorothy Canning Miller. *Edward Hicks: His Peaceable Kingdom and Other Paintings.* Newark, Del.: American Art Journal; University of Delaware Press Books, 1983.

McCoy, Ronald. *Kiowa Memories: Images from Indian Territory, 1880* (exhibition catalogue). Santa Fe: Morning Star Gallery, 1987.

Miele, Frank J. "Calligraphic Drawings: The Art of Writing." *The Magazine Antiques,* vol. 134, no. 3 (September 1988), pp. 537–49.

Miele, Frank J., ed. "Folk or Art? A Symposium." *The Magazine Antiques,* vol. 135, no. 1 (January 1989), pp. 272–87.

Miller, Richard. "Itinerant Artists and Roving Photographers: The Impact of Photography on Folk Portraiture." *Heritage,* vol. 3, no. 5 (June 1987), n.p.

Orlofsky, Patsy, and Myron Orlofsky. *Quilts in America.* New York: McGraw-Hill, 1974.

Patterson, Daniel W. *Gift Drawing and Gift Song: A Study of Two Forms of Shaker Inspiration.* Sabbathday Lake, Maine: United Society of Shakers, 1983.

Peluso, A. J., Jr. "James Bard's *Thomas Hunt & America:* An Appreciation." Manuscript in collection of Museum of American Folk Art, New York.

————. *J and J Bard: Picture Painters.* New York: Hudson River Press, 1977.

Persig, Robert M. *Zen and the Art of Motorcycle Maintenance.* New York: William Morrow, 1974.

Petersen, Karen Daniels. *American Pictographic Images: Historical Works on Paper by the Plains Indians* (exhibition catalogue). New York: Alexander Gallery and Morning Star Gallery, 1988.

Phelps, Mrs. Almira Hart Lincoln. *The Fireside Friend or Female Student; Being Advice to Young Ladies on the Important Subject of Education.* Boston: Marsh, Capen, Lyon, and Webb, 1840.

Posen, I. Sheldon, and Daniel Franklin Ward. "Watts Towers and the *Giglio* Tradition." In *Folklife Annual 1985,* edited by Alan Jabbour and James Hardin, pp. 143–57. Washington, D.C.: Library of Congress, 1985.

Quimby, Ian M. G., and Scott T. Swank, eds. *Perspectives on American Folk Art.* New York: W. W. Norton for the Henry Francis du Pont Winterthur Museum, 1980.

Rosen, Seymour. *In Celebration of Ourselves.* San Francisco: A California Living Book published in association with the San Francisco Museum of Modern Art, 1979.

Rubin, Ida Ely, ed. *The Guennol Collection* (exhibition catalogue). New York: The Metropolitan Museum, 1982.

Rumford, Beatrix T., ed. *American Folk Paintings: Paintings and Drawings Other Than Portraits from the Abby Aldrich Rockefeller Folk Art Center.* Boston: Little, Brown, a New York Graphic Society Book published in association with the Colonial Williamsburg Foundation, 1988.

————. *American Folk Portraits: Paintings and Drawings from the Abby Aldrich Rockefeller Folk Art Center.* Boston: New York Graphic Society in association with the Colonial Williamsburg Foundation, 1981.

Rumford, Beatrix T., and Carolyn Weekley. *Treasures of American Folk Art from the Abby Aldrich Rockefeller Folk Art Center* (exhibition catalogue). Boston: Little, Brown in association with the Colonial Williamsburg Foundation, 1989.

Safford, Carleton L., and Robert Bishop. *America's Quilts and Coverlets.* New York: E. P. Dutton, 1972.

Schorsch, Anita. *Mourning Becomes America: Mourning Art in the New Nation* (exhibition catalogue). Clinton, N.J.: Main Street Press, 1976.

Shelley, Donald A. *The Fraktur-Writings or Illuminated Manuscripts of the Pennsylvania Germans.* Allentown, Pa.: Pennsylvania German Folklore Society, 1961.

Stoudt, John Joseph. *Early Pennsylvania Arts and Crafts.* New York: Bonanza Books, 1964.

Strickler, Susan E. "Recent Findings on the Freake Portraits." *Worcester Art Museum Journal,* vol. 5 (1981–82), pp. 49–55.

Stutler, Boyd B. "An Eyewitness Describes the Hanging of John Brown." *American Heritage,* vol. 6, no. 2 (February 1955), pp. 4–9.

Tashjian, Dickran, and Ann Tashjian. *Memorials for Children of Change: The Art of Early New England Stonecarving.* Middletown, Conn.: Wesleyan University Press, 1974.

Taylor, Lonn, and Dessa Bokides. *New Mexican Furniture, 1600–1940: The Origins, Survival, and Revival of Furniture Making in the Hispanic Southwest.* Santa Fe: Museum of New Mexico Press, 1987.

Valentine, Lanci. *Rufus Hathaway: Artist and Physician, 1770–1822* (exhibition catalogue). Duxbury, Mass.: Art Complex Museum, 1987.

Vlach, John Michael. *The Afro-American Tradition in Decorative Arts* (exhibition catalogue). Cleveland, Ohio: Cleveland Museum of Art, 1978.

———. "Holger Cahill as Folklorist." *Journal of American Folklore,* vol. 98 (1985), pp. 148–62.

Vlach, John Michael, and Simon J. Bronner, eds. *Folk Art and Art Worlds: Essays Drawn from the Washington Meeting on Folk Art.* Ann Arbor, Mich.: UMI Research Press, 1986.

Wahlman, Maude Southwell. "African-American Quilts: Tracing the Aesthetic Principles." *The Clarion,* Spring 1989, pp. 44–54.

———. "The Art of Bill Traylor." In *Bill Traylor (1854–1947)* (exhibition catalogue). Little Rock, Ark.: Arkansas Art Center, 1982.

Waingrow, Jeff. *American Wildfowl Decoys.* New York: E. P. Dutton in association with the Museum of American Folk Art, 1985.

Warren, Elizabeth V. "Amish Quilts in the Museum of American Folk Art." *The Magazine Antiques,* vol. 132, no. 3 (September 1987), pp. 514–23.

Warren, Elizabeth V., and Stacy C. Hollander. *Expressions of a New Spirit: Highlights from the Permanent Collection of the Museum of American Folk Art.* New York: Museum of American Folk Art, 1989.

Weiser, Frederick S., Pastor. "I A E S D: The Story of Johann Adam Eyer (1755–1837), Schoolmaster and Fraktur Artist, with a Translation of His Roster Book 1779–1787." In *Ebbes fer Alle—Ebber Ebbes fer Dich: Something for Everyone—Something for You,* pp. 435–506. Breiningsville, Pa.: Pennsylvania German Society, 1980.

Weiser, Frederick S., Pastor, and Mary Hammond Sullivan. "Decorated Furniture of the Mahantango Valley." *The Magazine Antiques,* vol. 103, no. 5 (May 1973), pp. 932–39.

———. "Decorated Furniture of the Schwaben Creek Valley." In *Ebbes fer Alle—Ebber Ebbes fer Dich: Something for Everyone—Something for You,* pp. 331–94. Breiningsville, Pa.: Pennsylvania German Society, 1980.

Wilmerding, John. *American Masterpieces from the National Gallery of Art.* New York: Hudson Hills Press, 1980.

Woodard, Thomas K., and Blanche Greenstein. "Hawaiian Quilts: Treasures of an Island Folk Art." *The Clarion,* Summer 1979, pp. 16–27.

Wroth, William. *The Chapel of Our Lady of Talpa.* Colorado Springs: Taylor Museum of the Colorado Springs Fine Arts Center, 1979.

———. *Christian Images in Hispanic New Mexico.* Colorado Springs: Taylor Museum of the Colorado Springs Fine Arts Center, 1982.

Yoder, Don, and Thomas E. Graves. *Hex Signs: Pennsylvania Dutch Barn Symbols and Their Meaning.* New York: E. P. Dutton in association with the Museum of American Folk Art, 1989.